art cars

the Cars, the Artists, the Obsession, the Craft

Rick —

Maybe this might spark your interest?

Anytime you feel like painting —

Sue

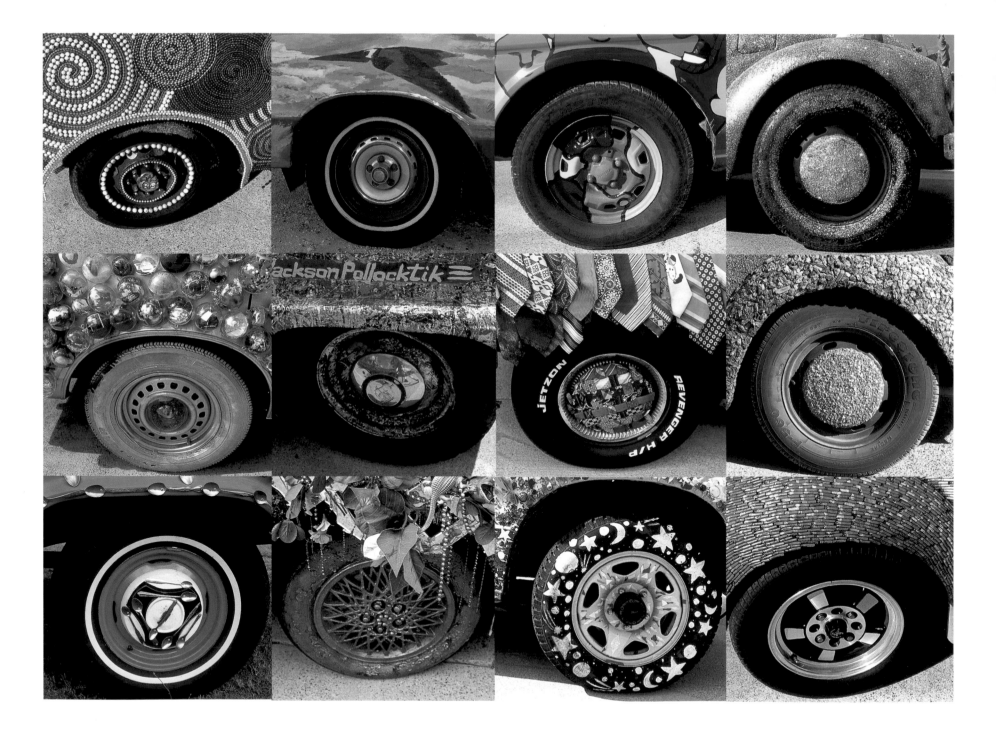

art cars

the Cars, the Artists, the Obsession, the Craft

Harrod Blank

LARK BOOKS

A Division of Sterling Publishing Co., Inc.
New York

Harrod Blank
4/2/02

Editor:
Janice Eaton Kilby

Art Direction & Production:
Tom Metcalf

Production Assistant:
Amanda A. Robbins

Photography:
Harrod Blank

Cover Design:
Barbara Zaretsky

Assistant Editor:
Veronika Alice Gunter

Editorial Assistance:
Rain Newcomb

Library of Congress Cataloging-in-Publication Data

Blank, Harrod.
 Art cars: the cars, the artist, the obsession, the craft/c by Harrod Blank.– 1st ed.
 p. cm.
 Includes Index
 ISBN 1-57990-330-4 (paper)
 1. Automobiles–Decoration–United States. 2. Folk Art–United States. I. Title.
TL255.2 .B53 2002
629.2'62–dc21

 CIP
10 9 8 7 6 5 4 3 2 2001042725
First Edition

Published by Lark Books, a division of
Sterling Publishing Co., Inc.
387 Park Avenue South, New York, N.Y. 10016

© 2002, Harrod Blank

Distributed in Canada by Sterling Publishing, c/o Canadian Manda Group, One Atlantic Ave., Suite 105 Toronto, Ontario, Canada M6K 3E7

Distributed in the U.K. by Guild of Master Craftsman Publications Ltd., Castle Place, 166 High Street, Lewes, East Sussex, England BN7 1XU
Tel: (+ 44) 1273 477374, Fax: (+ 44) 1273 478606, Email: pubs@thegmcgroup.com, .Web: www.gmcpublications.com

Distributed in Australia by Capricorn Link (Australia) Pty Ltd., P.O. Box 704, Windsor, NSW 2756, Australia

If you have questions or comments about this book, please contact:
Lark Books
67 Broadway
Asheville, NC 28801
(828) 236-9730

Printed in China

ISBN 1-57990-330-4

Wheel shots title page
From left to right, top to bottom: *Booga* by Daniel Winkert; *Whale Car 2* by Christian Zajac; *Human Race Car* by Michael Splawn; *Tank Grrl* by Rebecca Lowe; *Herod Bubble Mobile* by Herod Elementary School, Houston, and coordinator Marla Roberson; *Jackson Pollocktik* by Matthew A. Donahue and Andy Sirotnyak; *Tie Rod* by Brad Cushman, Mickey Howley, and Southeastern Oklahoma State Art Students; *Rocky Roadster* by Doug Flynn; *Spoon Truck* by Elmer Fleming; *Frogmobile* by Jay and Karen Goldberg and students from High School of Law Enforcement & Criminal Justice, Houston; *Sparky's Rainbow Repair*, also titled *Cate*, by Max Haynes; *Stink-Bug* by Carolyn Stapleton

Title page
Timeless Classics (detail) by Sandy Schorr and the Jacksonville Middle School Art Car Club, Tyler, Texas

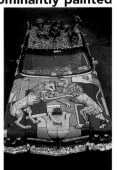
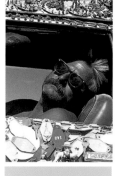

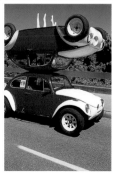

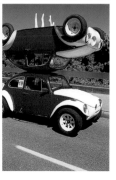

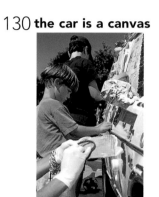

contents

Introduction

When I was 16, my first car was an all-white, beat-up 1965 Volkswagen bug. I had a disdain for cars in general because they were mass-produced and boring, but this old, raggedy VW was especially ugly and embarrassing.

Growing up in a forest in the Santa Cruz mountains with artistic, hippie parents, I felt different from most of my peers. I felt I had to show people I wasn't like everyone else, that I wasn't just another guy in a VW bug, but that I was . . . me. This desire to show my individuality, to create my own car, would become the foundation of my entire career.

Over the following years, I commuted to high school and college in my first art car, *Oh My God!* (right), working on it during weekends. As I matured, the car metamorphosed, too, becoming better and better. As you might imagine, people had strong reactions to me and my car. Some observers went so far as to assume I was on drugs, a certified hippie, or just plain crazy. I was harassed mercilessly by the police, which I figured was their attempt to squelch what they didn't understand. Their reactions intensified my desire to justify and celebrate not only my own automotive expression, but that of others, too.

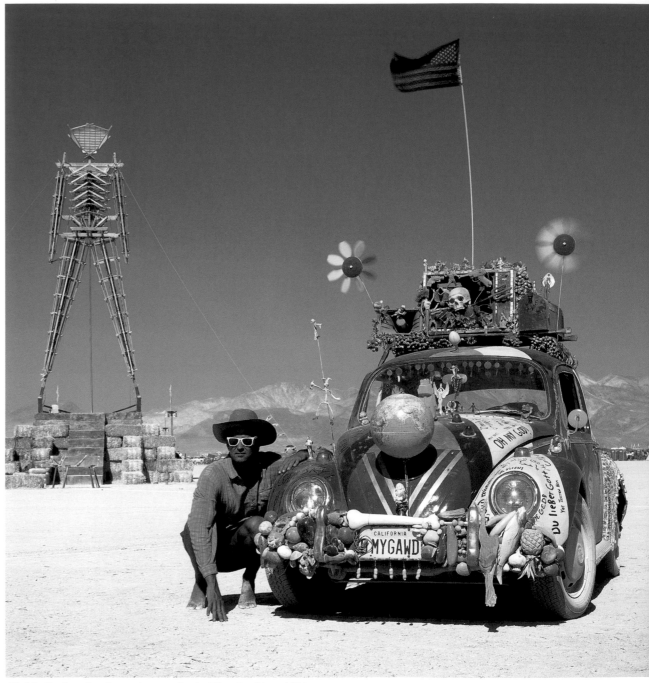

Oh My God! at the alternative arts festival Burning Man, 1996

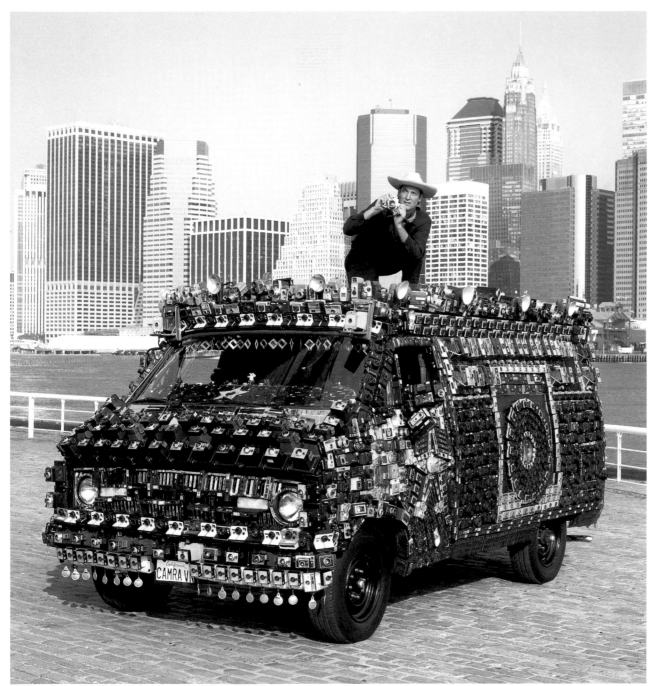

Camera Van under the Brooklyn Bridge, New York, 1995

After graduating from college in 1986, I spent the next six years creating several art car calendars, a feature documentary film, and a book, each titled *Wild Wheels*. Not to toot my own horn, but the film and book were distributed all over the world and had a tremendous influence. Indeed, through my own work and that of the annual Houston Art Car Parade, not to mention the work of the art car artists themselves, art cars have been defined as a recognizable cultural phenomenon. As a result, when people see an art car now, it conjures a more positive image, something that they understand, accept, and even embrace. In fact, nowadays people frequently say, "Look, there's an art car!"

In 1993, I was about to begin making my next documentary film, a study of uniforms, when one night I had a bizarre dream that suddenly changed my course. I dreamed that I was driving around in a van completely covered with cameras and taking pictures of the public's candid reactions. I was so blown away by this idea that I began making it a reality the very next day. The *Camera Van* (left) would take me two years to build and, ironically, reignite my passion for art cars. It inspired me to shoot a sequel to *Wild Wheels* in an attempt to dig deeper into the psychology and the ideology of art car makers.

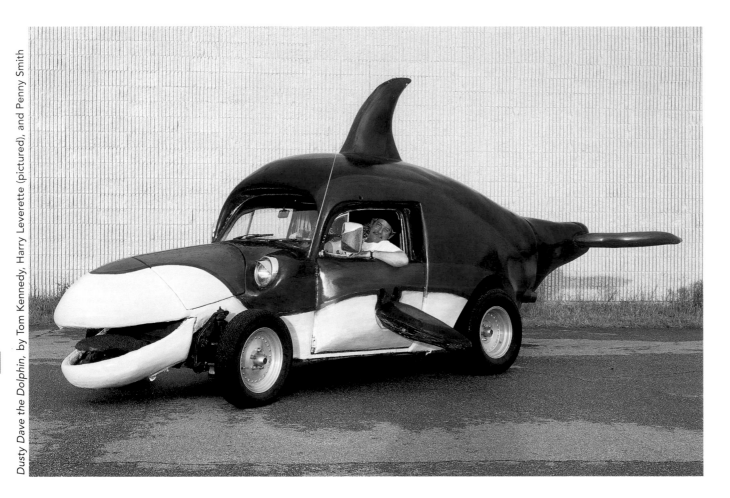

Dusty Dave the Dolphin, by Tom Kennedy, Harry Leverette (pictured), and Penny Smith

to befriend other art car people and gain their trust in order to document them. Ultimately, I personally know everyone who appears in this book and I'm quite close friends with many. So, as you can imagine, I am very pleased to have the opportunity to create this book and to introduce readers to this diverse, extended family of mine.

On and off from 1995 to 2000, I journeyed across the country filming and photographing art cars for this book and for a second film. The aesthetic behind

Once again, I'd been bitten by the bug of passion that has driven me from the very beginning—my love and admiration for oddballs, for the bizarre, and for the true individual in each of us.

I suppose my passion for eccentrics began as a boy. I was fascinated by my parents' friends. My

mother and father, Gail and Les Blank, are both artists. She's a ceramicist, and he's a filmmaker, and they attracted and interacted with a myriad of unique and bizarre people. As I grew up, I came to value and appreciate eccentricity and individuality. As much as I like showing off in an art car, I'm just as eager to document other kindred spirits. My dual disposition has enabled me

my imagery is simple, and I try to accomplish two things. First, I aim to preserve and present the art car as it really exists, and I try not to put my own stamp on the image. I choose simple, plain locations such as grassy fields, asphalt, sky, or ocean backgrounds near the subjects' homes to keep the focus on the art car. I use available light with little or no flash, and shoot most of the images an

there are chapters on painted vehicles, cars with objects attached, conceptual/sculptural cars, etcetera. To be honest, categorizing art cars goes against their one-of-a-kind spirit, but in the interest of presenting them in book form, I felt this was necessary, and I apologize in advance to anyone who finds this approach offensive.

To generalize about art cars and define what they are, it helps to look at what they're not and to compare them to other forms of automotive customizing and trends. I admit here and now that I am not a world historian of the automobile, that I am really a bit ignorant about cars mechanically and otherwise, and that my approach to the art car medium is not theoretical, but rather more visceral and ideological. I do have a tremendous amount of personal experience in making and documenting art cars, and I share the passion, values, and psychology of their creators. So here, in short, I offer my humble opinion and interpretation.

hour or so after sunrise or before sunset. I normally use low-speed film, such as ASA 50 or 100, to keep the grain to a minimum, and a 50 mm or slightly wider lens to reduce image distortion. My second goal is to include the artist in the image, capturing their individual spirit and pride of accomplishment. To me, the most powerful and beautiful aspect of an art car is that it reflects very strongly the individual who created it. I hope the images in this book fulfill both goals, and that my affection and love for the artists and their creations is apparent.

I have taken the liberty of organizing the art cars in this book into genres based on the artistic techniques used in their creation. For example,

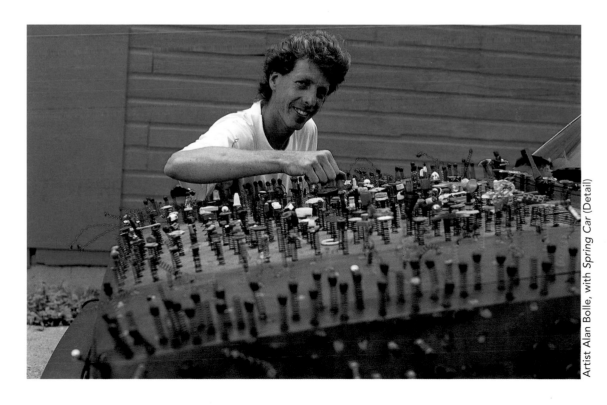

Artist Alan Bolle, with *Spring Car* (Detail)

An art car is often a fantasy made into reality, a symbol of freedom, and a rebellious creation. Not only does an art car question the standards of the automobile industry, but it expresses the ideas, values, and dreams of an individual. It's no surprise, then, that you'll find American flags on many art cars. The flag may be a direct link to the artist's patriotic feelings, or a symbol of personal freedom and the ability to think for oneself. In a culture in which automobile advertising is so ubiquitous, the pressure to desire, purchase, and drive brand-name cars is tremendous. It's no wonder that the average person doesn't make an art car. Frankly, people haven't been encouraged to do so . . . until now! It's especially difficult to separate the concept of a car from its *brand*, to start anew and consider a car as just a blank canvas. Then, once an art car has been created, it's equally difficult to drive it around every day to the market, to the gas station, and to work. The average person doesn't even think about pressures to conform until he or she confronts those forces by driving an art car. Thus, to me, the very medium of art cars is a form of rebellion, an act of bravery, and simply revolutionary.

There are no rules for making an art car, and no boundaries or guidelines to follow. Art cars are therefore different from custom cars, lowriders,

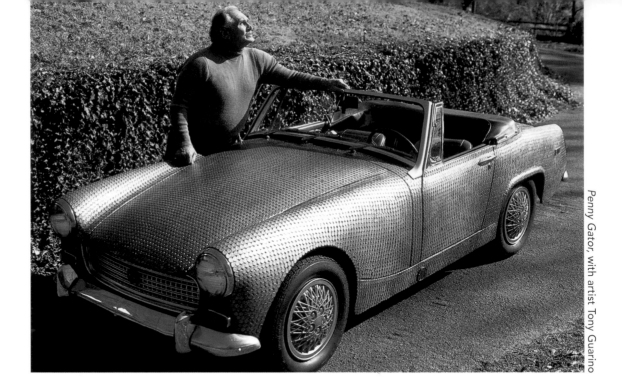

Penny Gator, with artist Tony Guarino

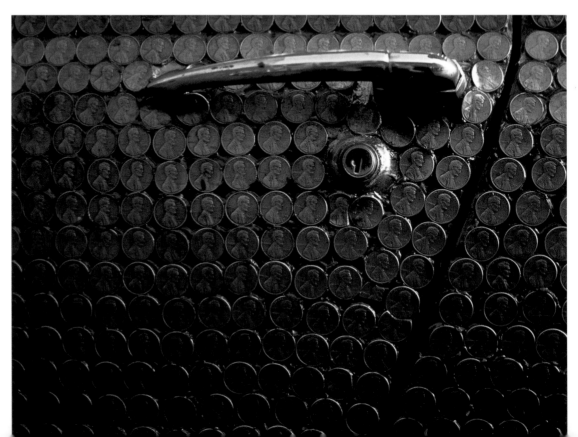

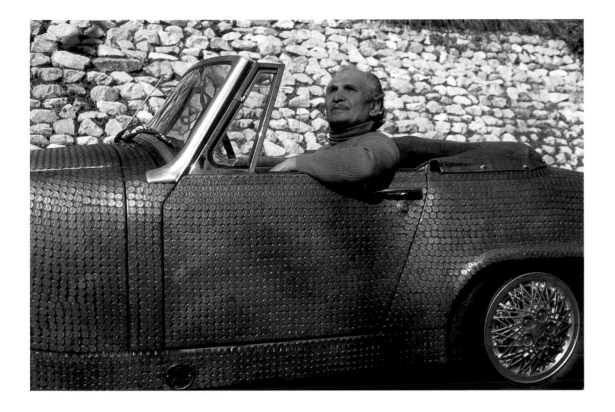

driver" art cars are strongly representative of the person behind the wheel, the artist's ideas, fantasies, and belief system. Art cars made for a parade or a one-time event can be cool and visually strong, but they're not daily drivers. It's much more challenging to create a street-legal, weather-resistant art car than to make a concept car for display in a parade, museum, or shopping mall.

The art cars featured in this book exemplify a variety of techniques, ideas, and stories. You'll see new work by some of the artists from *Wild Wheels* and wonderful work by people whose creations you haven't seen before. I've tried to include as many examples as possible, to demonstrate just how much variety and enthusiasm exists in this medium, but it was impossible to feature every great car. Consult the Internet and keep your eyes open, because you never know when you're going to see an art car. One thing is for sure: After reading this book, you'll never think of an art car in the same light again. I'll see you on the road, and don't forget to sa-a-a-ay "Cheese!"

monster trucks, step vans, historical vehicles, and race cars because all of those classifications have rather strict definitions. While people who create these other types of vehicles aim to embellish, enhance, and/or customize the inherent beauty and power of a given automobile, art car artists strip this away making completely different creations. At the same time, some lowriders, custom cars, and monster trucks could be considered art cars and vice versa. The definition of an art car is a bit loose. Most art car artists share with other car customizers a strong attention to detail and craftsmanship, a desire to stand out above the crowd, and an urge to create something special.

One of the most important aspects of an art car is that it can be driven, often on a daily basis. Art cars that can't be driven are really forms of sculpture; mobility is key to the art car medium. I have the greatest personal interest in and respect for art cars that are driven daily and are street-legal, i.e., that can pass required vehicle codes. "Daily

predominantly painted

When I began my first art car, *Oh My God!*, I painted a rooster on the driver's door. I simply copied a Peruvian poster of a rooster by tracing it with pencil, then rubbed the pencil marks onto the car door. I used spray paint unconventionally, spraying it into the caps of the spray cans until there was enough to apply with a fine brush. This was a messy way to paint, but it enabled me to mix new colors that weren't available in spray form. I painted in between the traced lines of the rooster and finished in one afternoon (see right). I was happy with the results, but what really blew my mind was how other people perceived the car. Suddenly I was getting "thumbs up," waves, and smiles in traffic. Strangers were coming up and talking to me. I had been exposed to the power of art cars, and this encouraged me to do more. Once I'd added a world globe as a hood ornament, there was no looking back.

Many art cars are, in fact, started with a paint job done by hand. It's the simplest and most direct way to enhance and transform one's car. There tend to be more painted art cars, because paint is more available and less of a risk to a car than extensive sculpting or gluing. A painted car can always be painted over, but it's difficult to turn a giant lobster-on-wheels back into a normal pickup truck!

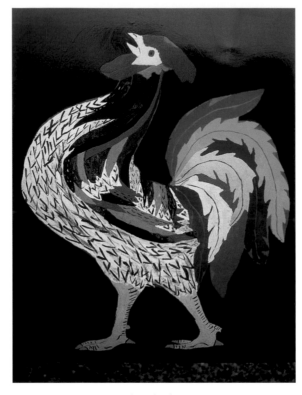

Many art cars, painted and otherwise, mimic popular animals and insects. An automobile is creature-like to begin with, having a body and four wheels for legs and moving through space as if it had a life of its own. Painted cars often imitate animal patterns, such as zebra stripes (*On Safari* by Raymond Fish, page 13, right), leopard spots, or, by far the most popular, cow spots. There are dozens of cow art cars, all variations on a theme, yet each one unique.

One example is *The Land of Milk & Cookies*, by Rumple (page 13, bottom left). This artist is known for offering his friends chocolate-covered cookies in the shape of . . . cows!

Just about every kind of paint is used on art cars, some more successfully than others. Enamel spray paint is a common choice, though it fades after a few years of exposure to the sun. Most art car artists use a lead-based sign painter's enamel called One-Shot. *Planet Karmann*, by Shelley Buschur (page 13, top left), with its deep, brilliant colors, is a good example of a One-Shot art car. The main drawback of One-Shot is its toxic lead content. Various paints and techniques are covered more thoroughly in chapter 9.

Though some art cars, such as the *American Flag Car*, by Mitch Haik (page 13, center left), are painted professionally using automotive paints and a sprayer, the majority are hand-painted with brushes. It is this handmade quality and aesthetic that attracts all sorts of people, not just artists, to make painted art cars and art cars in general. As you will see, many art cars begin as painted cars and become more elaborate down the road.

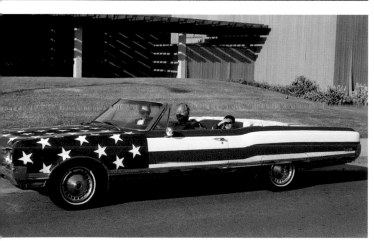

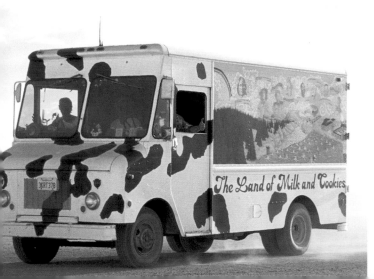

The Land of Milk and Cookies

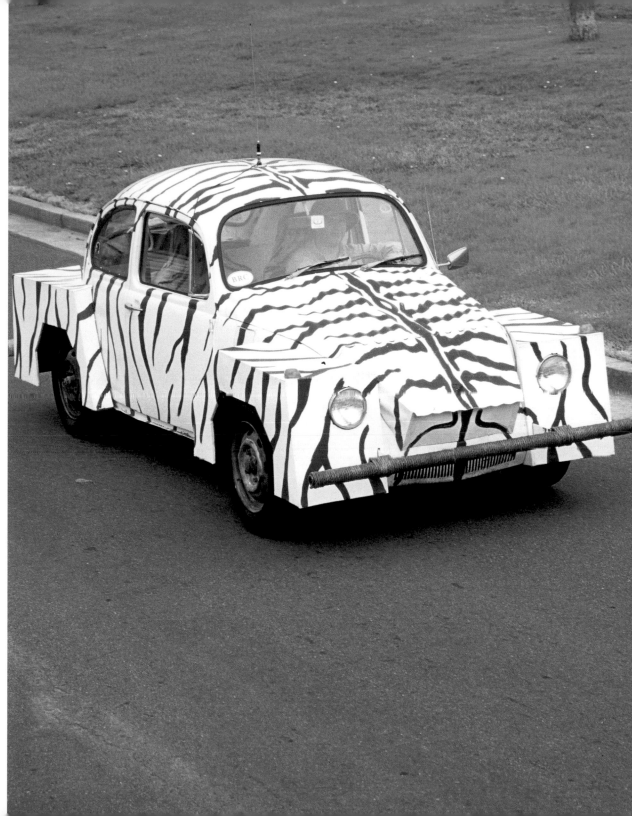

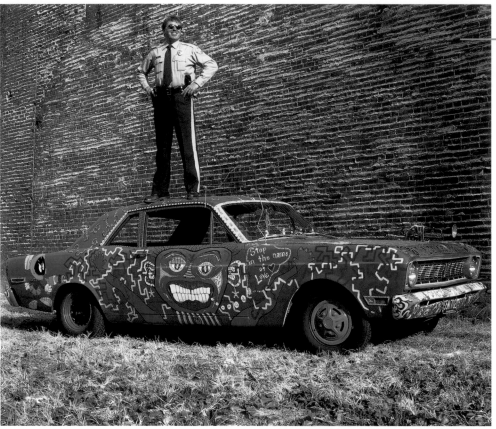

Art Car Cop Car by Officer Gary Wuest. Gary Wuest's car is another example of a St. Louis art car painted with One-Shot. Gary is unique in that, to my knowledge, he's the only police officer with an art car. The car features painted police tape, handcuffs, and other police symbols. Gary is also an art collector. He says, "I get a lot of negative looks driving a cop car, but it's the opposite with my art car!"

Whale Car 2 by Christian Zajac. After his first *Whale Car* was taken to the dump due to severe rust, Christian made his second attempt on a 1973 Chrysler Newport in great running condition. A fisherman and a painter, he paints seascapes on his car like the ones he's witnessed at sea.

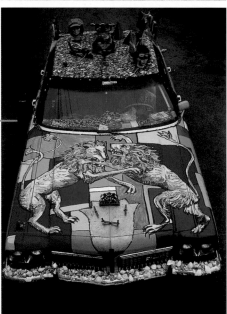

Funk Ambulance by Gretchen Baer. An artist living in Bisbee, Arizona, Gretchen Baer used One-Shot to paint mythological lions on the hood of her car to symbolize the power and strength needed for a cross-country journey she took. This car no longer exists, but she is working on another.

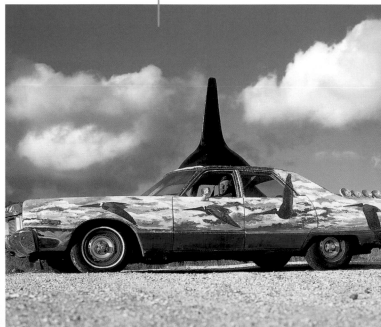

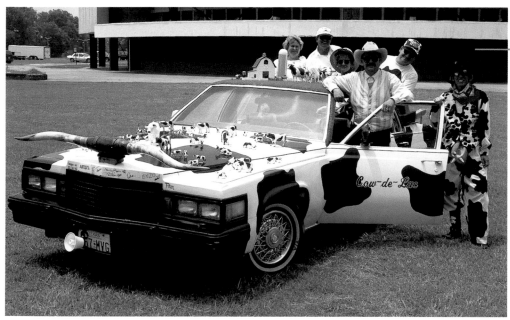

Cow-de-lac by Sam Draper and Julie Magenis. A group effort, this '79 cow Caddy was created for the 1990 Houston Art Car Parade. It makes "moo" sounds and carries a miniature farm on top, complete with Astroturf and a collection of toy-sized Breyer cows.

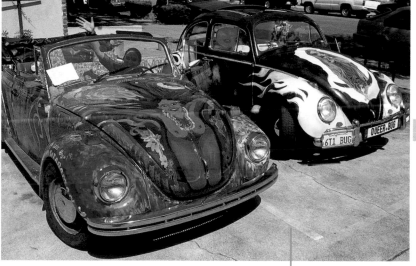

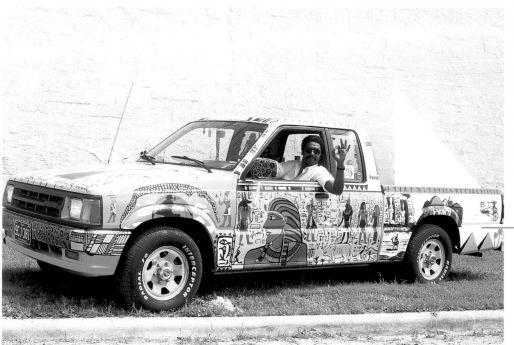

Kfusu by Ibrahim Yasein. In honor of his Egyptian heritage and inspired by St. Louis car artist Jeff Lockheed, Ibrahim Yasein constructed *Kfusu*. The car features paintings of ancient hieroglyphics, rendered in One-Shot paint, and a large wooden pyramid layered with brown stucco.

What We Live By by Souyma Sitaraman and **Alien Virgin** by Scott Alan. As seen at ArtCar Fest 1999 in Berkeley, California, these two VW Beetles display a variety of paints and styles. While artist Souyma Sitaraman painted *What We Live By* (left) with acrylic automotive paint, Scott Alan used Krylon spray paint on *Alien Virgin*.

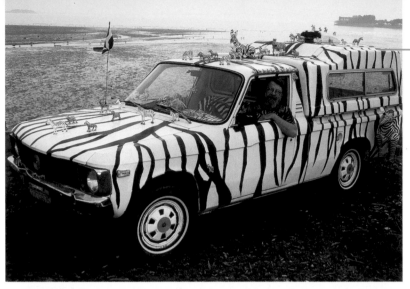

Zebra Truck by Jeff Carlock. Jeff Carlock used Rustoleum enamel to paint this 1979 Chevy Luv pickup truck. Jeff says, "The story of my 'inspiration' usually disappoints people who want to hear that I grew up with zebras, but the truth is that it came out of a long holiday weekend with all my friends, and I figured black stripes were something that I could just about manage. At first I thought it looked really stupid, but after a few months of adding more stripes and some zebras, little kids began to approve of it, proving once again that moderation in pursuit of art cars is no virtue!"

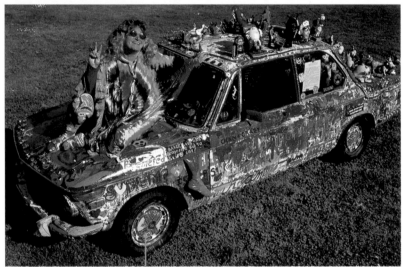

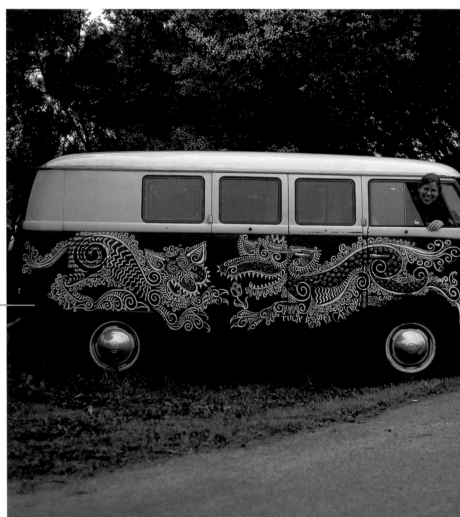

Come Play With Me! by Marilyn Dreampeace.
A grandmother, clinical social worker, and volleyball player, Marilyn was inspired by hippie cars in the 60s and today's art cars. She painted this classic 1973 BMW with the help of 800 people! Loving interactivity, she started putting items on the car that respond to people and/or the environment. To express the joy that music and play bring to people, she added musical icons and gave her car its inviting name.

Tulip by Nina Paley.
A talented cartoonist and illustrator by age 19, Nina Paley was asked to paint this VW bus owned by Armin Haken. She used Rustoleum paint, and this was her first automotive paint job. (And this is the first art car photograph I ever took!)

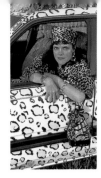

Leopard Bernstein by Kelly Lyles

Seattle, Washington

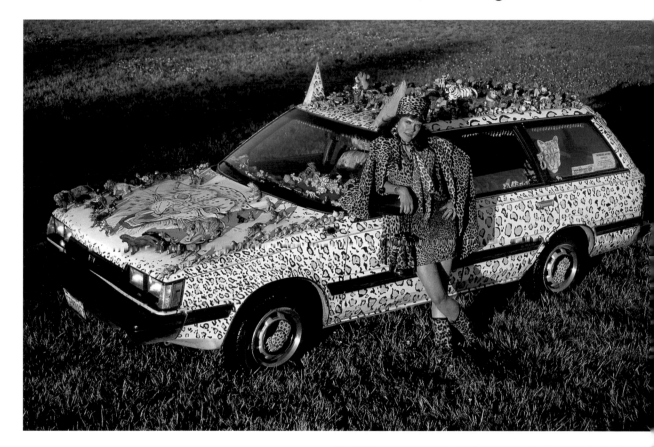

Considering that she owns 16 different leopard outfits and an art car painted like a leopard, one might think that artist Kelly Lyles is a feline fanatic. Wrong. "Although I love cats, I started the leopard car because I thought it would be a pretty simple paint job; that's it," Kelly says. The 1989 Subaru Wagon is painted with One-Shot and features ears, a tail, and 500 miniature jungle cats. It's her second art car and was inspired by her first one, a Ford Pinto painted like a pinto horse. Kelly discusses the car's genesis and the questions the car elicits:

"It could be that, subconsciously, I'm recreating my childhood. My Pinto was the pony I never got for Christmas. As a kid I collected stuffed animals and my favorite was a leopard called 'Leopard Bernstein.' Now, because of my car and spotted fashions, people assume that I'm obsessed with leopards and that I identify with them. That always makes me laugh because I'm really more like a hyperactive, cute little hamster, not wild and regal like a leopard. The one bad thing about having a leopard car is that I got six pairs of leopard slippers for Christmas!"

A successful graphic artist and painter, Kelly enjoys the fun and absurdity of having an art car. When asked what art car people have in common, she replies: "You have to like attention to drive an art car, and have a sense of playfulness. Humor is the one common denominator I see among us all."

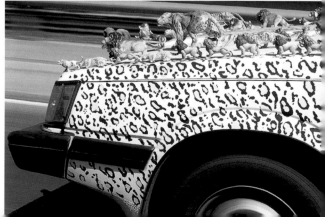

Homage to Timothy Leary by Jeff Lockheed

St. Louis, Missouri

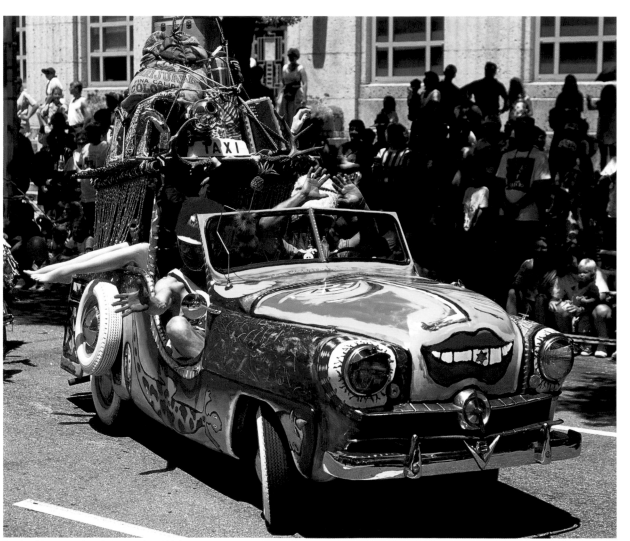

At the Houston Art Car Parade, 1995

Jeff Lockheed has come to be known among art car people as the "godfather of One-Shot." His influence has spread from St. Louis, where he's a well-known painter, to art car artists across the country. He paints One-Shot on all sorts of materials, including canvas, cars, and the interior and exterior of his famous, alternative-culture landmark, the Venice Cafe. He discusses his choice of paint: "I started painting with One-Shot in 1985 and painted a truck I had at that time. It's a durable paint that lasts for years and years. The color chart for it is really fantastic. There's a full color spectrum, so you don't have to mix very many colors."

In 1992, Timothy Leary visited the Venice Cafe, and he and Jeff went for a tour of St. Louis in an old police car Jeff owned. Profoundly inspired by their conversation about the left side of the brain, Jeff decided to paint his already-bizarre 1949 Crosley. Jeff bought the car in part because it already had a fan mounted on the front end. Paintings on the car include portraits of a goose and a duck that Jeff raised; sketches of friends; and a painting of Jesus on a cross, with the words, "This hurts!"

When asked whether he prefers the process of painting the car or the results, Jeff responds, "The best part of having an art car is driving it every day and there's no escape; you are stuck with it. Every time you get out of it, it's a rocking parade, you know, those people who want to talk to you whether you want to or not? To me, that's the real measure of an art car person, the ones who have the guts enough to do it every day of their life. That's the bottom line, that's my two cents. You gotta live it."

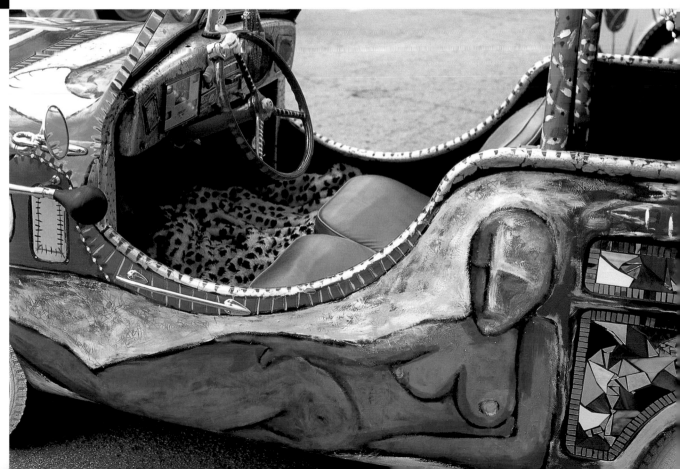

Lu-Lu by Lucy Harvey

Ojai, California

It was her father's death that drove Lucy Harvey to paint her 1972 Plymouth Valiant. At 4:00 a.m. one night after his death, she began painting her car without the influence of drugs or alcohol and with the help of friends. It was a cathartic experience for Lucy, and she dedicated the car to her father, writing on the driver-side front fender, "Thanks Dad wish you were here!"

An artist who works in a variety of media, Lucy is known for her painted household objects, including a series of painted luggage, some of which are on view on top of the car. She also created an alter ego for herself. "Pom-Pom" is a silly, gregarious character who wears a colorful, hand-painted outfit and a fruit headdress. Lucy likes to drive *Lu-Lu* while she's in character as Pom-Pom, to be the center of attention and entertain people. Lucy assumes her wild persona when she wants to feel free, on a rush of positive energy that she describes as being "almost like a high."

Recovered for more than 24 years from drug and alcohol abuse, Lucy now uses her creativity to heighten her daily experience and considers her art to be a way of life.

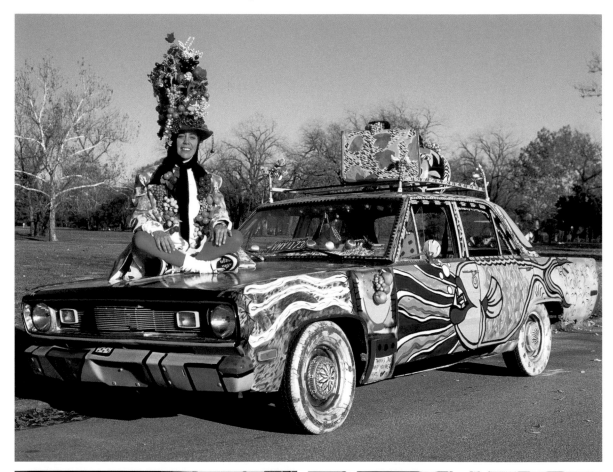

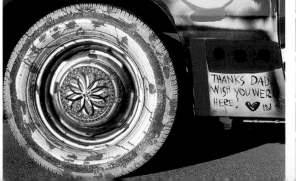

Miss Vicky by Dean Pauley

St. Louis, Missouri

This 1965 Dodge Dart may be difficult to recognize because 3½ feet (1 m) have been cut out of the middle, taking it from a four-door to a three-quarter-door. Started in 1994 by Dean Pauley in St. Louis, this project took one year to design and build, and three weeks to paint.

The paint job consists of two coats of One-Shot sealed with several coats of clear sign finish. Each coat of clear was lightly wet-sanded with steel wool and cleaned before the next application. This gives the car tremendous gloss and protection. Dean says the paint hasn't faded, yellowed, peeled, or flaked, and he is quite happy with the results.

Upon its completion in 1995, the car was given its name after its debut in the Soulard Mardi Gras Parade, where it carried Tiny Tim. Dean's friends told him that the car should be called "Tulip Car," but Dean thought it would be more fun to name the car after Tiny Tim's first wife, Miss Vicky, and that's the name that stuck.

Having a shortened wheel base, no windshield, and neither a top nor a roll bar, the car is not street-legal. However, Dean takes it out in his neighborhood and enters it in parades and festivals across the country. For him, it's just pure fun, a party on wheels. Its magical, taking-life-lightly energy is contagious and brings joy to fellow drivers and onlookers. Smiling and dressed in his signature Hawaiian shirt, Dean sits behind the wheel with the (windowless) wipers moving back and forth in front of him—an image that defines the carefree spirit of many art cars. Dean's friends Jeff Lockheed, Paul Cuba, and Janiece Senn all helped create the car.

Mondrian Mobile by Emily Duffy

El Cerrito, California

It may be difficult to tell by the looks of it, but this art car, like many, is a form of rebellion.

"Basically, I was acting out," Emily explains. "I was having a reaction to being in art school. I had just graduated from Cal Berkeley with a fine arts degree, and I had studied a lot of very male-focused art history. There were many women painters throughout history, but they weren't documented and aren't taught in art school. I didn't agree with that. I wanted to do realism and paint emotional content, and I got very little support from my professors. So the painter Piet Mondrian came to represent to me the cold, unemotional, sterile, high-art, male, intellectual snobbery that I was experiencing. I decided, as a joke, to poke fun at him and my professors and paint my car like one of his paintings. It's ironic, though, that what I created as a protest, people think is out of respect for Mondrian. So it's kind of funny how it all worked out!"

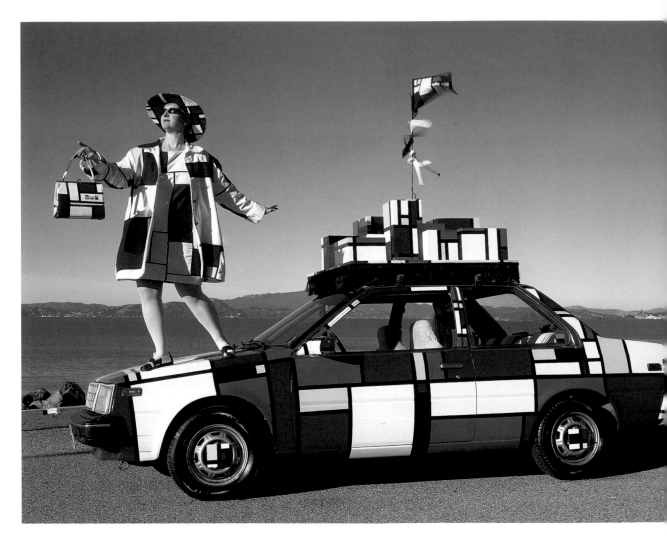

What Emily didn't know was how she would paint the car, as she'd never painted one before. She had to paint this 1984 Nissan three times until she got it right. The first time, she used spray enamel paint and the wrong kind of masking tape, which pulled off the paint underneath. The second time she used a special blue masking tape by 3M and enamel paint that she brushed on, but the paint faded after six months. Then she found out about One-Shot, repainted the entire car, and clear-coated it with "Trylon Clear," made by Triangle Coatings. It worked!

After completing the car in 1996, Emily drew on her 13 years of experience in the fashion industry and began making matching Mondrian outfits. She stresses, however, that she's not obsessed with Mondrian; she has her own ideas and makes her own art. In response to her school experience and exposure to images objectifying women, Emily created works about her daily life. She painted a series of still lifes of tampons, douche bags, and contraceptives. Her art focuses on a woman's control of her own body and makes fun of conventional wisdom.

Currently at work on *Vain Van*, her new art car about the high maintenance requirements of being a woman, Emily is excited about the art car medium.

"Absolutely, art cars are art," she says. "It gets back to the raw art-making process. It's just the artist and the materials and this strange form of the car, which is very important to our culture in the same way that marble was used during the Renaissance. So I think it's more apropos in the current culture to work on a car than a stretched canvas. And the fact that the high art world scoffs at art cars proves that they ARE art!"

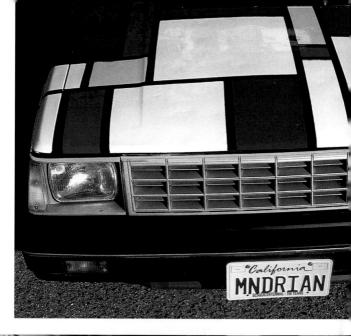

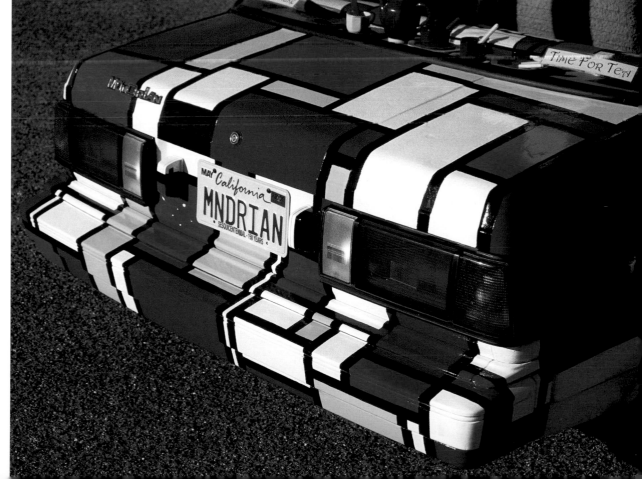

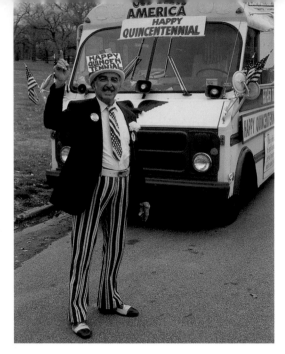

Patriotic Bus by Paul Pagano

St. Louis, Missouri

For the last two decades, many people in St. Louis knew of the legendary man known as "Father Time." He dressed in red, white, and blue, and delivered produce to the elderly from his hand-painted delivery bus. He was hard to miss, his bus blasting music from two crackly-sounding loudspeakers. "Ga-a-a-a-wd . . . Bless-s-s-s . . . A-a-a-mer-r-r-rica," sang Kate Smith, her rich voice carrying far into the distance as Paul drove up the quiet residential streets of his delivery route. Stop after stop, while the music played, he walked to each door, greeted his customers, took their orders, hustled back to the truck, and returned with bags full of groceries. Some of his customers thought it was a bit odd that Paul's clothes featured an American flag motif and that he acted as if he were on parade every day. Paul didn't care what people thought. "I like to make people happy," he says. "I made them forget about their ills, pills, and doctors' bills!" Paul laughs a lot, and perhaps this happiness is why he is so active in his mid-seventies.

On the side of *Patriotic Bus*, painted in red house paint, were the two slogans Paul most believes in: "Don't Worry Be Happy," and "God Bless America." He also created the latter saying in gold glitter on a derby hat that he wore continually. At public events, Paul carried a handmade placard above his head like a miniature billboard. Indeed, Paul himself was a living advertisement of his patriotic ideology and values. He frequently participated in parades and public events, brought the bus to church every Sunday, and attended tailgate parties at the local pro football games.

When questioned about how this all started, Paul makes it sound simple. "When my first wife died

in 1979, I grieved for several years," he says. "Then, on Halloween in 1983, I went to a party as 'Father Time,' complete with a mask, beard, and white robe. It made people laugh, and I had a good time. I was a changed man after that. I started wearing different costumes for each holiday. My favorite outfit is red, white, and blue. In fact, I always wear a red sock and a blue sock, and I never leave home without them. There shouldn't be any one day to be patriotic; every day should be celebrated with patriotism."

An Italian immigrant who fought in the Normandy invasion in World War II, Paul is extremely grateful and proud that he served his country. As someone who puts a tremendous value on freedom, Paul was dismayed to learn that a neighbor, claiming that his vehicle was an eyesore, had urged the city to pass an ordinance preventing him from parking in his own driveway. As a result, Paul was driven out of business and eventually gave the bus to the American Cancer Society. Those who valued what Paul did for the community are now left to ponder what life is like without his contribution.

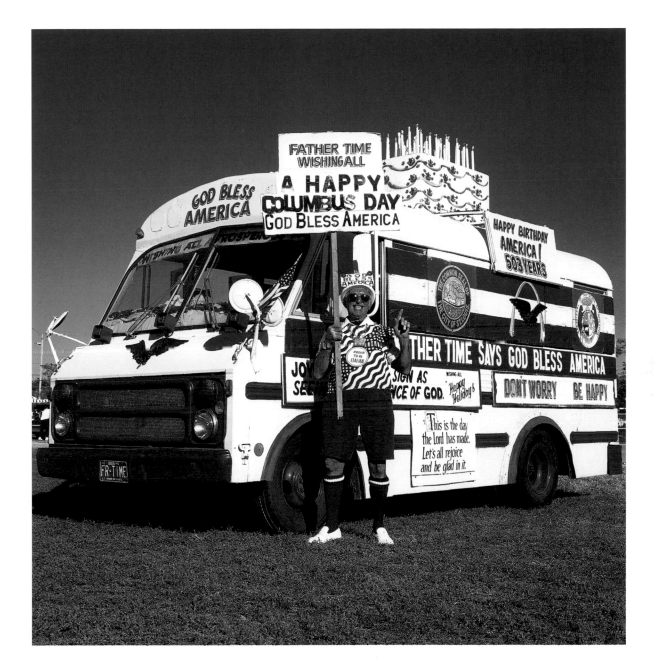

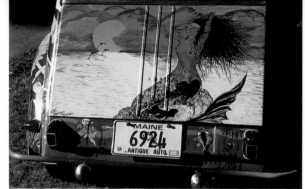

Whimsy by Bill Stevenson

Gumboro, Delaware

Unlike most people with art cars, Bill Stevenson didn't make his own. Convinced that he wanted an art car, he bartered his skills as auto mechanic and carpenter with several artist friends, who painted sections of his car in return. A big fan of Citroen 2CVs for their quirky style, Bill wanted his 1958 model to be unique.

In July of 1993, Bill's friends used acrylics to paint the scarecrow, sunflowers, hummingbird, cat, and rabbit on the driver's side and the mermaid on the back. Midway through the project, however, Bill learned about One-Shot and made the switch. The passenger's side and even the inside of the trunk and hood were painted with One-Shot.

Having an art car has changed Bill's perspective on life and opened up new friendships all across the country. He has towed the car several times to the Houston Art Car Parade and the Artscape Arts Festival in Baltimore, and has participated in many Citroen 2CV club meets. "I have received so much joy from operating *Whimsy* that I was com-

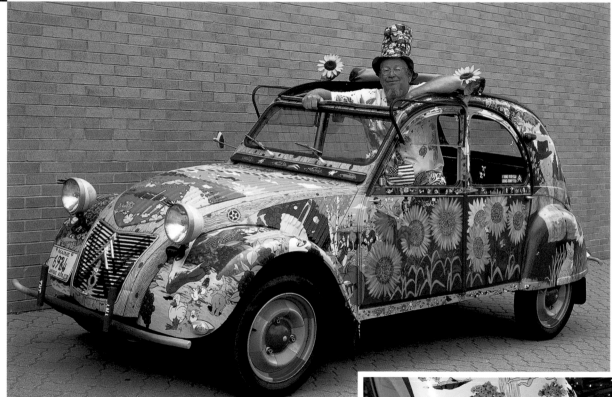

pelled to have an everyday art car as well. *Whimsy* was never intended to be a daily driver. So I asked a friend to help paint a VW van that I call *Topcat*, and I drive it every day." Jo Martyn-Fisher, David Cedrone, Edith Tucker, and Dan Britton were the artists who painted the car.

2 second skin

This category of art cars is similar to painted cars. The lines and general integrity of the original cars are preserved, while materials or groups of objects are literally laid over the car like a second skin. Perhaps Ron Dolce explains it best in reference to his masterpiece, the *Glass Quilt* (top right):

"I am like a painter, but instead of using a palette of paint, I use a box of broken bits of colored glass, and the car is my canvas." The result of 18 years of meticulous labor, his VW Beetle is covered entirely with stained glass cut precisely by hand to fit without any gaps between the pieces. He often says to his audience, "If you want to really see it, you must touch it. Run your hands over it like you are blind, and fe-e-e-el it!"

It is this tactile element that attracts many people to work with different materials to break up the stereotypically smooth and shiny surface most cars have. Objects are usually added to the surface of the car using adhesives such as glue or

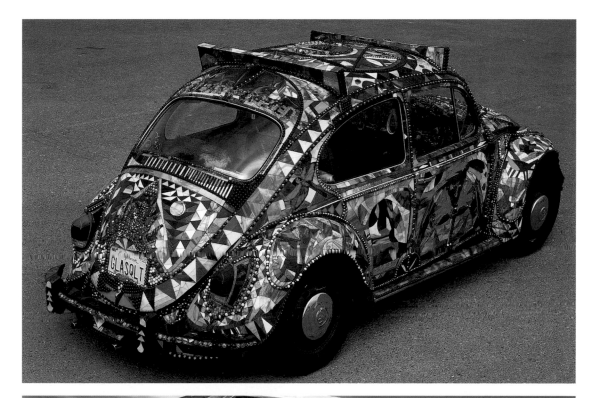

silicone, but sometimes objects are welded or screwed on. Finished textures vary from the smooth bumper stickers on Conrad Bladey's *Sticker Car* (above), to the rough and rugged craters of the *Marsmobile*, by Gary Siebel (left), to the sharp-edged holes in the *Bullet Car*, by David Gross (page 27, bottom).

Part of the magic is in making the "skin" seamless so that the creative techniques do not dominate the overall work. The high attention to detail, meticulous application, and tremendous time factor involved in the making of second-skin cars can invite the label of "fine art."

Bluebird Mini by Jacquie Shane.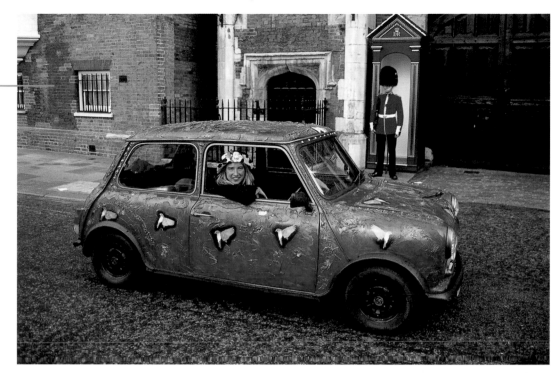
Jacquie used putty to attach feathers, beads, glass, pendants, and bluebird illustrations to this 1982 Austin Mini, which is one of the few art cars in the U.K., due to that country's strict vehicle codes. "The inspiration for the car was my best friend Melanie, who died of breast cancer in 1998. Bluebirds were special to both of us. I wanted to do something in her memory that would make a difference to other people and spread hope and happiness."

Blue Jean Car by Marshall Barer.
Marshall dressed his car with blue jeans, making it very comfortable to lean against and inviting to anyone inclined to rub it! Like many art car people, he was multi-talented, and the art car was only one facet of his artistic expression. Famous for writing the Mighty Mouse theme song among others, Marshall died of cancer in 1998.

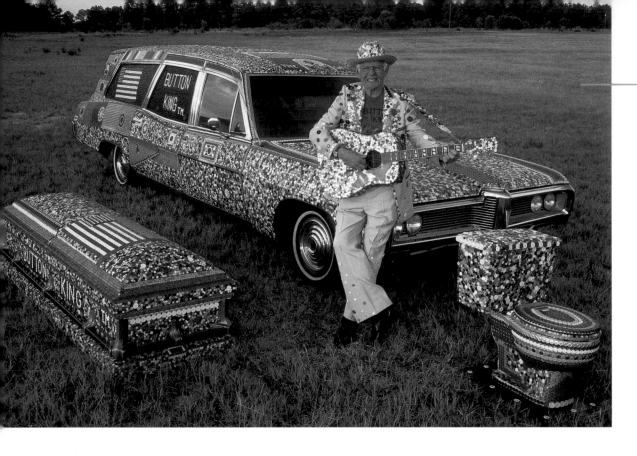

Button Hearse by Dalton Stevens. The latest button-covered object in Dalton Stevens's legacy is this 1968 Pontiac hearse, which he started in 1994. It took two years to complete and is covered with 600,000 buttons, which he counted while attaching them. Also known as the "Button King," Dalton is an insomniac who has spent many sleepless nights working at his craft. When he can't sleep, he pulls out a bag of buttons and a tube of silicone, and glues all night long. He made another vehicle called the *Button Car* and put buttons on several suits, a commode, a guitar, and a coffin in which he intends to be buried. The *Button Hearse* will take him on his final lap.

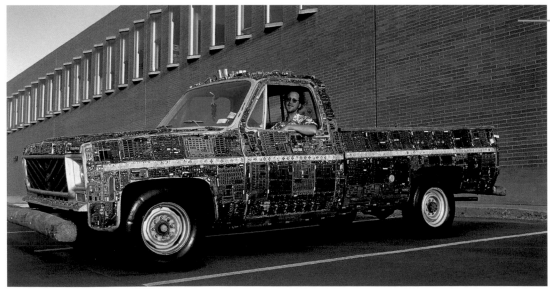

Circuit Board Truck by Dr. Atomic. This '75 Chevy C20 truck was previously covered with stucco, and before that, with postcards. Thus, it's the only vehicle that I know of to be made into an art car three times. Doc is a former nuclear scientist who now uses electronic parts to create art. He explains why he works on the skin of a car: "I personally like the idea of NOT changing the shape of the vehicle. While I like and appreciate other people's sculptured cars, my thing is that I want the vehicle to still look like the same vehicle from a distance, but when you approach it, it becomes something else. I like art that way, that things retain their utility but are untraditional and unique in some way. The truck is still used regularly for work and transportation."

Grass Bus by Gene Pool. An artist famous for making many *Grass Cars* and a collection of incredible suits, including the "Cork Suit," "Grass Suit," "Can Suit," "Egg Suit," and "Money Suit," Gene created this living bus with the help of artist Lucy Harvey (page 20). The bus was made for the inauguration of the new grass field put into the St. Louis Cardinals baseball stadium in 1996.

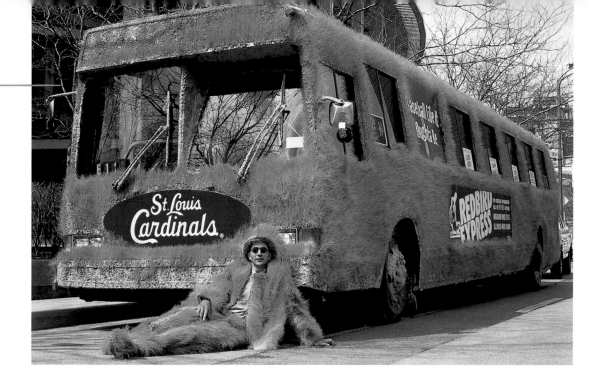

Universe Hearse by Todd Ramquist and Kiaralinda. This 1973 Cadillac hearse, covered with Plexiglas mosaic, took one year to build and is an interactive art car. Todd and Kiaralinda, both prolific artists living in Safety Harbor, Florida, ask the public to etch their own "words to live by" into the Plexiglas using an engraver. They also live in an "art house" named "Whimzey," shown in the background of this photo.

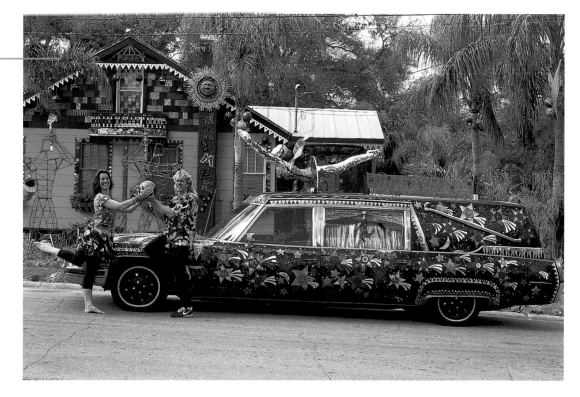

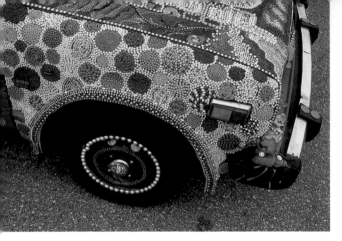 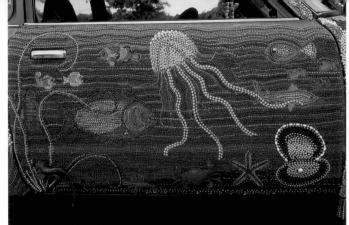 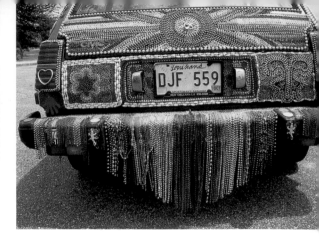

Booga by Daniel Winkert

New Orleans, Louisiana

Daniel Winkert, also known as "Wink," has chosen to work with one of the icons of New Orleans, the Mardi Gras bead, and to carry the spirit of Mardi Gras with him all year round.

Wink is an architect, and when he and his ex-girlfriend Rechelle Parent attended the Burning Man Festival, they looked at the art installations and thought about ways to have fun and to do something to bring out their own creativity. After seeing art cars at the event, making his own car seemed the obvious thing to do.

"Living in New Orleans with its Mardi Gras, I had gotten tired of collecting Mardi Gras beads every year and then just throwing them away," Wink explains. So I decided to just start gluing them on my car. Getting the beads was no problem, as much if not more fun than gluing them on, especially during Mardi Gras. I'd had this 1979 Honda Civic for years already, and my friends and I started doing it one weekend. The beads come in strands, so that made gluing them on a lot easier and quicker. Only one of us was really a trained artist, so it was easier to work with beads and glue instead of messing around with paint

and all. It was fun and easy, and we got to see the rewards real quick. Friends, passersby, and kids in the neighborhood all helped work on the car, so it was like a community event. It took about 150 tubes of silicone, two months, and thousands, maybe even a million beads. I'd like to have a contest someday to see who can guess the right number, but then I would have to count them!"

Makers of *Booga* include Daniel Winkert, Rechelle Parent, Brenda Wolf, Jeff Smith, John Goodson, and Dave and Liz Langlois.

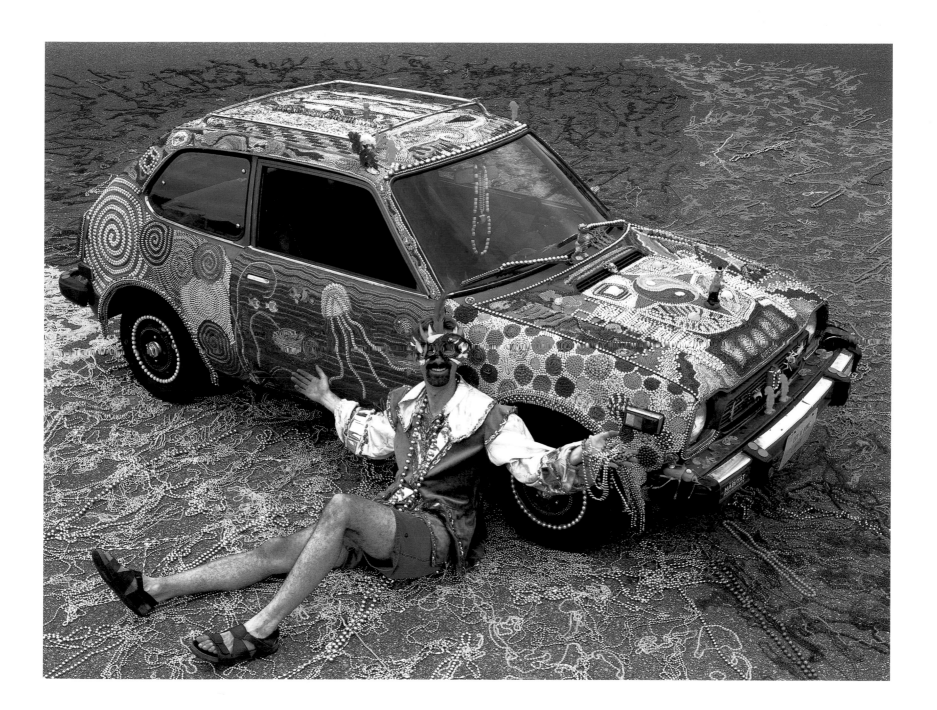

Brickmobile by Mark Monroe

Sherman, Texas

The *Brickmobile* was a project created in 1996 by a sculpture class taught by Mark Monroe at Austin College, in Sherman, Texas. The 1968 Ford Country Sedan station wagon was donated by its original owner, Mark's father, Kenneth Monroe. The class searched for a connecting theme among its 16 middle-class college students. Since they all came from similar suburban neighborhoods, they decided to embrace their absolutely safe and sound, American-kid backgrounds by making a monument to the nostalgia of car pools, V-8 engines, and streets named "Pleasant Valley." Mark tells how the *Brickmobile* was made:

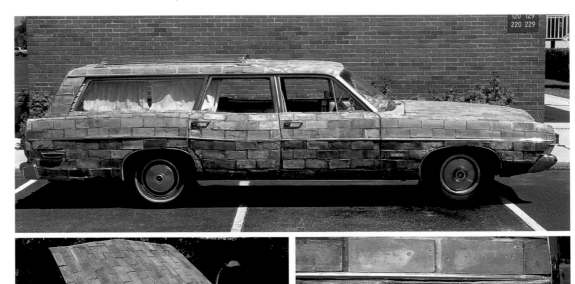

"It was a bit more complicated than building a brick wall. The initial work involved carefully grinding and numbering what turned out to be 839 separate spaces for the 'bricks.' Using hand-crafted ceramic tiles made from clay deposits from the Red River, the students formed the exact contours of the car, numbered each tile to correspond with the car's grid, and fired the tiles. Then they affixed them by using a special system of two blobs of adhesives. One blob was a sub-floor adhesive called M-200, and the other blob was 100 percent silicone put at the centerpoint of the brick to suppress vibrations. Finally, they applied a grout prepared with a concrete bonding adhesive, then reattached all the original chrome. The car looks heavy, and it is. However, it's equipped with a 390-cubic-inch (6.24 L) V-8 with a four-barrel Holley carburetor, and the added weight of all of the bricks and concrete is only 870 pounds (395 kg)."

The accolades Mark and the students received when they brought the *Brickmobile* to the 1996 Houston Art Car parade convinced him to use art cars in his future classes. He finds that the art car is an ideal teaching tool, one that incorporates ingenuity, design, sculptural techniques, and most importantly, fun and creativity.

Thorny Rock 'n Roll by Alex Coward

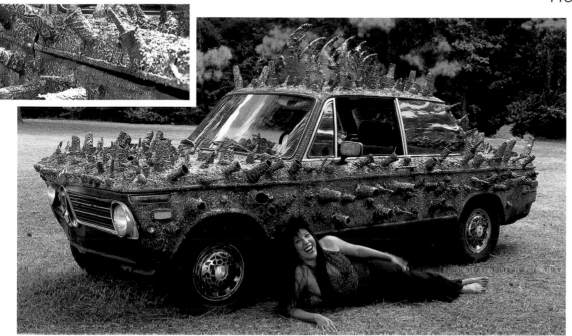

Everybody has their own perception and it's really cool listening to what everyone thinks it is."

Alex was approached by a representative of BMW, who offered her a new BMW M3 in exchange for her car, but she's holding out for a place in the BMW Museum in Germany. The collection contains vehicles painted by famous artists, but so far it includes no sculptured or textured cars.

Responses to *Thorny Rock 'n Roll* are usually positive, but Alex is baffled by some people. Because she's a woman, many people seem shocked when she tells them that she made it. Others think it's a dark, Satanic vehicle. Alex frequently finds herself explaining and defending her car. "My car was never intended to be a form of rebellion, but unfortunately, it's become that. My neighbors call the cops whenever I park on the street because they think the car is ugly and obnoxious. They really want my car out of there. This just makes me think, 'Wow, wait 'til they see my next one!' "

Also called *The Swamp Boogie Thing*, this car has one of the most extreme textured surfaces ever, about as far as one can get from the smooth skin of a BMW. Most people have no idea what it's made of, which is part of its mystique. The wart-like shapes are halved plastic Easter eggs, and the volcanic cones are plastic champagne glasses that artist Alex Coward sliced diagonally with a red-hot knife. After sanding off the paint, she used Bondo to apply the cones all over the car. The dorsal fin was cut out of aluminum, adhered to the car's body with JB Weld, and then the seam was blended in with added fiberglass.

"I love texture and natural, organic shapes," explains Alex. "I wanted to create something that seemed like it was alive even though it was a material object. My car reminds me and others that we are all on planet Earth and that there are other living creatures here. It's not all about strip malls, parking garages, and office buildings. Nobody knows what my car is, but it gets them to think about a lot of things and to wonder. People say, 'Oh, wow! Is that a blowfish?' 'It's a dinosaur, isn't it?' 'Are those mud dauber holes?' 'Is this the bottom of the ocean, like the first forms of life?'

36

Cork Truck by Jan Elftmann

Minneapolis, Minnesota

Jan is a well-known art car artist, teacher, and missionary to the outside world who promotes art car events in Minneapolis. She views her car as an inspirational tool, both for herself and others. The car reminds her every day that she's privileged to lead her life as an artist, and it's also a concrete manifestation of her artistic process, through which she collects society's refuse and transforms it into works of art. "What started out as collecting corks during a waitress job while I was in art school has sent me on a wonderful journey of creating art using this incredible natural material from a tree. I even met my future husband at the Italian restaurant where I began collecting the wine corks."

"Art car artists have to be extroverts to survive," according to Jan. "They have to be willing to answer the same questions from curious spectators 10 times a day. Some of the most frequently

After saving wine and champagne corks for more than 13 years, Jan Elftmann glued the first cork onto the *Cork Truck* in the summer of 1996. Using an outdoor tiling adhesive, she ultimately glued more than 10,000 corks onto her truck. She found that cork was an ideal material to use in a place like Minneapolis, where the weather varies from 90°F to -25°F (32 to -31°C). Cork repels water, wine, and dye, and it doesn't burn or decompose.

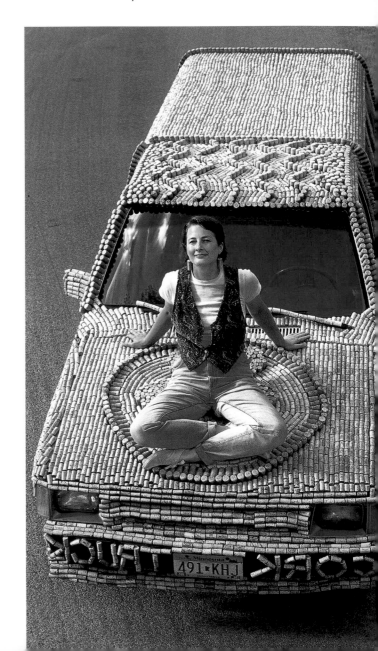

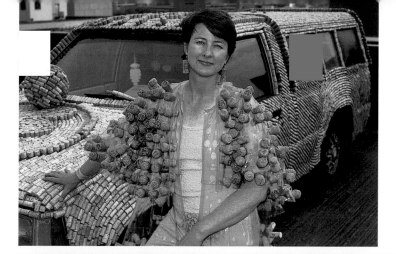

asked questions are whether it floats, and whether I drank all the wine to produce all the corks. I haven't driven it into a lake yet, but I hope to someday!" She also calculates that to accumulate enough corks to cover the truck, she would have had to drink a bottle a day for 28 years, at a cost of $100,000 based on wines cheaper than $10 a bottle.

Jan believes the *Cork Truck* protects her when she drives, but at the same time, she feels highly visible, so she drives carefully and considerately and waves at people who honk. "People think the truck has its own persona, particularly when they report to me that they've seen the truck in their neighborhood, as if I weren't driving it. Maybe they think it's driving around town by itself! Driving the *Cork Truck* every day has given me a deeper, richer relationship with a car than I ever could have imagined. My question is, 'Why isn't everyone doing this?'"

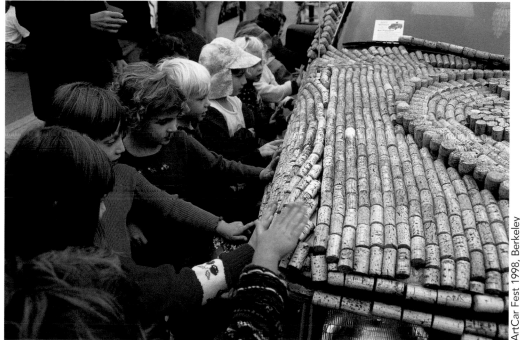

ArtCar Fest 1998, Berkeley

Penny Van by Steve Baker

Tucson, Arizona

A legend in Tucson, Arizona, and beyond, Steve Baker is known as the "Penny Man." Often armored in full penny regalia, complete with a penny jumpsuit, copper armbands, penny rings on every finger, and a penny crucifix around his neck, he resembles a warrior ready for battle. The battle is in his own mind, though; it's an allegorical fight with imaginary foes, all for the pursuit of fame and recognition that was stolen from him as a young man.

Steve has always been a star who shone in everything he attempted. He was high school valedictorian, fluent in French and Spanish, and a great cross-country runner. An excellent golfer, he was just on the verge of making the pro golfing circuit

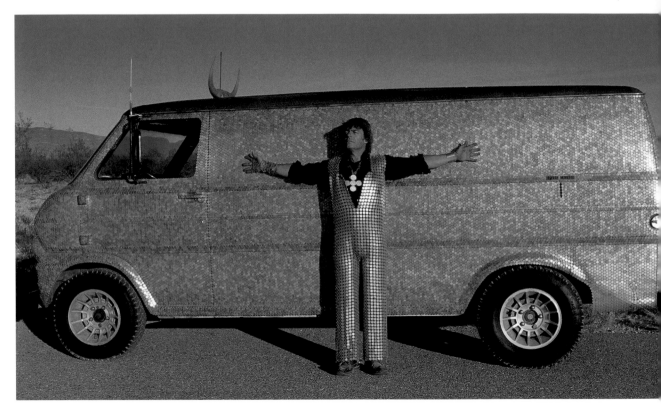

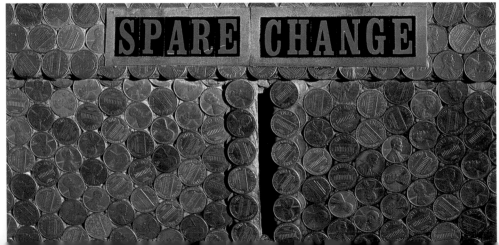

SPARE CHANGE

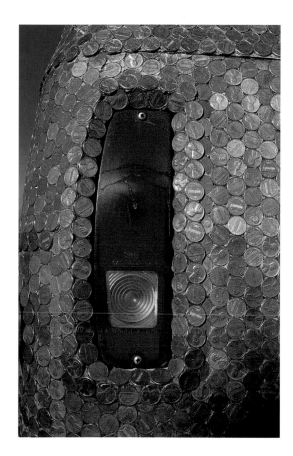

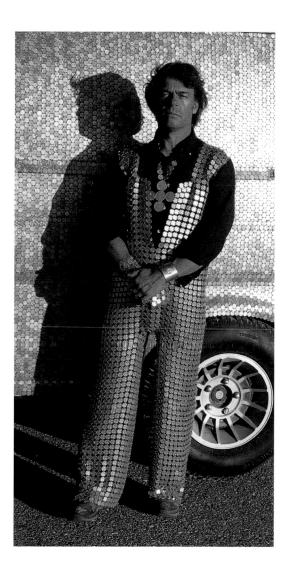

impressed with the descriptions of the King of Atlantis and his belief in the healing powers of copper. Steve became so engrossed in the power of copper, he began adorning his own body with it and created his persona of the "Penny Man," claiming he was the reincarnated King of Atlantis. Steve made copper jewelry and covered his van with pennies not once, but two times over, using a total of 90,526 pennies. He used Liquid Nails adhesive caulk the first time, and the pennies fell off from the vibration of the van. The second time, he used silicone sealant, and that did the trick. He drives the 1969 Ford Econoline Van everywhere he goes. He loves the attention and views getting it as a competition or game, as he explains:

"As far as being an exhibitionist with the art car, I am. I'm out there to beat every car on the road. It's not just to be an egomaniac. I go to golf tournaments to mess up every golfer. Do people look at the golfer? No. They all look at me. I steal the attention. I'd love to be that golfer out there making a million dollars a year, but I can beat them in other ways. I beat them with my art cars and my clothing. My suit looks like gold to the public. They turn away from the stars who won't give them an autograph, and they approach me. *I've* become a legend in my own time. It's my mystique that wins."

at age 18 when he was drafted for Vietnam. The threat to his dream of turning pro gave him ulcers, and he was released, but the trauma affected his golf game, and he didn't turn pro after all. He had failed and was broken-hearted.

Steve became a stripper and a gigolo for a period of time, and in his heyday he appeared in *Playgirl* magazine. An avid runner, he kept his body in great shape and even ran marathons. One day, he read the works of Edgar Cayce, and was very

Indeed, Steve has found his own way to shine, and no one can take that away from him because with art cars, the individual is king. Whether you love him or hate him or think he's weird, Steve is the only, world-famous Penny Man.

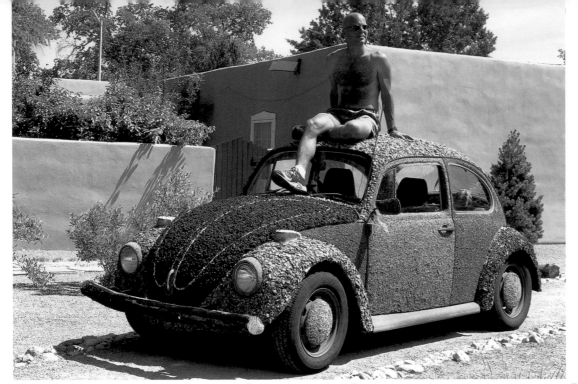

Rocky Roadster by Doug Flynn

Albuquerque, New Mexico

For many people, the idea and the urge to make an art car exists long before they actually create one. People will often put it off or make excuses not to do it. It's always interesting to learn what actually drives a person to get started and to see their satisfaction once the idea is realized. Doug Flynn's car, a 1972 VW bug covered with a variety of landscaping rocks, blends into the panoramic backdrop of the Albuquerque mountains and desert. Doug talks about how it all began:

"I had thought about making an art car for many years. Then my ex-wife and I bought a hand-painted car covered with handprints. It was kinda neat to see people's reactions. They would wave all the time when we were driving it. Also, I saw *Wild Wheels*. The movie was the final motivation for me to create an art car. I was thinking of putting asphalt all over my car and a yellow stripe down the middle, to make it like a road car. Then one day it just came to me in an epiphany: It would be so cool to landscape the car like the Southwest. I had the patience, the ability, and the vision, but what did I know how to do? I didn't want it to be half-assed and to look like a mediocre sculpture. I was attracted to mosaic, and I wanted it to have

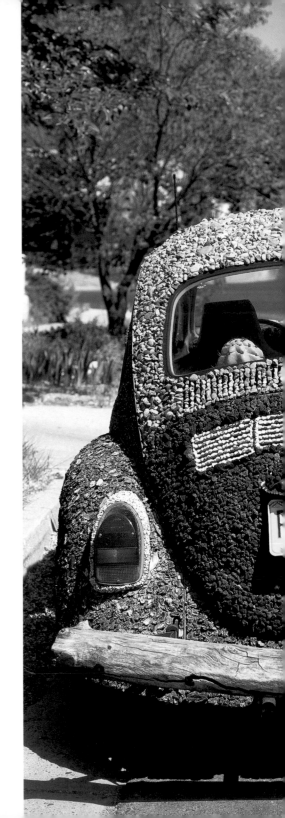

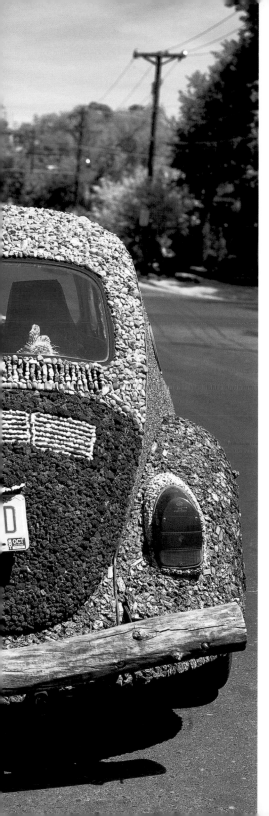

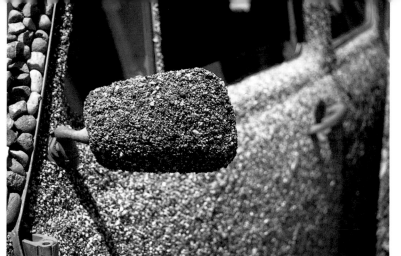

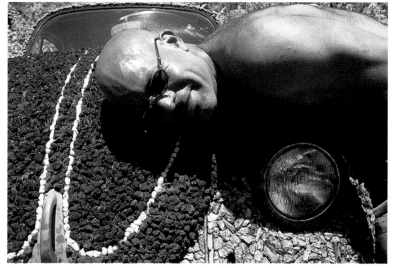

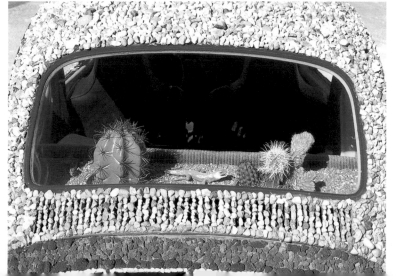

a theme and be organic. I like the texture of rocks. I love rocks! I have lots of rocks inside my house. So rocks were a natural choice for me. I'm so tactile that when I go to art galleries, I'm the guy that the security guards approach and say 'Please don't touch!'

Rocky Roadster has held up extremely well and has required little maintenance since its completion in 1995. Very few rocks have come off, a sign that the silicone adhesive was a good choice. Doug has taken the car to the Houston Parade several times and to many events in New Mexico. The car brings him pride because he completed what he set out to do and he did it the way *he* wanted. He elaborates on his need to create, a need that resonates with many artists:

"I have a drive to create. I mean, why are we alive?! I don't feel good when I'm not creating. There's something about creating something out of nothing that I think is very rewarding, very fulfilling. I do care about people seeing my art and enjoying it, but the actual magic is in the creating. My approach to building the car was not to rush or hurry the thing. Its different elements and designs revealed themselves to me. My advice to other car artists is to take your time, don't rush into it, think about what you're doing, and just do it."

public display of collection

A trait common to many art car enthusiasts, particularly those featured in this chapter, is the desire to collect things. In addition, these artists exhibit their collections by adhering them to their cars. These art cars have been divided into two categories based on the type of materials collected.

The first category, *kitsch mosaic*, consists of art cars that feature a variety of objects that could be called, kindly, junk. This category includes nostalgic memorabilia, recycled materials, found objects, and just about anything that can be attached to a car. For example, *One Trick Pony*, by Rockette Bob (page 43, top left), is covered with hotel keys, CDs, plastic bananas, pink flamingos, action figures, and more. What is actually on one of these art cars may not be clear from a distance, because they appear to be

covered with everything. Upon closer inspection, one can see that there are themes and currents that run through the collection on each car and that the juxtaposition and placement of objects create new meanings. Art cars in this category are like time capsules that shed light on our contemporary culture, values, lifestyle, and waste.

The second category, *motif in relief*, includes art cars that feature multiples of one item, such as baseball cards or stamp collections. For example, Renee Sherrer collected hundreds of McCarthy-era plastic coffee cups, used spray foam to make faux cappuccinos, and attached them all over her *Cappuccino Car* (page 43, top right). The car was used to promote a coffee shop, and it was effective because people grasped the concept instantly. The clear themes of these art cars are conveyed through the

commonality of the objects placed on them. As a result, these cars are sometimes referred to as theme cars or thematic glue cars.

The art cars in both subcategories are often called glue cars because their objects are generally attached with some type of adhesive, most commonly silicone caulk. Some artists find the term "glue car" offensive because it implies that a bunch of stuff is just glued haphazardly onto a car. This usually isn't the case as careful choices are made for each object that is adhered. David Best, the widely-acknowledged master of the glue car form, shows just how meticulous and tight the sticky process can be on his car, *Faith* (detail, page 43, bottom). Though it may appear that many of the art cars in this chapter are glue cars, some are constructed with rivets and screws and no glue is used at all.

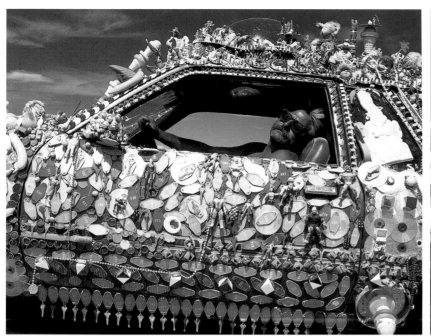

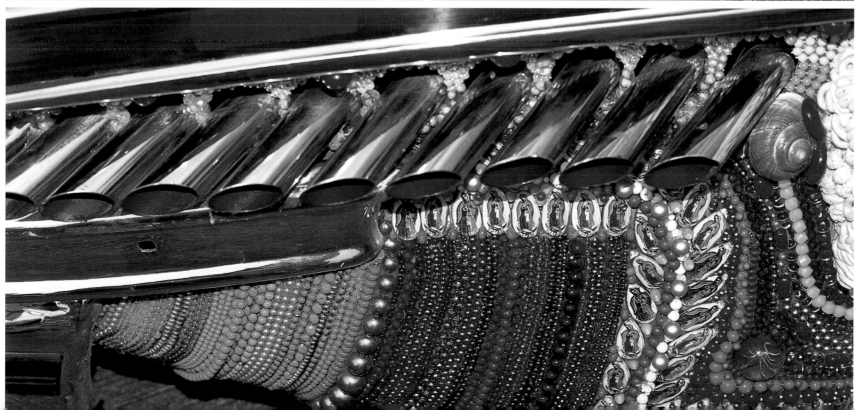

Ifism by Seven. This 1993 Honda Civic hatchback represents confusion to its artist Seven, who works in Bisbee, Arizona. A noted abstract painter, he decided to try his hand at gluing objects on his car. Ultimately, he decided that the result wasn't particularly original. He has since stripped the car of its toys and made it into a sculptural car about the "blue race," Seven's expression of what it's like to be handicapped.

Max's Recycle Job by Max Higgs.
In 1972, Max Higgs began decorating his car so he could find it in parking lots. He continued embellishing it over the years as an escape from his wife and the TV set. His materials included items he found in his own trash, such as pieces of ribbon, bottlecaps, and other things his wife had thrown away. "It's funny, but she won't ride in the car. I guess it's too embarrassing for her. I don't care though, it's my hobby," says Max.

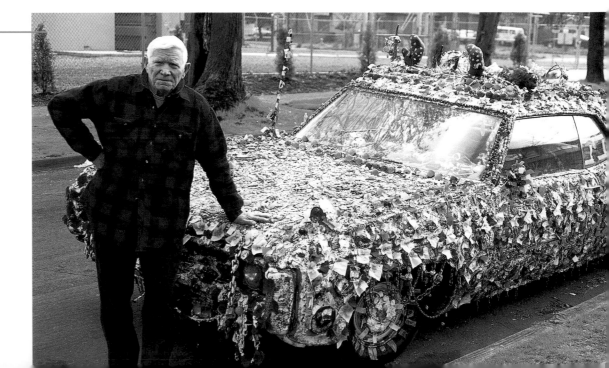

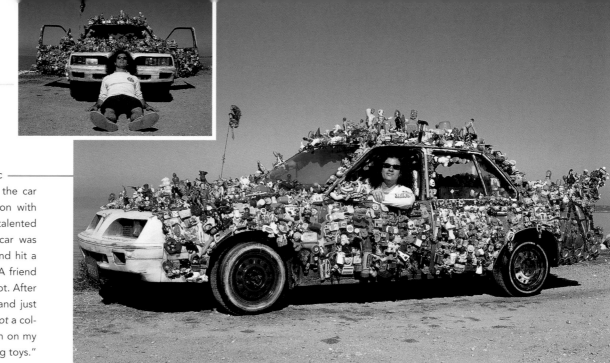

Pontiwreck by Paul De Valera. This 1984 Pontiac Sunbird makes a bold statement, especially in the car culture of Los Angeles. Its objects are glued on with Liquid Nails adhesive to reduce thefts. A multi-talented artist and history teacher, Paul tells how the car was started by accident: "I did a bad parking job and hit a shipping container, putting a gash in the door. A friend and I just started painting it right there on the spot. After that I glued some stuffed animals to the roof and just kept adding things. I have a lot of junk, but I'm *not* a collector. I've ruined collectible toys by gluing them on my car. I'm against the whole idea of adults collecting toys."

45

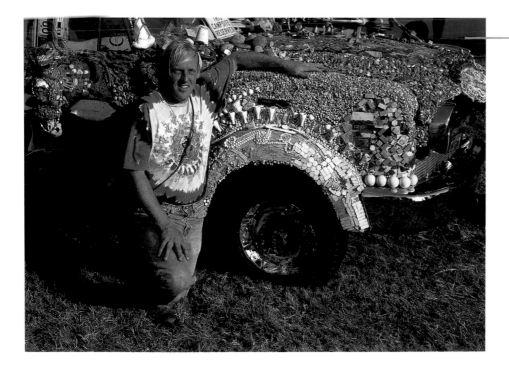

Nevada Car by David Best, owned and maintained by Patrick Daily. Created in 1993 by David Best, this '71 International crew cab pickup, also known as *DC-14*, features recycled gambling artifacts, including gaming chips, dice, two slot machines, and an interior made from a crap table. Current owner Patrick Daily is pictured in front of a fender made of materials found in the desert.

Faith by David Best
Petaluma, California

When David Best started making art cars in the mid-'70s, there was no such term as "art car." He referred to his creations as "decorated cars" and he still does. *Faith*, his twentieth art car, is also called *DC-20* and is on permanent display at the Art Car Museum in Houston, Texas (page 126). Like Larry Fuente (page 96), David has influenced contemporary art, especially in the art car medium. In addition to his extensive body of work, including assemblages, wall hangings, paintings, and handmade frames, he has created more than 25 decorated cars and two art buses. He is easily one of the most prolific art car artists.

David's process for making an art car is first to destroy the original car, chop it up, and re-create it. When he made *Faith* from a mid-'70s Camaro, he removed all the fenders and bumpers. Then he welded on fenders from a '59 Jaguar, '41 Chevy truck, '53 Chevy, '59 Volvo, and a VW Beetle. After attaching Packard bumpers and '58 Mercury taillights, he affixed his signature animal head hood ornament, in this case a Cape buffalo. Once the newly designed body is in order, he's ready to begin gluing.

David is constantly collecting items for his cars and his art. One of his favorite places to gather a wide variety of items is the city dump. He likes the surprise of what he can find there, but his favorite objects are personal items given to him that have stories attached. He often creates his art cars with a group of friends or volunteers, and each person works on his or her own section. He works from his emotions and asks others to work from theirs so that the car as a whole becomes emotionally charged and meaningful. He talks about his process:

"The objects that end up on my cars are based on the budget and the availability of materials. If I had no money, I'd glue rocks on. I will not glue real or toy guns, cigarettes, or beer cans on my cars. I'm not going to glorify those things by putting them on a car. I try to give meaning to the objects I put on my cars. For example, when I use McDonald's figures, I never use them thoughtlessly. I'll put a few hundred McDonald's characters on an area that speaks to the fact that the kids playing with them are the same age as the child laborers who make them. I think that if you

put something genuine into your art car or into any art, it's gonna be a good piece of art. If you don't put anything into it, you can't expect anything to come out. I feel that I charge things with energy, and when I put them on the car, they become radioactive. It's all about energy."

Indeed, *Faith* itself is energy. Made up of thousands of objects, including beads, teaspoons, animal and human skulls, Virgin of Guadalupe key chains, and pool balls, the car is a tribute to David's friends, who have had faith in him. Having friends who believe he can create a beautiful art car feeds his ability to do so. "If someone has faith in me, I can do anything."

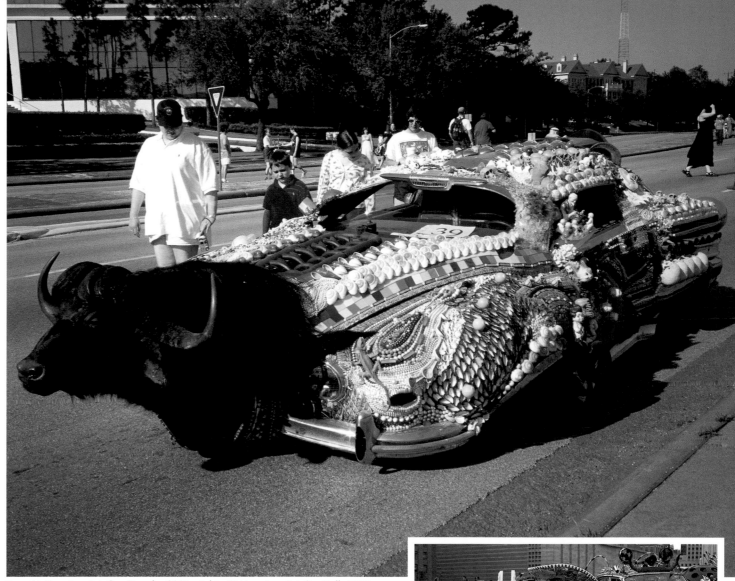

Top: At Houston Art Car Parade, 2001; right: At Houston Art Car Ball, 1999

Love 23 by Kathleen Pearson

Bisbee, Arizona

Love 23 symbolizes Kathleen Pearson's years of collecting pop icon memorabilia. She started collecting in childhood, and the objects ultimately became the material of her adult art. Like many art cars, *Love 23* developed over many years, a process Kathleen truly enjoyed. She elaborates on how it all happened:

"The car started in 1990 simply as metallic blue with stencils of pink flamingos, cacti, and cow skulls. In 1991 I had it painted pink at a body shop. The color pink is my favorite, an influence from my childhood in Florida. In 1993 I added leopard spots and trophies. From that point on, I began adding things to the car to make it more three-dimensional. It gradually became a collage of American kitsch and pop icon images, such as hamburgers, cartoon characters, velvet paintings, pink flamingos, and palm trees. It's now covered with more than 4,000 objects on the out-side and 800 on the inside, and I'm still adding to it. The message of the car is simply . . . love. I hope that other people will see things on the car that they remember and love from their own childhood. It's all about being positive."

If you see Kathleen walking down the street, there's no mistaking which car is hers. When she's not wearing the outfit that matches her car, she'll be wearing something equally unique and noticeable, such as a black velvet tapestry outfit or faux pickle earrings. Whatever it is, she's designed it herself. Considered by many to be the art car diva, Kathleen has modelled her own fashions for years and designed clothing made from tapestry long before it became trendy.

Kathleen is a prolific artist with a studio in down-town Bisbee. The walls are covered with her paintings of pop icons and portraits of art cars.

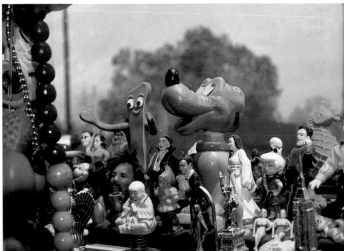

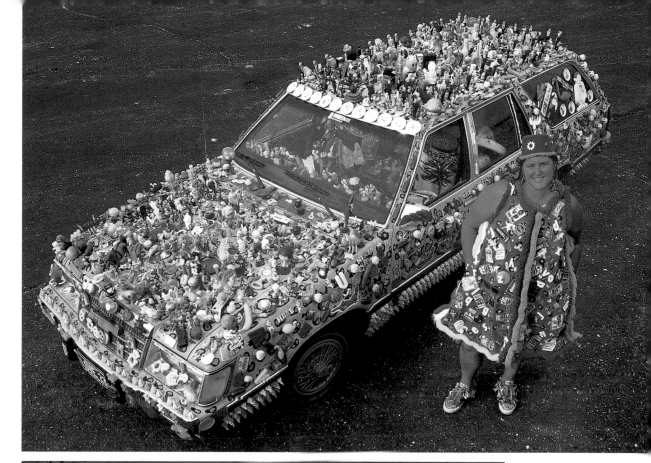

Could it be that art cars are becoming pop icons? According to Kathleen, they are. She has made three other art cars, including *Hex Mex* (lower right), which combines her Pennsylvania Dutch heritage and Mexican influences. She discusses the inherently whimsical medium as a whole:

"The art car movement is bringing all this art out onto the streets. It's phenomenal that all of these cars have been created in just the last 25 years. It really is a movement of art. Each art car has its own personality, presence, and mind of its own. It evolves, but not necessarily by our own doing. It starts from one idea, but then grows into something totally unexpected and into what it wants to be. We mold the art car and try to make it what we want, but the art car molds us, too."

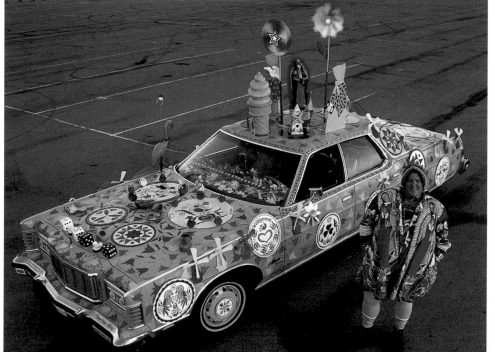

Santa Bug by Rockette Bob

Reno, Nevada

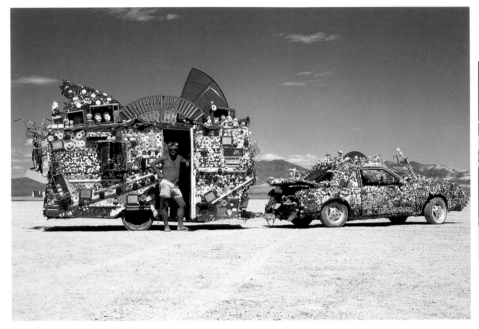

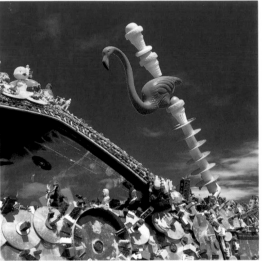

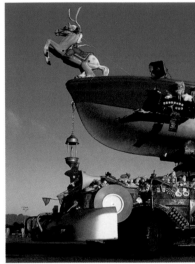

A dealer in a casino in Reno, Rockette Bob is a very laid-back guy, and yet he's a prolific maker of art cars. He has created eight heavily encrusted art vehicles, including *Woodie With Horns*, a 1980 Mustang covered with 10,000 popsicle sticks; *One Trick Pony* (top left and middle), a Mustang and travel trailer covered with motel keys and CDs; *Santa Bug* (opposite page), a 1984 Volvo station wagon with a VW Beetle on top, towing a trailer covered with Christmas objects; and his latest, *House-Boat-Car* (top right), a 1982 Datsun B-210 carrying a boat on top.

For Bob, making art cars is purely recreational, an escape from the daily grind of making a living. He discusses his playful process:

"It's mostly just for fun. Most of my materials relate to toys and games, since I'm in the gambling business. When I'm putting a piece together, if I'm giggling while I'm doing it, I usually end up liking it. It's relaxing for me to work with objects that speak to me and make me laugh. I go to thrift stores, flea markets, and garage sales to collect things. When I see an object I like, it leaps out at me. I'll see the one good item in a pile of junk. Some items I know I'll need a lot of, so when I see poker chips, for example, I'll buy the whole box."

Motivated by his desire to entertain himself and others, Bob isn't one to brag about or analyze the value of his creations. He simply enjoys collecting and the creative process. He isn't motivated by the notion of making "art" or the attention it gets. When asked if his cars are "art," he responds:

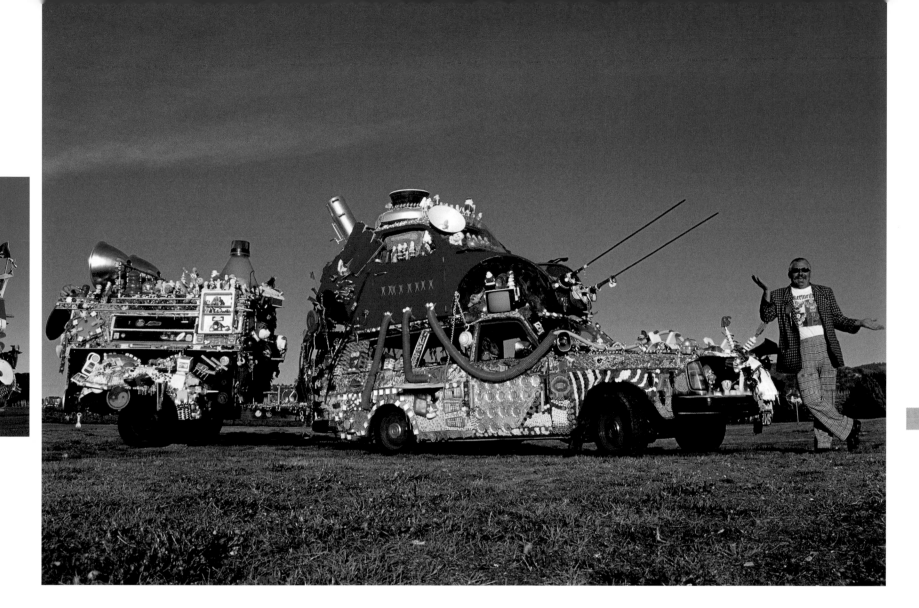

"No, I don't take it that seriously. People have said it's art, and I've been called an artist, but basically it's for fun. Art is subjective. I guess mine could be considered art, but it's definitely not highbrow art. Some artists have spent 10 years sculpting a piece of art or an art car, unlike me, who throws together a piece in six weeks. There is a difference. I am a surrealist, really. Like, on *Woodie With Horns*, I have a picture of Salvador Dali on one door and Zippy the Pinhead on the other; those guys really got to me. My cars are a form of rebellion. I think it's ridiculous that people cherish and worship their bland cars. More than anything my cars are really anti-car statements."

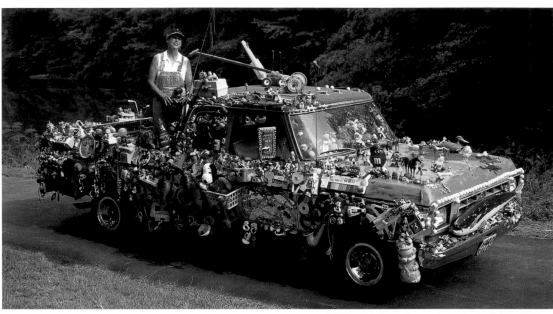

Yard Sale by Cass Flagg
Taylorsville, Georgia

For Cass, her art car replaces the attention and purpose that she once enjoyed through showing her horse. Now she shows off her beloved old 1979 Ford F-150, which she combined with her passion for yard sales. The idea of making the car came to her in part when she and her husband, Hyler Bracey (page 54), attended an art teachers' conference. Hyler gave an inspirational speech about living one's dream, and this time it inspired Cass to fill the void left by her horse. Now she and Hyler both have art cars. They plan to participate in events together, supporting each other while keeping their own identities intact.

Always a collector, Cass says one of her favorite pastimes is shopping for unique items for *Yard Sale*. She talks about how her collecting has developed over the years:

"I collect for the thrill of the hunt, the satisfaction of the acquisition, and the stories to explore. My collecting has expanded and exploded over the years. First I collected points and awards by showing my horse. But not much dusting there, so I turned to collecting Roseville, Hull, and Weller pottery. In the early '70s I began collecting frogs. I now have items ranging from toilet seats to pump soap, and from an extensive frog statuary to my signature gold frog ring. Most folks remember me as 'that lady with the gold frog ring' long before they remember my name."

Cass, who lives outside of Atlanta, has found that there are fewer opportunities to show art cars than horses, but she hopes this will change. Art car events were given trial runs in Atlanta, Jacksonville, Birmingham, and Tallahassee, but so far no annual events have been established in the Southeast.

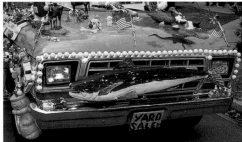

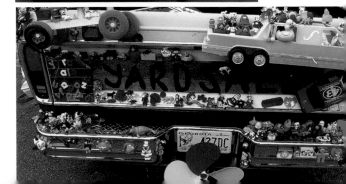

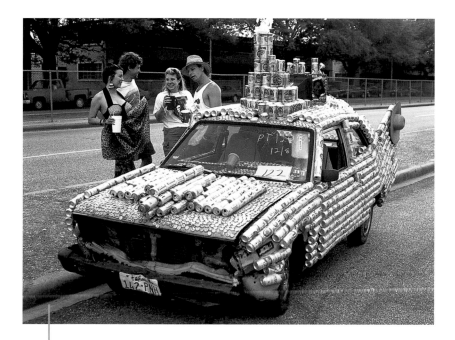

Nasty Habits by Mike Macha. In one day, Mike divorced his wife, got drunk, killed his dog when he rolled his Jeep, got a DUI ticket, and was jailed. When he was released, he continued his recklessness until he crashed another car. He then decided to clean up his act. He glued beer cans all over his crashed car so that the police would follow him and keep him in line. His plan worked! He is pictured here with some of his friends in the lineup for the 1993 Houston Art Car Parade.

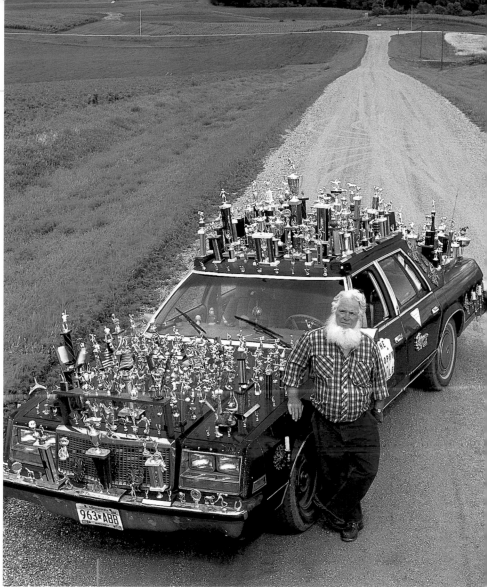

Trophy Car by Flip McDonald. Art cars can be found just about everywhere in the United States, even in rural areas like Watertown, Minnesota. This 1989 Chrysler Newport is covered with more than 500 trophies. Flip tells why: "I had this ol' car I wasn't usin' no more, and I put on top of it this trophy I had won playin' pool. Then somebody saw it and gave me a box of trophies, and I put them on the hood. After that, people started givin' me trophies left and right. That's how it all happened."

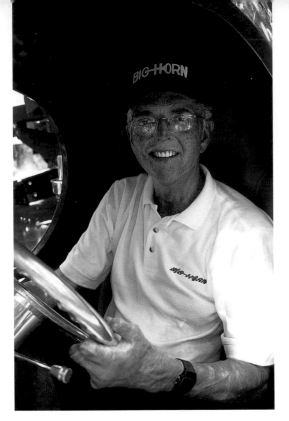

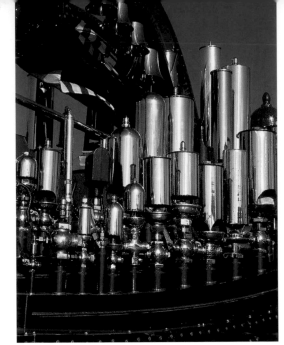

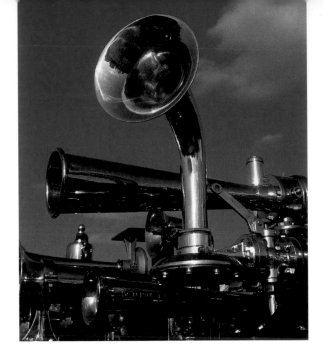

Big Horn by Hyler Bracey

Taylorsville, Georgia

Meet the new *Big Horn*, also known as *The Millennium Machine*. This 18,000-pound (8.1 t) vehicle combines the Industrial Age with the Information Age, featuring an incredible collection of more than 100 whistles, 20 horns, and 20 bells, many of which have significant historical value. All are operated by a sophisticated, state-of-the-art computer network with an illuminated control panel. In addition, *Big Horn* features a working calliope, bell carillon, air cylinders that operate the doors, an air compressor and air tanks that power the horns and whistles, smoke

machines, assorted antique steam gauges, an external audio system, a hydraulic front suspension, and many other accessories. Hyler Bracey custom-built all of it, with the support of his wife, Cass Flagg (page 52), the genius of famed race-car engineer Al Moody, and a specialized work crew. At a cost of more than half a million dollars and by far one of the most expensive art cars ever made, this amazingly inventive creation is used as a prop to inspire people to live healthy, joyful, productive, and spiritual lives.

Hyler is a living example of the pursuit of one's dream. After being badly burned in a race car accident in 1970, he overcame tremendous physical and psychological pain to obtain his Ph.D and run his own business. He realized a vision of making a vehicle on which he could display his extensive horn and whistle collection, the first *Big Horn*. Unfortunately, while Hyler was towing the vehicle to an event, the hitch broke and the car was destroyed. After his initial devastation, Hyler realized that it was part of his life's path to overcome another obstacle. He would make a

bigger, better, and even more inspiring *Big Horn*, and he proceeded to dedicate several years of his life and much of his savings to that goal.

Hyler's current mission is to tour the United States and perhaps the world, to exhibit *Big Horn* and inspire people through his speeches. He also maintains a Web site (see page 142) to tell his story. He shares his key points about making dreams come true: "One, have and own your dreams. Be a dream keeper. Two, muster help and support. Enroll others to help you figure out the 'how' of making your dream happen. Three, overcome obstacles. Stay the course and never give up. Four, have fun and celebrate small victories. Dreams happen in many small steps. Five, treat people with respect in the process."

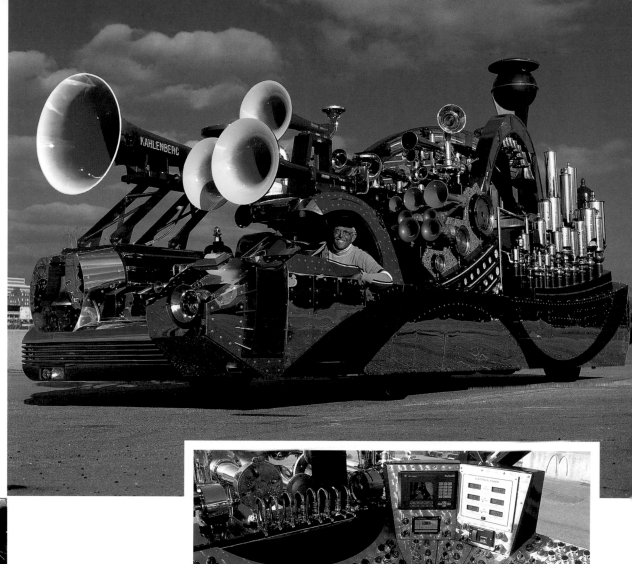

California Fantasy Van by Ernie Steingold

Burbank, California

For much of his adult life, Ernie could be found in his dusty garage, tinkering with vacuum cleaners. A perpetual pile of vacuums of all makes and models awaited his attention while he busily repaired them one at a time. Calling himself a "dirt sucker," he supported his family and proudly put all three of his kids through college. However, the brass van he began creating in 1989 was his greatest pride and joy.

On a whim and because he thought they would look good, Ernie put three brass elephants on the hood of this 1975 GMC van. Pleasantly inspired by how nice they looked, he added more brass objects. That's how it all started. The van became his hobby and something he looked forward to working on every day. On weekends he searched flea markets and thrift stores for brass, until he found a Sherman Oaks store that specialized in copper and brass. The store gave him such great deals, he bought 80 percent of the van's objects there. Using a ⁹⁄₆₄-inch (3.6 mm) drill bit, he drilled each object and pop-riveted it to the van, creating what he called a "monument," one piece at a time.

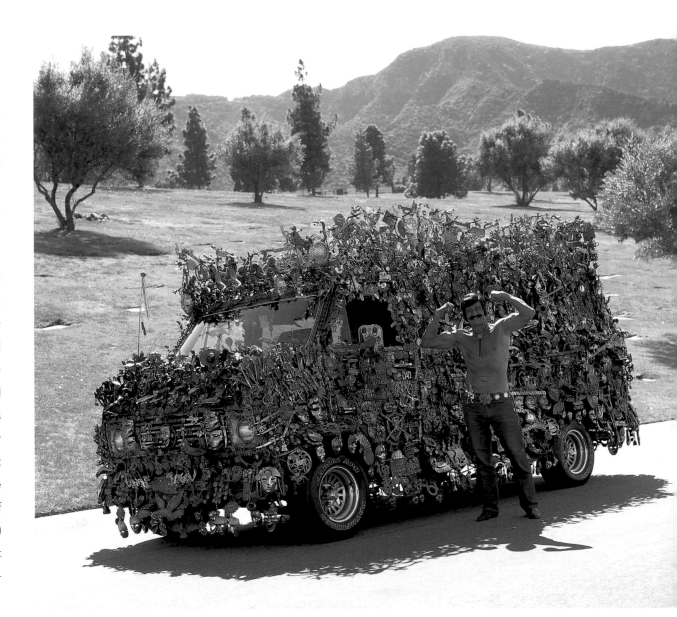

During the course of 10 years, Ernie riveted more than 5,000 brass items and $15,000 in coins to the van. Yes, you'd have to look closely to see them, but in and around the objects are riveted silver dollars, quarters, and nickels. Among the brass objects are collectibles such as Chuck Connors's letter opener, a Frank Sinatra medallion, and an Evel Knievel commemorative coin. The driver's side of the car represents Ernie himself and features masculine objects, such as a plaque with the word "Dad" on it. On the passenger's side are objects dedicated to his beloved second wife, Gretchen (pictured at top), and there are portraits of the couple in little brass frames all over the van.

Ernie also decorated the belt he always wore. It featured 80 Susan B. Anthony dollars, and to the right of the buckle was his signature brass fox. Looking good and standing out from the crowd were things he valued. He kept in shape with daily weightlifting and liked to brag that, in his prime, he was a Mr. Michigan bodybuilder. Admittedly vain, Ernie felt he looked his best when he was in his van. One month before his death, he confided why the van was so important to him: "Some guys don't accomplish anything. With this van, I feel like I've accomplished something. I'm the man who did something that nobody else could do, and that was to make the *California Fantasy Van*, which is irresistible."

Ernie passed away in the fall of 1998 and is survived by his wife Gretchen and three children. This book is dedicated in part to him because he had a profound effect on me personally. Besides making an incredible monument, he was real, he was eccentric, and he was . . . himself.

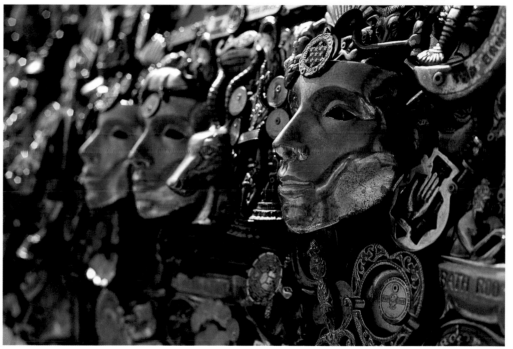

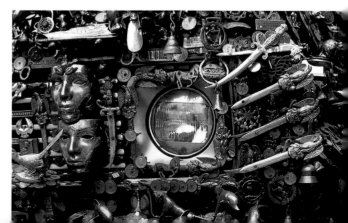

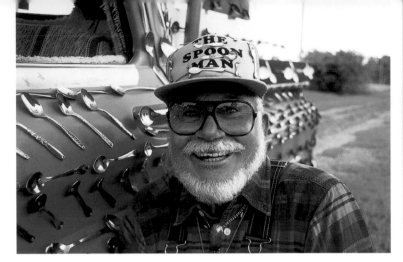
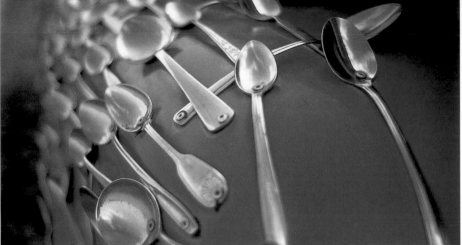

Spoon Truck by Elmer Fleming

Newberry, South Carolina

"Tackity-tackity-tack-tack-tack" is the familiar sound that precedes the man known as the "Spoon Man." Always wearing his denim overalls, Elmer Fleming can frequently be heard playing the spoons. He plays them on his leg, against his chest, over his open mouth ("tockity-tockity-tock") and against his forehead ("tackity-tack-tack-tack-tack"). Whether he plays them around the house for his wife, Doris, does a duet with his spoon-playing daughter, or performs in various bands, Elmer *loves* playing the spoons. He's been playing them for more than 45 years, and he's good. Thanks to his unusual talent and lovable, country-boy character, Elmer has been on "Late Night With David Letterman," "The Bill Cosby Show," and many other TV programs.

"I've been the Spoon Man for years," boasts Elmer. "I don't claim to be the best, but I'd bet there's nobody that has as much fun as I do when I'm playin' 'em! I play along to country, jazz, pop, blues, soul, rock and roll, and western swing. I've even made a rap song called 'Spoon Man Rap!'"

One day Elmer had a gig playing spoons in a music festival alongside a man known as the "Button Man" (page 30). He was inspired by the fact that the Button Man not only wore button-covered clothing, but also had a button-covered guitar and car! When local TV stations came to cover the festival and flocked to the Button Man, the idea came to Elmer that the Spoon Man needed a *Spoon Truck*: "I started collectin'

spoons in 1989, the same year I started makin' the *Spoon Truck*," he says. "The collection got so big that I started puttin' them on the wall in my home. Now I got a separate buildin' to display all of them in. I call it my spoon museum. It's wall-to-wall with spoons."

Onto a Chevy truck that he'd bought new in 1966, Elmer riveted 1,480 spoons, of which no two are alike. Some spoons are arranged in primitive floral patterns, and on the tailgate they spell out "Chevrolet." He often refers to his art car as his "pick 'em up truck" because so many fans beckon him for a ride. Elmer tells why he loves his truck:

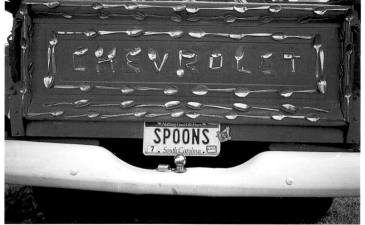

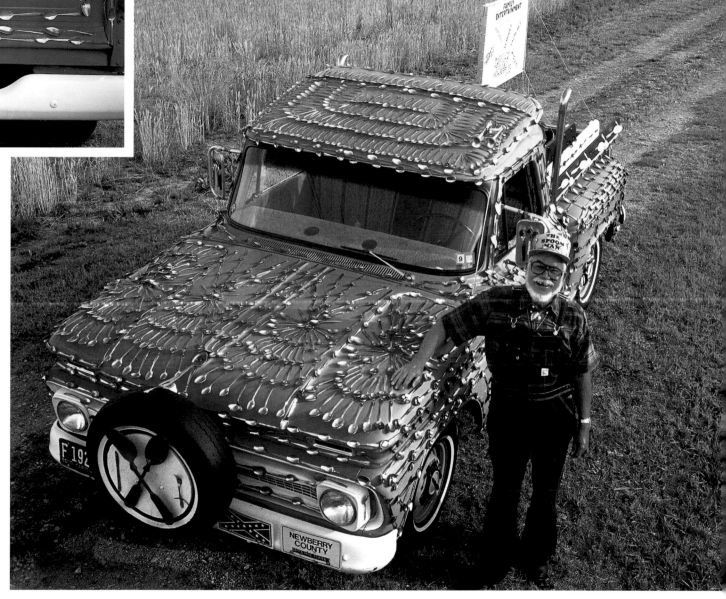

"Most people say that the truck looks good. Other people ask me why I messed up that pretty truck. The truck is the only thing I've got my name on so I reckon that I can mess it up if I want to, if that's what you want to call it. I don't call it messed up, though. I think my old pickup truck is a nice piece of art. If you came to my town and asked for Elmer Fleming, most people wouldn't know who you meant, but if you asked for the Spoon Man, everybody knows that name! Before I became the Spoon Man, I was just another person on the street. It's hard to describe the great feeling that I get by being the character that I am."

The Doll Car
by Coleena Hake and Phillip Estrada

Bisbee, Arizona

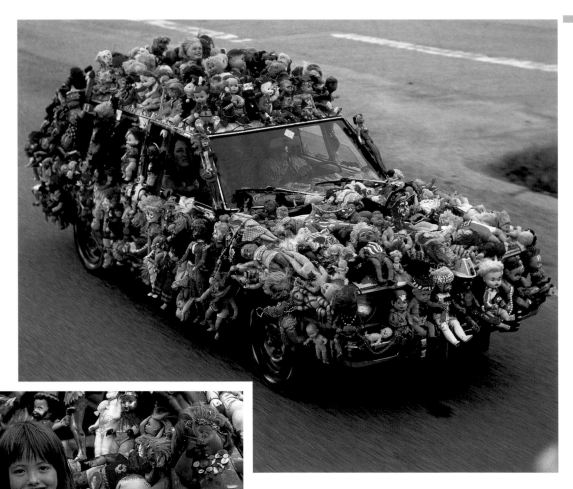

The genesis of *The Doll Car* was in 1994, when Coleena Hake and her daughter Gypsy (lower left) went on a journey as passengers in Kathleen Pearson's art car *Love 23* (page 48). They traveled at "art car speed" to the Houston Art Car Parade, allowing time to answer people's questions along the way. There they encountered a vast selection of art cars and enthusiastic artists. Coleena, a zany performer and artist extraordinaire, was blown away by all she saw and returned home dreaming of creating her own art car.

"When I got back I was raving about it to my husband Phillip. I really wanted to make an art car together, for it to be a partnership of love like creating a baby. It seemed like a fertile, creative time. As it turned out, I conceived my child Cypress during the making of the car. It was just synchronicity."

When Coleena and Phillip (also an artist) began the process of making an art car, they looked around the house for ideas, asking, "What do we have a lot of?" Phillip remembered that his grandmother had lots of dolls, and he thought she might sell them cheap. In fact, his grandmother gave them about

half of the 500 dolls they needed. It was a great start, and *The Doll Car* was under way. "We first glued the dolls onto the car with them all naked," says Coleena. "They had that just-born kind of nakedness. Then we painted them with acrylic paint, individualizing each one with found objects, vintage cloths, and old jewelry. I painted gods and goddesses and portraits of Gypsy and Cypress on the inside ceiling. The car took about nine months to make, just like a baby."

Over the next several years the family of four adventured all over Arizona and traveled to San Francisco and Houston art car events. They lost only one doll off the car, and that was in Bisbee. One of their friends found it, and it was rather obvious who it belonged to. Eventually the car began to have mechanical problems, as Coleena recalls:

"The art car had been like the glue that held our marriage together. When the car started breaking down, coincidentally our marriage started breaking down, too. When we divorced, he got the car. It's an interesting analogy because the car really mirrored our personal lives. You'd think that something as mechanical as a car couldn't be so human. It helped us to reflect upon ourselves. Phillip ended up abandoning the car and hitchhiked to a Rainbow Gathering [a periodic meeting of hippies and New Age adherents to celebrate love and sharing]. Then the car got towed away. I tried repeatedly to rescue it, but eventually *The Doll Car* got crushed. Metaphorically, my love was crushed. I keep wanting to go to the dump to look for the crushed car because I think it could be a whole new art form, a shrine to itself. It might actually look really interesting after being crushed."

Coleena currently lives in Bisbee with her two daughters and drives a 1993 white Toyota. "It drives wonderfully, but it's really boring. It's hard finding it in a parking lot sometimes. My daughter Gypsy has been begging me to buy a convertible so she can make an art car. It's tempting. Maybe the art car tradition will continue through the generations!"

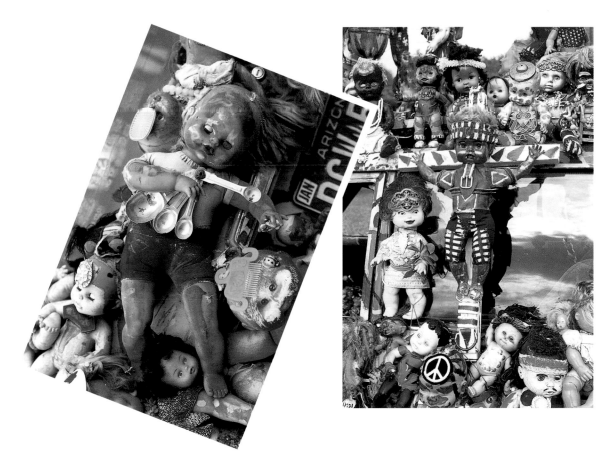

The Peace Car by Uri Geller

London, England

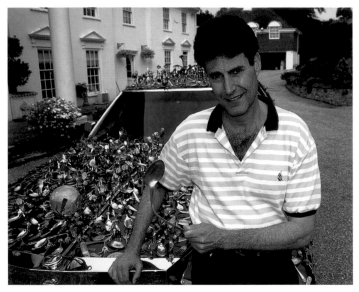

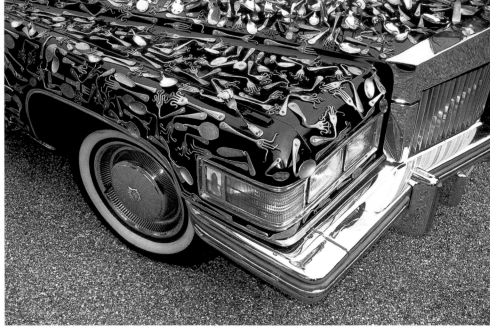

World-famous for his telekinetic ability to bend spoons by using the power of his mind, Uri Geller met hundreds of celebrities around the world, many of whom gave him special spoons. Uri's art car came to him in a bizarre dream, in which someone stuck a fork into the top of his car. Struck by the image, he decided to rivet his extensive spoon collection all over the car, thus sharing it with others. He talks about how he first discovered his power, the source and impetus of his magical and inspirational career:

"It happened the first time when I was four years old. I was eating soup, and as I lifted my spoon towards my mouth, the spoon started bending and then broke. As I got older and was in school, I realized that I had a unique ability, a gift. In school I was bullied and abused by kids and teachers who didn't understand my powers. I tried to blame my mother because she's descended from Sigmund Freud—my name is actually Uri Geller Freud—but she denied I had inherited any powers from him."

The car features spoons given to Uri by Elvis Presley, John Lennon, Jacqueline Kennedy Onassis, Muhammad Ali, Princess Diana, and The Spice Girls, to mention just a few contributors. He also acquired the spoon found in the glove compartment of James Dean's crashed

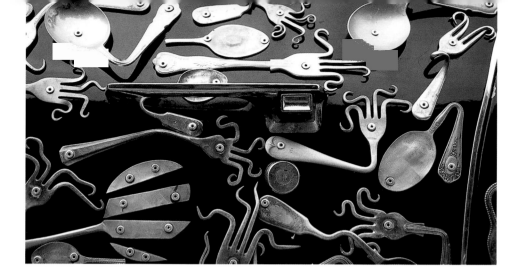

Lebanon, Syria, and Iraq. While raising funds for a children's charity, I'll bend spoons for villagers and their kids, both Palestinians and Israelis. My car will definitely bring smiles to their faces, and hopefully encourage peace and happiness. That is why I call it *The Peace Car*." Like *The Peace Car*, Uri's many books and Web site (see page 142) are intended to help people use the power of their own minds to heal themselves and their communities.

Porsche and Walt Disney's first Minnie Mouse fork. With the help of an Israeli sculptor named Avi Pines, more than 5,000 spoons and forks were riveted to the car. Some spoons form religious symbols, while others spell out the word "Peace" in different languages. The hood ornament is a crystal ball, a gift from Salvador Dali.

During his career, Uri was often in the company of presidents and prime ministers, riding in bulletproof, armored limousines. Wanting a limo as his own symbol of his success, in 1976 he had a Cadillac Brougham custom-built. Years later, after moving to London, he decided to convert the Cadillac into a special art car to help bring peace to the Middle East. Uri explains:

"My intention is someday to drive the car from the Egyptian pyramids into Israel, then into Jordan to meet with the king, and then on to

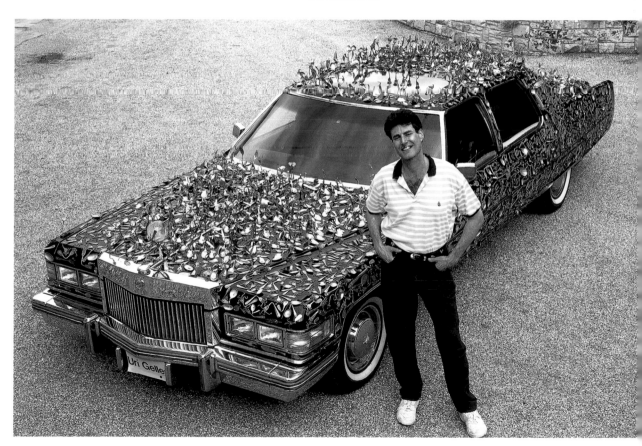

Pez Car by Cliff Lee

Houston, Texas

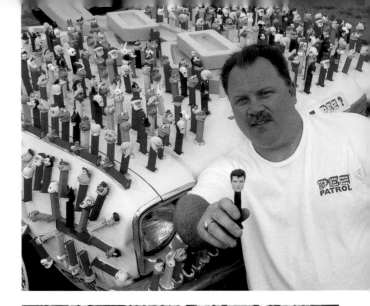

Inspired by the Houston Art Car Parade, Cliff dreamed of making the *Pez Car* for eight years before he started it in 1997. During that time, he amassed a huge collection of Pez dispensers but needed more to cover the car. When PEZ Candy, Inc. declined to help, Cliff found an alternative source in the Pezheads e-mail list on the Internet. He posted a query to the list, and his dream of covering a car with Pez dispensers was met with great enthusiasm. He received thousands in the mail.

Using white tub-and-tile silicone, Cliff carefully glued more than 1,400 Pez dispensers onto his white 1977 Dodge Aspen. The project merged Cliff's two hobbies, Pez collecting and art cars. He speaks about both:

"To me, collecting is a journey. Each Pez dispenser has it own unique story about how I acquired it, whether I was in pouring rain at a flea market in Paris or at a flea market in Richmond, Texas. I've bought them everywhere. It's the quest that I enjoy, and the collection is like photos from a travel book. My art car is a statement of joy and amusement, intended to show how cool a collection of Pez dispensers can be. If you define art as something that evokes emotion, then the *Pez Car* is art. Perhaps it's more performance art than anything, but it brings out a reaction in all who see it. Some people are attracted to art cars because they do not want to fall in line with everyone else. To others they're personal expressions of concepts or images. And to others, they're ways to draw attention to themselves. We all have portions of these traits, some more than others. To me, art car folks always seemed to be having fun, and I wanted to be a part of that."

64

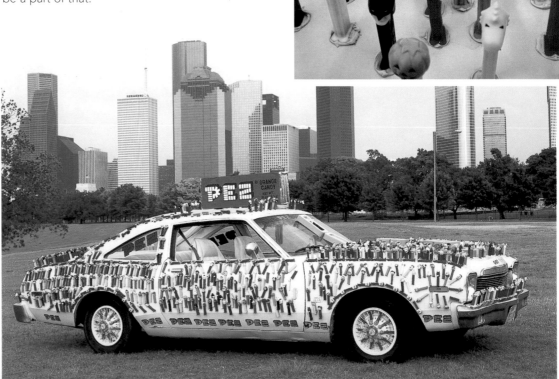

4 just for the attention?

It's an understatement to say that art cars get a lot of attention. Their images are often reproduced in the media, and I would argue that art cars rank up there with film, television, radio, and the written word. This is largely due to the mobility of the automobile. A drive in heavy traffic can mean being seen by hundreds, perhaps thousands, of people. This ability to reach the masses is a powerful attribute, and many art car makers enjoy the attention. This is not to say, however, that all art cars are created just for attention, as the public might surmise. Art car artists give the public something to look at and be entertained by. At the same time they drive around with their values, ideas, and identities on display, sharing their inner selves with their communities. Some art car makers intentionally seek an audience and create with the distinct purpose of getting attention. The art cars in this chapter are broken down into two categories: cars that commmunicate a message, and cars that interact with viewers.

Messenger cars are like mobile billboards. They advertise an idea or personal value, be it self-

chalkboard car by Lissie Fein and Peter King (detail left). Containers of chalk are mounted to the car, and the public can simply look at the car, write on it, or both. Being able to write on a car gives audience members the chance to share in the benefits and thrills of making an art car without the responsibility of owning it or driving it around.

Because art cars like those shown in this chapter invite the public either to read a message or interact, the public may feel more entitled to confront the drivers, relate to them, and ask questions. This can be refreshing for the art car artists, because it connects them with their communities. Of course, not everyone will agree with a car's message, and some people don't want to participate, so interaction is not a given. In general, though, art cars attract like-minded souls and repel others.

promoting, religious, environmental, or political in nature. A good example is *Absolute Pollock*, by Greg Metz (page 65, top). This car calls attention to the fact that drinking and driving killed the painter Jackson Pollock, and also mocks the Absolut Vodka ad campaign. Commercial art cars that advertise a product also fit into this category. The *Chicken Car*, owned by Gloria Lombas (page 65, bottom), is a classic example of a commercial art car. There are many commercial art cars, but this one is more personal than

most in that it promotes a family-owned fried chicken joint.

Interactive cars are designed to promote and encourage interaction with the public. Without an audience, these cars are incomplete. One example is *Jay's Crazy 9-Hole Miniature Golf Car*, by Jay Kelleher (right). Anyone interested in participating is given a golf club, and the players become part of the performance and the theater of the car. Another example is *Write On*, a

Cast Me! by Dennis Woodruff

Hollywood, California

Dennis Woodruff tells how he became an art car artist: "When I was a little boy, I painted my name on my bicycle, and I'd ride it around, waving to an imaginary crowd. My mother would ask me, 'Why are you waving? There's no one there.' I told her, 'Well, maybe someday there will be.' As I got older, I realized that my calling was to be an actor, so I moved to L.A. Initially, I did what everyone else did. I got a $2,000 portfolio with head shots and showed it to almost 200 agencies. But no one would even take the time to look at it. One day I got so frustrated that I put all of my head shots on the outside of my car. As I drove, I realized a lot of people were looking at it. Some people thought I was weird, but I just kept doing it. Then I put my name on the car and eventually added my phone number, so the car ended up being like my mobile business card. As I added more stuff to the car, it became an art form, and people starting calling me an artist. I realized that two cars would be better, and it kind of became obsessive. When I get my motor home, I'll have seven—so I can drive a different art car each day of the week!"

Dennis's art cars are so successful that he has become a recognized Hollywood icon. In a region where one's appearance and car have such exaggerated value, his handmade approach is novel and revolutionary. While using his car to solicit acting work, Dennis crit-

icizes the system and its methodology by doing it his own way. He has appeared in many films and TV shows, including *L.A. Story* and *Volcano*. Using the same handmade approach he uses with his cars, he also makes, stars in, and distributes his own films, and sells his videos to curious passersby. Able to support himself this way and live his dream, Dennis is doing quite well compared to many of his contemporary counterparts.

Dennis's cars display his raw, untrained artistic talent, and he uses inexpensive materials such as house paint and found objects to express his vision. One of his cars is now in the Petersen Automotive Museum collection in Los Angeles. Although some view Dennis as a blatant self-promoter, his art cars resonate beyond his own pursuit of fame and success. They symbolize the dreams and struggles of so many actors trying to make it in Hollywood. "My message," Dennis stresses, "is that it's okay to be yourself. I've created my own reality, my own world that I feel comfortable in. My individuality is my identity. I don't wanna be Tom Cruise. I don't wanna be Brad Pitt. I don't wanna be anyone else. I wanna be me, Dennis Woodruff! Life is my movie, and I am the actor. It's being filmed as we speak!"

Top: Dennis with *Head Car*
Bottom: Dennis on *Actor's Dream*

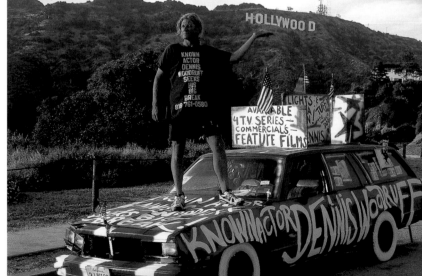

68

Litter-Bug and Stink-Bug by Carolyn Stapleton

Orlando, Florida

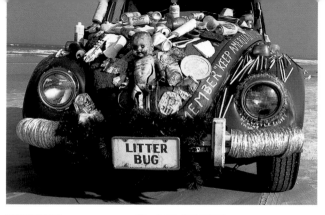

Carolyn Stapleton enjoys nature and often walks along roadsides, collecting litter. She leaves the places she visits a little better off than they were before, and at the same time, she gains insights into our modern values and "archeology."

"You can learn a lot about people by what they leave behind," Carolyn explains. "I felt that it was alarming how nature was so disrespected by our culture, and I wanted to do something about it. Performing a volunteer cleanup blossomed into my first art car. What began as a few bumper stickers and an interest in making a difference became a visual pun. It all just came together with silicone and litter, which was easy to come by. Baby boomers remember the slogan, 'Don't be a litterbug!' and many refer to the VW as a bug, so one morning I woke up and thought, that's what I'll call her, *Litter-Bug*! Its purpose is to be a vehicle for change. It is not a statement saying, 'Look at me!' It's saying, 'Look at us; look

who we are and what we throw away.' I'd love it if people got over the idea that it's up to someone else to clean things up."

After several years of driving the *Litter-Bug* as her only car, Carolyn modified her message into another pun, the *Stink-Bug*. It's a mosaic of art,

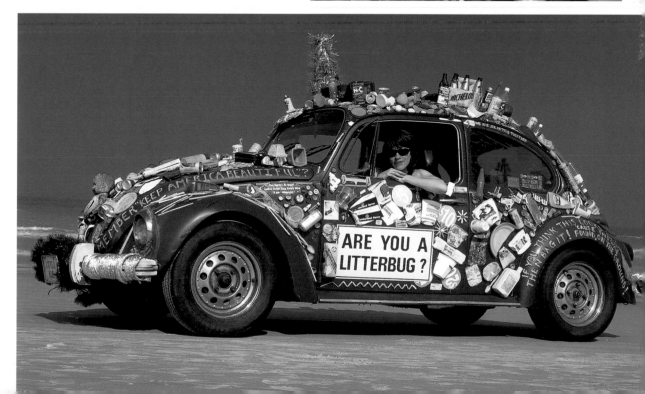

aversion therapy, and the form of litter she detests the most, cigarette butts. Starting in January 1999, Carolyn spent a year collecting, sorting, and gluing used cigarette butts onto the *Litter-Bug* to make it a rolling, stinking memorial to smokers and nonsmokers alike. The *Stink-Bug* features the messages "Kick butt" and "Stop in the name of lungs," and a pair of skulls and crossbones on the hood. The bamboo-like texture really surprises folks when they step close enough to realize that the car is actually covered in cigarette butts. And the final touch to make sure people listen: the all-too-familiar sound of coughing that's broadcast from under the hood!

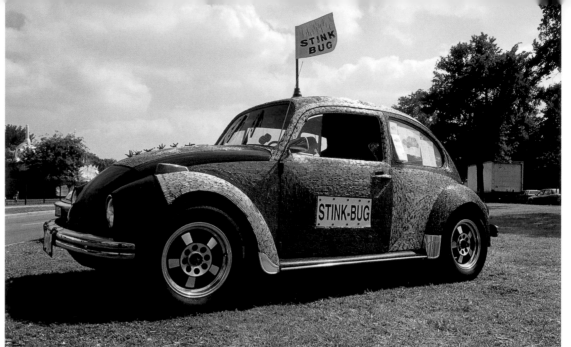

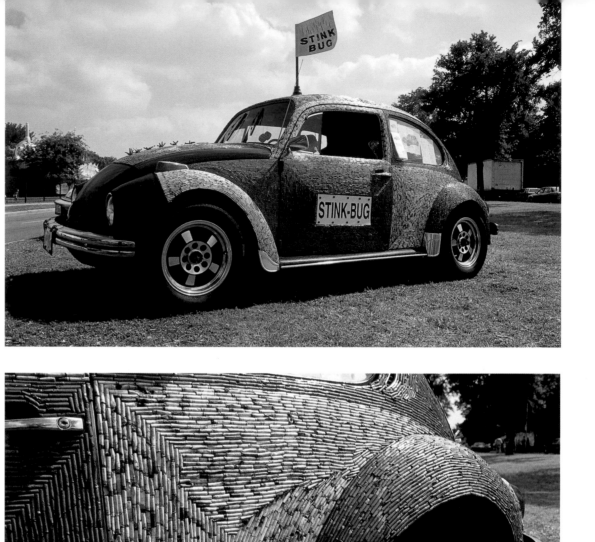

Salvation Mountain Truck by Leonard Knight

Niland, California

Outside the desert town of Niland, California, is an abandoned military installation nicknamed "Slab City" for the flat slabs of concrete scattered about. "Snowbirds" from up north come down for the winter and live in their RVs, each claiming a slab as his or her own parking place. Leonard Knight left Nebraska to find someplace warmer and ended up here in 1985 with his own plot of concrete. With a desire to share his religious passion, he began painting an 8-foot-tall (2.4 m) monument on the side of an adjacent mountain, and he ended up painting for the next 14 years until the entire mountain was covered. He continues working on the monument to this day, in addition to painting his two trucks, a tractor, and anything else that comes his way.

Leonard talks about the genesis of his passion: "It was in 1967 when all of a sudden one day I said 'Jesus, I'm a sinner; please come into my heart.' It felt so good that I wanted to tell the whole world. I first put the "Sinner's Prayer" on a giant hot-air balloon. I painted the prayer in white letters on a red heart so it was easy to read. I was going to travel around the world in the balloon, but it broke and wouldn't hold air. Then, when I ended up here several years later, I painted this mountain and my trucks, and I put

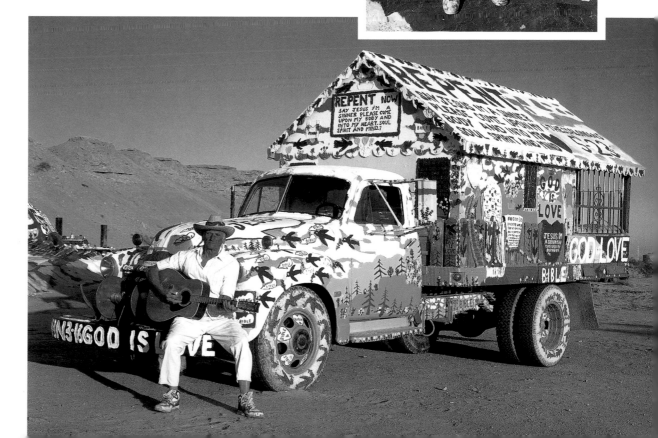

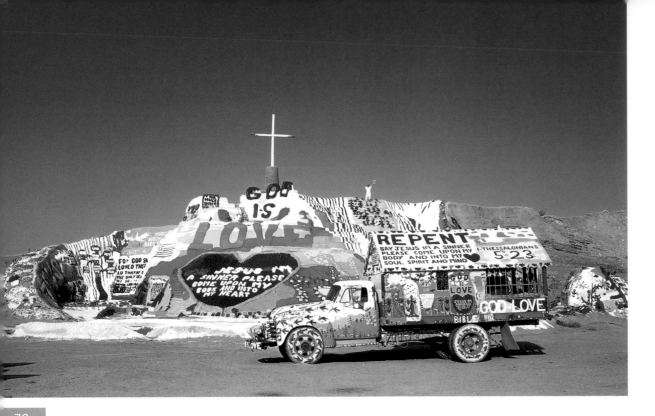

the prayer on those, too. I just want to put it to people in a nice, beautiful, and friendly way. I'm not going to tell anyone how to live their life, but this is how I want to live mine."

Considered a visionary artist, Leonard is a pure soul and totally self-taught. In contrast to the boldness of his religious messages, in person he is gentle, jovial, and not one to proselytize or pass judgment on others. He leads a very simple life, often sleeping under the stars on an old couch, with a cat as his only companion. He bathes in a nearby spring and rides his bicycle to town to get his mail and supplies. Most of his time is spent painting. From sunup to sundown, Leonard paints on the mountain, which is now coated with a quarter-inch-thick (6 mm) layer consisting of more than 18 coats of paint. He stops only to nap in the heat of the day or to greet visitors, to whom he offers postcards of the mountain and artwork he's made, including painted flowers made from adobe and cat food cans. In return, he receives donations of money, paint, and supplies.

A decision by the United States government on whether or not to declare Salvation Mountain a National Monument is pending.

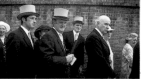
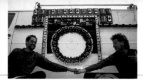

Camera Van by Harrod Blank

Berkeley, California

In 1993, I had a bizarre dream in which I drove around in a van covered with cameras and pushed shutter buttons on the dashboard to take candid pictures of people's reactions. Their surprised and amazed expressions were fantastic. When I awakened from the dream, I scribbled some notes on a piece of paper and went back to sleep. The next day, I realized that the dream was a solution to a problem. For years I had attempted to photograph the public's reactions to my first art car, *Oh My God!* (page 6). I wanted to show people what I saw every day, what the experience of driving an art car was like. But whenever I picked up a camera to take a picture, the subject reacted to the camera and changed his or her expression. I figured if a vehicle were completely covered with cameras, how would people know which one worked? They wouldn't, and their reactions would be unguarded, pure, and candid. Then I could document that moment of discovery when a person's brain has no definition for what it sees, like when a child is seeing something for the very first time.

From left to right, top to bottom: star (detail); interior monitor; Queen's Garden Party, London, 1998; Harrod Blank and Ron Dolce; Walter Gordon Jr., Pass Christian, Mississippi,1996; onlookers in Bensonhurst, New York, 1996; bewildered man in Trafalgar Square, London, 1998; monitor with onlookers, Bensonhurst, New York, 1996; scouts looking at TV monitors, Hyde Park, London, 1998

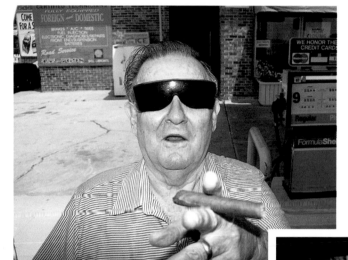

I began collecting cameras, and I found this to be much more difficult than I'd imagined. Even worthless, broken cameras commanded $10 to $20 each at flea markets and garage sales. Fortunately, the Santa Cruz Goodwill Bargain Barn agreed to give me the cameras they couldn't sell, rather than sending them to the dump. Every couple of months I picked up a huge barrel of cameras, and after I'd amassed about 1,000 cameras, I figured that would be enough. I then purchased a 1-ton (.9 t) Dodge Van for $400 from a friend.

Initially, I planned to glue on the cameras in an unspecified order when my friend Ron Dolce (page 27) suggested that I "paint" something with them. Ron helped me sketch a giant Kodak Instamatic camera on the driver's side of the van. I began gluing on the lighter cameras and riveting on the heavier ones. Progress was extremely slow, taking me six months to do just three-quarters of one side. Then, Dan Lohaus (page 78) moved in next door. I hired Dan to hunt for more cameras; then he moved into gluing, and the project picked up some much-needed speed. There was no manual for how to make a *Camera Van*, so I had to seek advice from a lot of friends. There was a tremendous amount of trial and error involved. For example, it took two weeks to

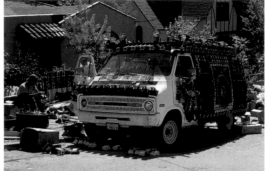

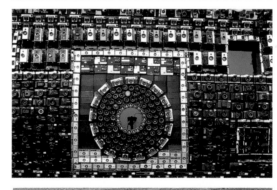

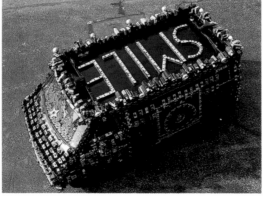

glue thousands of 35mm film canisters to the roof, only to learn later that silicone caulk wouldn't adhere to that type of plastic and the entire roof had to be redone. The single most important technical aspect was to make some of the cameras function and take pictures. It was a nightmare, and I'm still perfecting the process to this day.

After two years of work, I completed the van in 1995, and it debuted in that year's Houston Art Car Parade. The 2,000-plus cameras include 140 Super-8s, virtually every type of Polaroid, antique and foreign cameras, and collectibles such as Mickey Mouse, Girl Scout, and Reese's Peanut Butter Cup cameras. The *Camera Van* also features two murals of kids staring out the back, a giant "filmstrip" of four working monitors on the passenger's side, and "Smile" written out in cameras on the roof. Six functioning Canon EOS cameras are wired via remote cables to a shutter-button panel on the dashboard. The Canons feature a very fast and accurate auto-focus and flash, which is necessary for this type of photography. A video monitor on the engine cover serves as a viewfinder for the rear camera, and the windows in the cab, both front and side, serve as approximate frames as well.

After completing the van, I realized that my own appearance was paltry in comparison, so I designed an outfit called the *Flash Suit* to go with it. It's covered with 2,000 Magicubes and flashcubes. One hundred of them have been rewired to flash intermittently, powered by two 6-volt batteries attached to a belt. I can't drive wearing the suit, however, because I can't sit down in it.

I drove the van on a cross-country tour of the U.S. and took more than 5,000 photographs which formed the exhibit, *The Americans Astonished*. In 1998 the van was brought to the U.K. to promote Photo '98, an international festival of photography, and several thousand images were taken there for an exhibit called *The British Bewildered*. In 2000, the van was exhibited in the Essen Motor Show in Germany. Unfortunately, German traffic laws are so strict that the van wasn't allowed to be driven, and photos of *The Gawking Germans* were limited to those taken in the showroom.

One day, I'd like to equip the van with enough working cameras so that every angle could be covered by the push of a button. This would virtually guarantee that I could capture any interesting image I saw. My other fantasy is to drive the van around the world and do a comprehen-

sive photographic study of how different cultures react to something extraordinary. The differences among Americans, British, and Germans are vast, for example. I'd also like to meet other eccentric artists around the world with the *Camera Van* and document them for a film or TV series. Okay, that's enough dreaming for now. It's time to go do it!

The *Camera Van* crew included Dan Lohaus, Kevin Ratliff, Kimric Smythe, Neil Ruppert, and David Pugh.

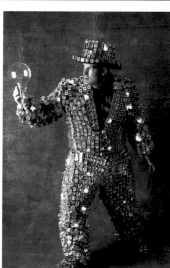

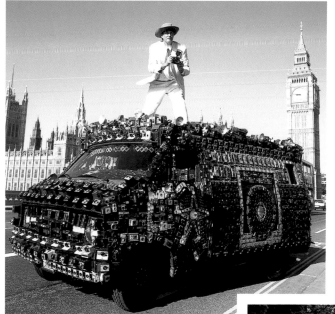

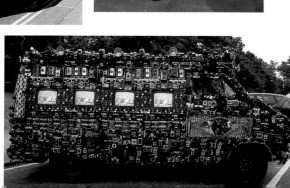

Pico de Gallo by Harrod Blank

Berkeley, California

I enjoy being able to step away from an interactive art car and let *it* do all of the entertaining. For one thing, I'm not musically inclined. I prefer not to perform on my car, though I've done so many times when in an especially extroverted mood.

Pico De Gallo is an interactive music mobile I created in 1998. It was my third art car and its name is Spanish for a spicy salsa or hot sauce. My fantasy was to make the ultimate performance vehicle for a *mariachi*, hearkening back to a year I lived in Mexico City. I added silver trim, maracas, a Mexican blanket for upholstery, and some typical band instruments. The car features a stage on top that was cut out of 1-inch-thick (2.5 cm) plywood and painted to resemble a 45 record, and the running boards are covered with piano keys. The back of the car contains a working stereo amplifier with an 8-track tape player and four mike inputs. When fully up and running, the car can broadcast music from the stereo system, and many of the instruments are miked up to be played. There are also several working mikes for vocals, two plug-in electric guitars, and pouches containing drumsticks. The car is in effect a musical instrument just waiting to be played, and it can be very, very loud.

Of the three art cars I've created, this one is the most popular at parties and public events, as you'd imagine. *Pico De Gallo* is often rented and used as a mobile stage; since it runs off a power inverter and an extra car battery, it can be taken anywhere. I am still upgrading the vehicle, trying to make it more sophisticated musically, and one day I hope to live that fantasy of hosting a real mariachi!

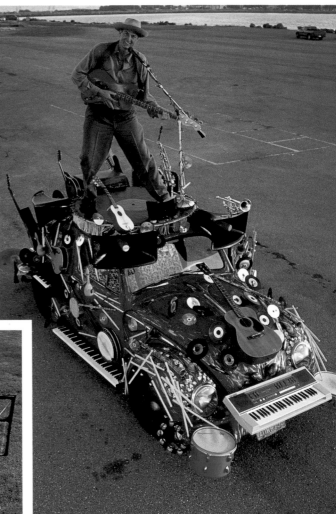

Write On by Lissie Fein and Peter King

Oakland, California

In September of 1997, Lissie Fein and Peter King spent two weeks creating their interactive art car. They sanded off the original paint, taped off the car, and used seven cans of Krylon chalkboard paint to paint it. The seats were covered with green fabric, the mats with Astroturf, and the hubcaps were modified with sheet metal to make them flat. Every six months, they give the car a new coat of paint to keep it looking good and suitable for the public to write on. Chalk is provided in boxes mounted in various locations around the car.

Wherever this 1987 Toyota Corolla FX Hatchback is parked, it becomes a catalyst for human interaction, much like a campfire. People want to be a part of the car, to respond to it, study it, talk about it, and, of course, write on it. It draws people in, and they mingle, even in parking lots. The car's relationship with people is what most impresses Lissie and Peter:

"The car engages people, and they decide what they want to express. The audience becomes the performers. Sometimes people draw pictures, sometimes they write witty words, other times the car gets hit with a graffiti tag. People really like expressing themselves personally and adding something to the ongoing canvas. It makes daily life more fun, changing normal driving and parking experiences into something creative. We like providing the canvas. It's like a moving soapbox, and it's for everyone. For us, it fills the desire to connect with people that we otherwise might not interact with. It says something about us, too: that we're interested in free speech and in what people have to say."

TV Truck by Dan Lohaus

Brooklyn, New York

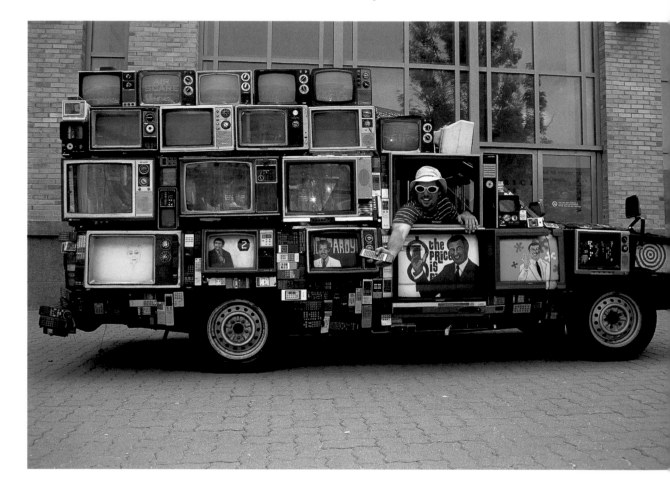

Dan Lohaus credits the *Camera Van* and the Houston Art Car Parade with opening his eyes to the world of art cars. "I was blown away that you could just do something weird like that and get everybody's attention. When I went on the road with Harrod to Houston, I got to meet all of these other car artists, and that just kind of blew the doors wide open. I knew I wanted to be one of those crazy freaks too."

Dan had dreamed of being a game-show host ever since he was a boy, so it was only natural for him to create an art car to facilitate his fantasy: a mobile game show on wheels, the *TV Truck*. It all started when Dan and his friend Chris Weiser were driving in Brooklyn, fantasizing about turning Dan's 1992 Toyota pickup into a game show on wheels. When they saw a TV set on the street, it soon became the hood ornament. Some 53 TV sets and 400 remote controls later, the *TV Truck* began to take shape. Dan's mom, Martha Lohaus, painted portraits on the truck of Bob Barker, Richard Dawson, and Wink Martindale, the game-show hosts Dan idolized. To complete his mission, Dan and his friends fleshed out the

back of the truck to function as a set for *Traffic Jam*, their mobile game show. They added a scoreboard, spinning lights, a PA, buzzers for the contestants, and a generator to power it all.

"When you have a dream of becoming a game show host, there's no school for that," says Dan. "How did Bob Barker become a game show host? How do these people do it? It's kind of a hard job to get. We figured the best way to do this was to take the car to the streets of New York and shoot our own show. We'd park the *TV Truck* in Times Square, and it would attract the crowd and our contestants. The truck is what propels the whole fantasy and buzz. But the truck is not just about the interaction between me and the public. It's about the interaction that happens even when the truck is just parked somewhere. People find a little common bond with the *TV Truck* and with each other, watching one of the TVs or talking to each other about art cars. Like, 'Isn't this the weirdest thing you ever saw?' It makes people happy and gives them an opportunity to be funny and make jokes. It reminds them that they can do whatever they want."

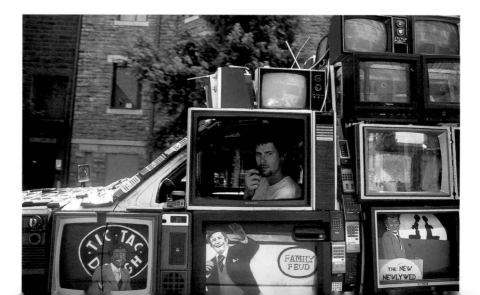

hybrid motors

This chapter contains art cars that incorporate a variety of techniques and applications and therefore are more difficult to classify. One section of the car may appear completely different in style and meaning than another part, for example. Cars in this group are not conceptualized beforehand, but are created intuitively, emotionally, and gradually. Highly personal, they are like shrines or extensions of their makers' souls. The values, emotions, ideas, and personality, what is inside the artist, is taken out and put over the outside of the car. Rarely considered complete, these cars grow and mature over time, as do their artists. The cars in this chapter thus represent only moments in their own histories.

Constantly changing and full of character, these art cars seem to have lives of their own.

One example of a hybrid art car is Ken Gerberick's *The Frivolous Niece & the Dowager Aunt Emblem Car* (below). On the hood of his '85 Chevy Chevette is a miniature city block, complete with two used-car lots and an adjacent junkyard full of cars. The hood, with its three-dimensional, painted model of an urban landscape, is very different from the sides of the car, which are laden with car emblems, and the roof which is emblazoned with license plates. The car emblems are used as words to spell out sentences expressing Ken's ideas. Though this car

has highly conceptual elements and is tighter than most in its application, it's a personal work. When the car died, Ken cut it up and mounted its parts on the walls of his house.

Because hybrid art cars are driven on a daily basis and are so personal to the artists, any loss or damage to them can be devastating for their makers. Therefore, these artists will do anything in their power when attempting to preserve and maintain their automotive alter egos.

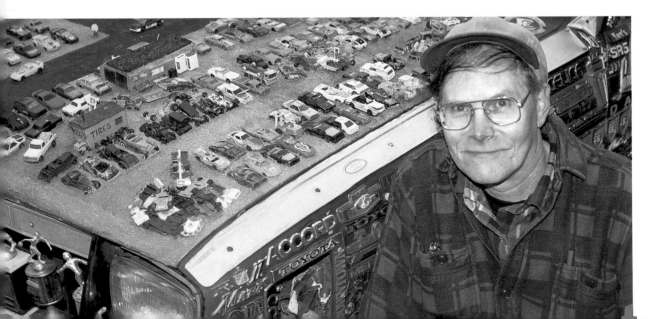

Pestilencia by Cheri Brugman

Forest Grove, Oregon

Cheri Brugman started decorating her 1983 Subaru in 1995 just for fun and because it was an ugly, factory beige color. She used decapitated heads, bloody body parts, dead fish, guns, and flamethrowers (detail, page 80, right) to decorate her art car, poking fun at the violence and greed of today's culture. Cheri was particularly fond of the sign on the back that reads, "This Machine Kills Fascists."

"Woody Guthrie, the folk singer, wrote that on his guitar," Cheri explains. "The flamethrowers were the final touch, probably one of the best touches. People love them! They're like, 'What the . . . ??!!' I mean, it's the last thing you'd expect to see coming out of the hood of a car, two flames shooting straight up, and the driver isn't even panicking!"

Pestilencia enabled Cheri and her two dogs to travel the country attending art car events, but reactions to her car's appearance were varied and sometimes extreme. "Most people sensed that the car wasn't really serious, that it was just a joke," Cheri says. "But some people asked me if I'm a Satan worshipper, and others freaked out and thought I'm some ax-murdering weirdo. One time, while I was stopped at a light, this woman got out of her minivan, walked out into the middle of the intersection, and yelled at me, 'TAKE ALL THAT CRAP OFF OF YOUR CAR! WHY DON'T YOU JUST GROW UP!' Everybody was staring at her like *she* was crazy. I just laughed at her. That was actually one of my favorite reactions."

Unfortunately, *Pestilencia's* eventual mechanical failure was too expensive to fix. So, Cheri decided to throw a goodbye party at the junkyard where she worked. She invited her friends over to celebrate and watch her operate the car-crushing crane. Though she was sad to see her art car go, she is optimistic about the future.

"They're so much fun to make, I think I'll always have one. It'll depend on what else is going on in my life, on my time, motivation, and money. My next car is a secret, so no one else will make it first. I've got a name for it, now I just gotta get a car for it!"

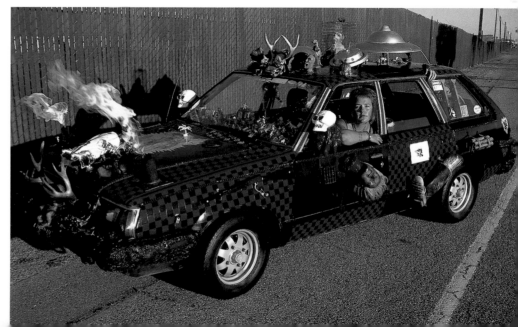

The Duke by Rick McKinney

Albuquerque, New Mexico

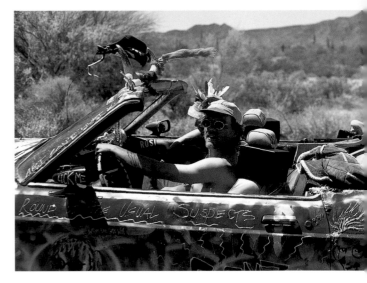

Fresh out of college in 1991, Rick McKinney wasn't interested in pursuing the conventional career track. He felt like a misfit too, scorned by his journalism professors for his offbeat style. Walking the streets contemplating his destiny, he came upon an old, beat-up car for sale. It was love at first sight, as Rick recalls: "I discovered *Duke* abandoned in a backyard in Trinidad, California. It was this mutant, black, post-apocalyptic Batmobile. Its owner had chopped off the roof with a chainsaw and left it for dead. I saw it as an adventurous, much-needed escape from it all."

On his birthday in 1991, Rick's friends and even his 85-year-old grandmother helped him spray-paint the car with graffiti. From its outset, the car was an ode to Rick's hero, gonzo writer Hunter S. Thompson. "Gonzo journalism is about immediacy, and the art car was no different," Rick explains. "The car never would let me forget my dream to write and create work worthy of legend. It's sad how some people have to forget themselves in order to survive in the professional world. In an aggressive endeavor to avoid this plague of amnesia, I followed the road-trip ethic of Dr. Gonzo and Don Quixote, chasing windmills and mad savants from gas station to gas station, always with notebook and pen in hand."

Eventually the car took the name of *The Duke*, one of Thompson's pseudonyms. At that time, a beat-up typewriter hood ornament was the only sizable object on the car. In 1995, however, Rick joined the Art Car Caravan (page 127) to the Houston Art Car Parade, and the wheeled wonders he witnessed on that trip set him and *The Duke* on the road to a new artistic dimension. As he drove along desert highway straightaways, Rick smoked cigars and grinned as the pink hair of a dozen trolls and his own blond mane blew wildly in the wind. Through the ecstasy of the art car road trip, Rick discovered a joyful irreverence akin to the free, literary spirits of his favorite writers including Charles Bukowski, Henry Miller, and Samuel Coleridge. He felt at home.

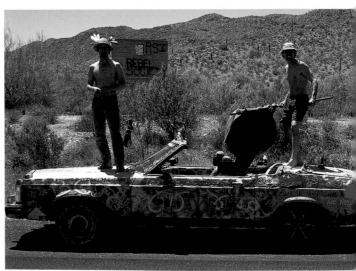

Right, top and bottom: Rick and Mike Loutzenhiser on art car caravan, 1995

In 1996, a dream gave birth to *The Duke's* maddest addition yet, the trunk sculpture. Rick gutted 24 old steamer trunks and two TV sets, framed them together with rebar and spray foam, topped the mass with a 3 by 5-foot (.9 x 1.5 m) bubble skylight, and welded everything atop the car. Voilà! *Duke* the art camper! Rick never intended to live in it, but that's how it turned out. Unable to sell his first novel, he became depressed and wound up homeless, living in the car. He managed to climb out of the depression after two years, and attributes his recovery to the strength of his dream, a good woman, and his new art car "family." With three recently completed screenplays under his belt, Rick expresses the essence of his art car experience: "It takes immeasurable courage to glue a mosaic of your soul onto your car and parade it around in public. I highly recommend it to anyone with depression. It forces you to smile, and it takes your mind off yourself."

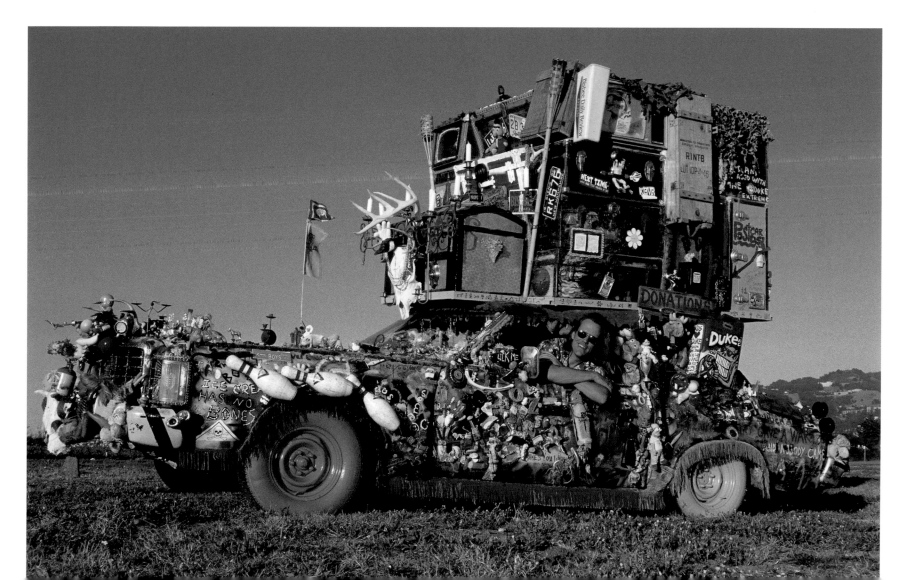

Mirabilis Statuarius Vehiculum by Scot Campbell

Portland, Oregon

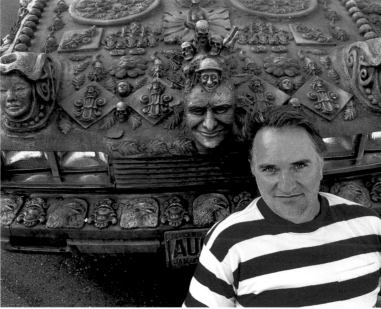

If you drive slowly past storefronts under Portland's overcast skies, you'll occasionally spot colorful, cartoonish window paintings whose sheer lunacy demands your attention. You've probably just seen the work of Scot Campbell, who's even better known for his public performances as a clown and for his art car, the majestic *Mirabilis Statuarius Vehiculum* (Latin for "extraordinary sculpted vehicle").

Scot had an inspiration that was totally new to the art car genre: a working waterfall with related motifs. His artistic process reflects his feelings about the true nature of art cars: "The art car is fine art sculpture, it's original art. Everything on it, I created. I don't like putting stuff on my car that I didn't make myself."

Scot started sculpting pieces for *Mirabilis* in 1996. There are more than 50 original pieces of art on the car. He first sculpts each piece in clay, then makes a flexible rubber mold. He then makes a second "shell mold" into which the first rubber mold fits. He fills the mold with liquid resin, and after the piece has set and cured, he paints, stains, and glues it to the car. Using plastic makes the car much lighter. For example, the head on the front weighed 200 pounds (90.8 kg) in clay, but only eight pounds (3.6 kg) in plastic. The whole process is very time-consuming, a reflection of Scot's obsession. The Poseidon hood ornament took three months to sculpt, and each little head on the car took eight or nine hours. Ultimately, Scot has worked for more than 1600 hours on the car. "I sit there, like in a trance, making these things. That's the creative part. I have this need and drive to create for endless hours."

Scot drives the car to work every day carrying his window-painting supplies, which

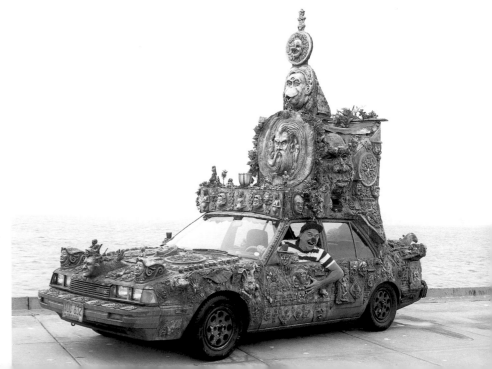

are conveniently hidden inside the car's waterfall tower. He enjoys clowning in public, interacting with spectators, and using his car as a prop to entertain himself and others. He's more than the life of the party, he *is* the party, and he takes it with him wherever he goes. People stop to marvel at the waterfall, and he clowns with them until everyone is laughing. The fun is contagious, and Scot's needs are met, too. He's up front about his desire for recognition: "It may be a form of egomania, but I just love being acknowledged. I hope that they like me, instead of hitting me! Ha-ha-haaaaa. Whether it's painting windows, sculpting, singing, or dancing, I'm always creating and giving of myself to entertain people. I also need challenges. The art car is challenging—can I do it? So you see, it's a big part of my life."

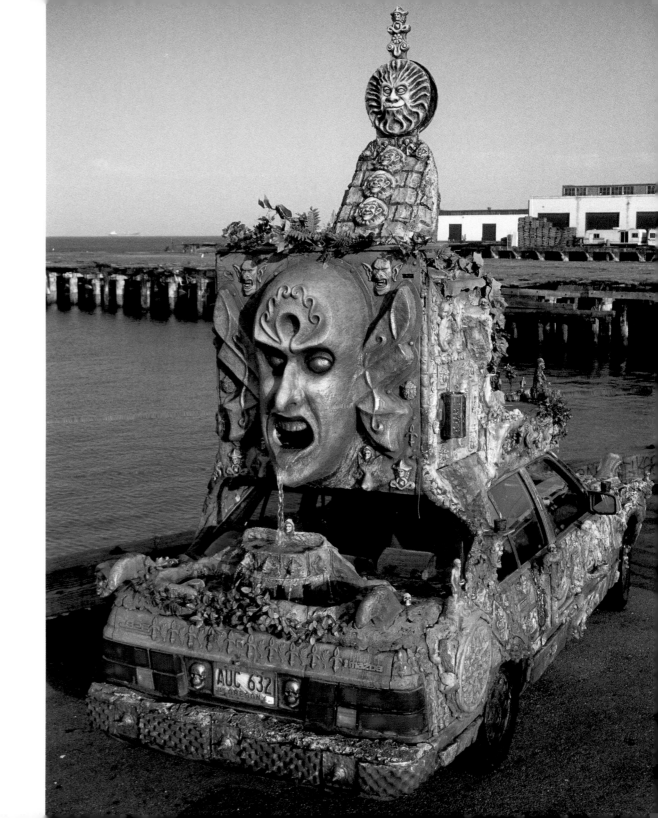

Truck in Flux by Philo Northrup

San Francisco, California

Like the majority of people who began art cars in the early '80s, Philo Northrup was completely unaware of any other art cars before he started. There were no artists in his family, he never studied art in school, and he was not influenced or encouraged by others to make art. Philo's work was unpolished and meant for his own satisfaction. Thus, he created what some people would classify as folk or visionary art. His art cars are made by hand and involve a fair amount of trial and error. As a result, they are never finished. They are always changing (or "fluxing," as he likes to call it), thus the name *Truck in Flux*.

Philo makes his art cars with classic assemblage techniques, juxtaposing objects of disparate origins that somehow seem to belong together. It's the intuitive nature of the techniques, he feels, that makes assemblage and collage such attractive media for self-taught artists. One trademark of his art cars and many of his other art pieces is the incorporation of living plants, generally succulents. "Succulents are the only plants that

I seem to have a green thumb with," he says. "They weather the abuses of being on a moving vehicle quite well. Most plants aren't meant for going down the highway, but succulents are!"

His latest art car, the *Buick of Unconditional Love* (right), employs assemblage techniques to explore the themes of relationships, manhood, and mortality. It incorporates canine imagery to ask the questions, "Are men dogs? And if so, is that a bad thing?" With more than 15 years of art car experience, including creating five art cars, organizing numerous art car caravans, and cofounding the ArtCar Fest (page 128), Philo is one of the key people at the heart of the art car movement:

"Art car artists come from every conceivable background and work at every conceivable trade, but we all have this remarkable affinity for each other. We follow a very individualistic aesthetic, and this distinguishes us from other car customizers. I love hot rods and lowriders, very sexy stuff, but those folks are aiming at a prescribed aesthetic and enter their vehicles into competitions where they're judged according to that prescription. They're serious craftspeople

spending many hours and dollars erasing any feature that seems organic. Art car artists, in contrast, invent their own personal aesthetic. That is why you see such a variety of art cars. It's not that we choose to follow the beat of a different drummer, it's that we choose to listen to ourselves. The fact that our drum beats differently is involuntary. The fact that we listen to it is the source of our strength."

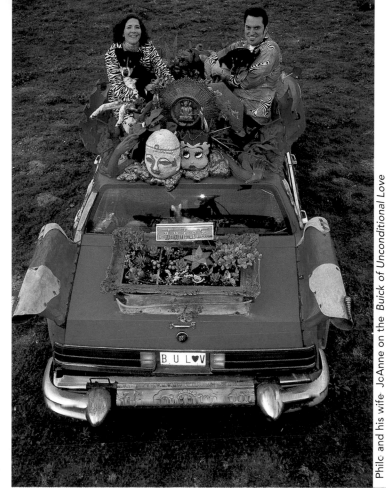

Philo and his wife JoAnne on the *Buick of Unconditional Love*

suspension of disbelief

A wheeled dragon, a giant toy wagon, a boat, and a majestic mobile cathedral! These creations are all sculptural representations that strive to disguise the fact that they're cars. They tend to be easily recognized from afar and stimulate a suspension of disbelief in the minds of onlookers. One doesn't expect to see a giant shark driving down the freeway, but that's sure what it looks like. These art cars toy with our perceptions of reality, making a drive in traffic a lot more fun for both the art car driver and the public.

The majority of sculptural art cars resemble animals or fantastic creatures. As mentioned earlier, this is because cars, with their headlight eyes, hood noses, and bumper lips, lend themselves to being perceived as alive. With a few sculptural modifications, these traits can be exaggerated to create something even more creature-like. People generally go nuts over this type of art car because of the surrealistic experience and sense of humor it provokes. For these reasons, and because they are quickly recognized in traffic,

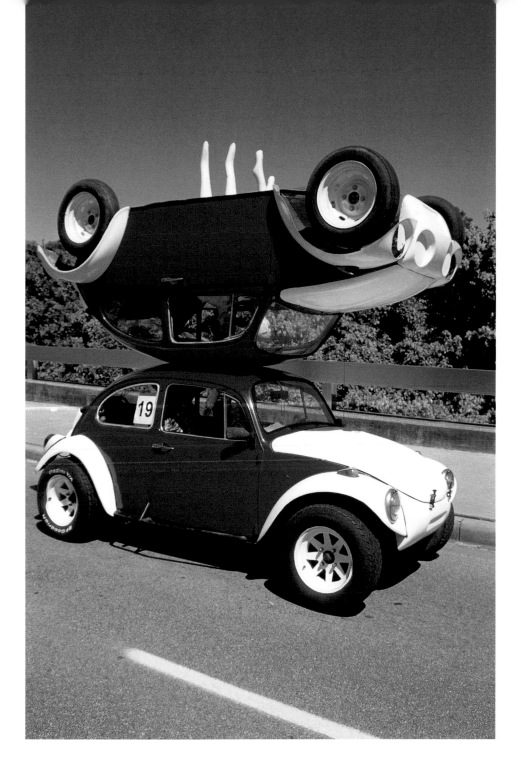

sculptural art cars such as the *Chicken Car* (page 65) and the *Oscar Meyer Weinermobile* are favorite choices when it comes to advertising. Due to the popularity of such commercial art cars, the public often mistakes all sculptural cars for advertisements. A common question asked off these artists is, "What are you selling?"

This group of art cars can be divided into two subcategories, depending upon whether the original shape and structure of the car has been maintained or altered. *Sculpted shells* are vehicles for which a custom shell is made to fit over the existing car. *Modified bodies* are cars with bodies that have been cut away, and in many cases, they also have altered chassis.

A sculpted shell, such as *Mirror Image*, by Dennis Clay (left), is more likely to pass a legal inspection because the integrity of the original car's frame has been maintained and reinforced to support the additional VW shell on top. Another example of this category is the *Lighthouse* Car (page 90, top), by Robert Burke. In addition to its attached elements, all of the structural requirements of a regular car are intact.

Modified bodies such as *Toyboata*, by Matt Slimmer (detail, lower right), show very few signs of the original car body, if any. In this case, the body of a Toyota car was removed and a boat used to replace it. Taillights, running lights, mirrors, and other accessories were added to the boat to help make it street-legal. Another good example is the *Covered Wagon*, by Greg Parker (page 88), which also bridges the definition of an art car with that of a monster truck. This vehicle was custom-built from the ground up, and as is the case with many modified bodies, it runs great, but is not street-legal.

For all sculptural art cars, attention to detail is the crucial element in effectively suspending viewers' disbelief. As in the case of the *Toyboata*, the details of the outboard motor, flags, fishing poles, and fishing net all help to portray the desired illusion. In fact, fantasy is a key element in the conceptualization of these particular art cars. Sculptural art cars, also called *fantasy cars*, are often motivated by dreams or fantasies. Like children, their artists imagine ideal forms of transportation regardless of how silly, impractical, or dangerous they may seem. Dissatisfied with just the fantasy, these art car visionaries won't rest until they've made their dreams a reality!

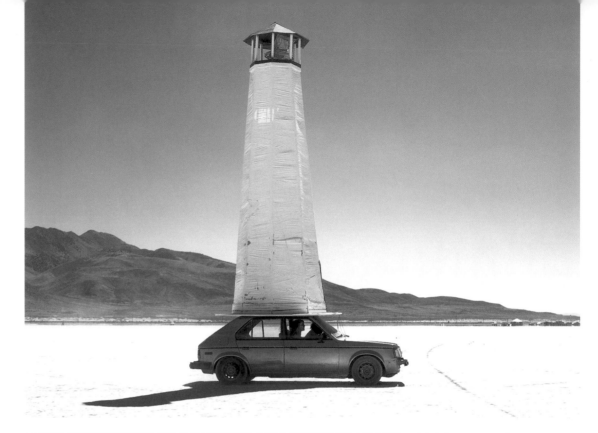

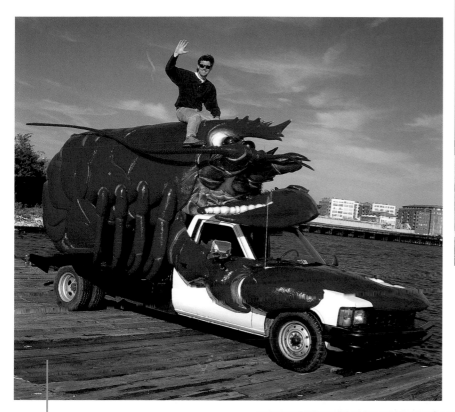

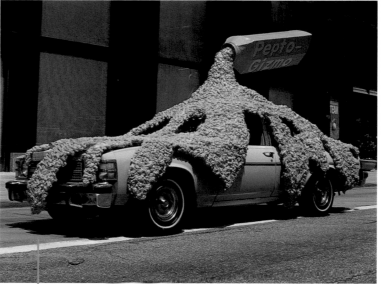

Pepto Gizmo by Sam and Nancy Jones. Created by home-schooled kids, ages nine to 16, and their art instructors Sam and Nancy Jones, this 1979 Buick Skylark was made into an art car in three weeks following months of deliberation. It is made from chicken wire and metal pipe covered by 30 cans of expanding spray foam insulation; an upright, papier-maché bottle; and Pepto pink latex paint. This art car spells R-E-L-I-E-F for anyone suffering cramps and nausea from being stuck in rush hour traffic!

Art the Lobster by A.J. Strasser. A commercial sculptor who builds permanent installations and props and sets for events, A.J. used sculpted wood, polyurethane foam, and a fiberglass shell to convert this 1986 Toyota 1-ton (.9 t) truck into a lobster. Completed in 1991 after 2000 hours of work, this vehicle was leased to Red Lobster in 1999. Due to Art's success, the Red Lobster restaurant chain commissioned A.J. to build an even bigger lobster for them named *Clawde*.

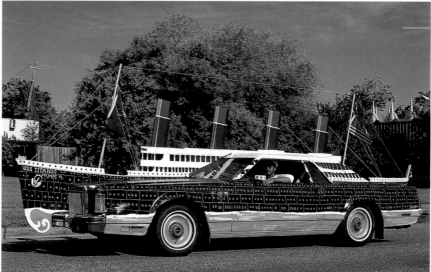

The Titanic by Rick Worth. One of the most prolific makers of art cars, Rick has more than 40 under his belt. He has been instrumental in making art cars an integral part of the Key West, Florida, island community where he lives. In response to the movie *Titanic*, he built and painted this 1974 Lincoln Continental in two weeks, using exterior gloss enamel paint. Rick's take on the art car medium: "It provides art to people who are hard to reach, who are unable or unwilling to participate in our society and culture."

Calliope the CANaloupe CANapillar, world's hairiest limo by Gustine Castle

Sunnyvale, California

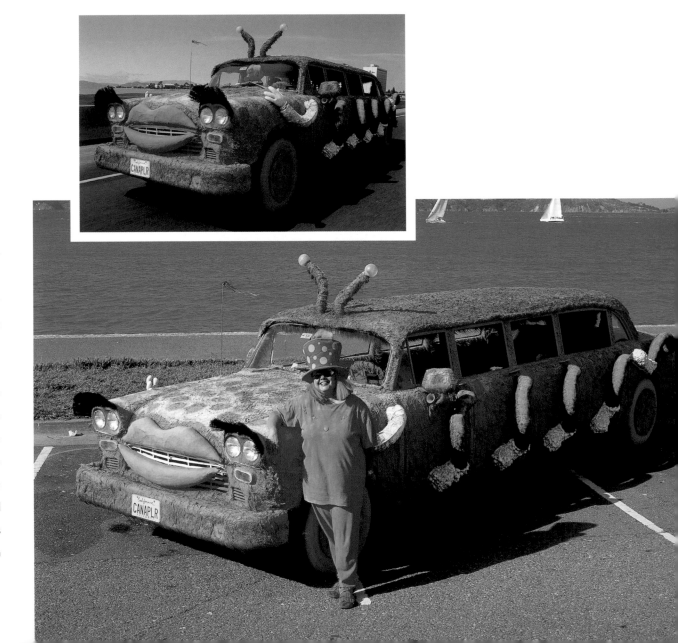

Originally a 1977 Checker Limousine made by the Checker Cab Company, this car was given a face lift in 1986 and has been looking flashier ever since. Gustine began by exfoliating the old paint and decals. Then she glued on synthetic fur and used expanding foam to build a pair of nice, full, movable lips. She attached three-dimensional drainpipe legs, with clown shoes for feet, and for the arms she used dryer duct tubing and Mickey Mouse hands. She painted the car with fluorescent road marking paint which fades quickly. As a result, she repaints the car every two weeks in the summer or every six weeks in the winter.

Calliope is a fully-operable, in-service limousine which Gustine uses for her business, Canaloupe Castle. Its larger purpose is to serve as a role model for what Gustine calls the "can-do, type C" personality. This personality is about living a happy, can-do life, maintaining optimism, and pursuing one's dreams. The type C philosophy is revealed in a TV show Gustine is creating in

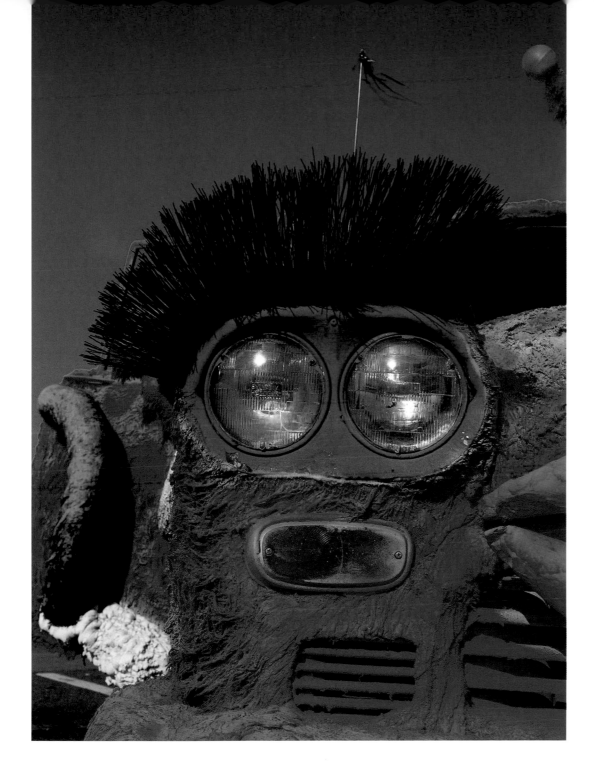

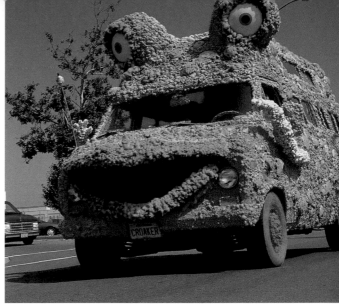

Kazoo the Can-Do Croaker, world's wartiest van CANversion

which all three of her art cars appear as characters. In the meantime she'll continue driving her dream, earning a living with her wacky limo. She says:

"I love driving passengers in *Calliope* because it shows that people are still innocent even when they grow up. You don't outgrow being a kid. I love it when men or women who are driving around in the car are waving at people and carrying on. It's like they're being children again, or rather remembering what they used to be like as kids. Just because you turn a certain age doesn't mean all of the fun is gone. Forget it! It's not too late; you CAN do it!"

Land Yacht by Eric Lamb

Rural East Texas

When is a car apparently not a car, but something else? A classic example of an art car that creates this illusion is the *Land Yacht*. This 1976 Oldsmobile Regency four-door hard top was modified by artist Eric Lamb with such attention to detail that it looks like, well, a boat. Viewers feel for a split second as if they're on the ocean, and yet there's no water! The result is a surreal and magical experience that often causes people to smile or break out laughing.

Eric most wants people to feel the sense of freedom that we all seek in our everyday lives: "For most of us, being allowed to drive our cars across the country unchallenged by governments and bands of marauding thieves is the freest feeling we ever get to experience. When the freedom of the automobile is combined with the fantasy we all have of sitting on a seashore and wishing we were out on a boat we see in the distance, away from any interruption of our private thoughts, the illusion is complete."

Eric built the *Land Yacht* in Ruidoso, New Mexico, from 1990 through 1995. The superstructure was built in the first six months from scrap lumber, and coated with fiberglass and gel coat. Then it took years for Eric to add the final touches, such as the anchor, portholes, rigging, and wood trim. The detail work is as authentic as

that of a real boat. For example, the mahogany wood trim was assembled and finished with marine-grade glue and varnish.

Once a person experiences the power, joy, and freedom of having an art car, it's very frustrating to have it taken away. One day, Eric learned that not all places support art cars or the concept of freedom of expression: "I moved my studio from Ruidoso to a small, midwestern city where many people think of plastic yard ornaments and plywood animal cutouts as outdoor art. City policy was influenced by the real estate industry and the neighborhood associations they support, and the city filed criminal charges against me, claiming that my vehicles were inoperable and were bringing down neighborhood property values. I demonstrated on local television that the vehicles were operable, but inspectors testified otherwise in court. So I'm moving to an unincorporated town in east Texas that's full of junk cars and houses that are so dumpy, realtors won't list them!"

Eric's experience shows what can happen when individual artistic expression comes in conflict with community power. It all comes down to the ongoing question, "What is art?" and the value our communities give to art. Some cities accept and define art cars as a positive phenomenon, but history shows that new artistic expressions are often met with initial resistance from the larger culture. Hopefully, the continued efforts of individual artists and enthusiasts will change public perception of art cars for the better and expand our ideas about public art in general.

Rex Rabbit by Larry Fuente

Mendocino, California

Also known as *The Bad Hare Bayou Bunny*, this 1980s-vintage VW Rabbit is the latest in a series of animal-like creations made by an acknowledged master art car artist, Larry Fuente. He is well known for his breathtakingly majestic, bead-encrusted *Mad Cad*, as well as the hilarious, traffic-stopping, bovine-on-wheels, *Cowasaki*. Revered by many as the godfather of art cars, there is little doubt that Larry has had tremendous influence on the art car medium and on contemporary art in general. Collected by the Smithsonian Museum, Larry's art is psychedelic, intricate, playful, and mystical. His art transforms everyday objects into ornamented creations of beauty and whimsy.

Carved from blocks of foam, painted with white acrylic, covered with white duct tape, and glued with synthetic fur, *Rex Rabbit* took two years to complete. Unveiled at the 1997 Houston Art Car Parade, where it won Best Art Car, *Rex* is, as Larry puts it, part lowrider, part custom car, and part art car. It has movable ears, a mouth that opens and closes, and hydraulics all the way around so that it can hop like a real rabbit and dance like a lowrider. With the push of a button, it can even drop eggs out the back!

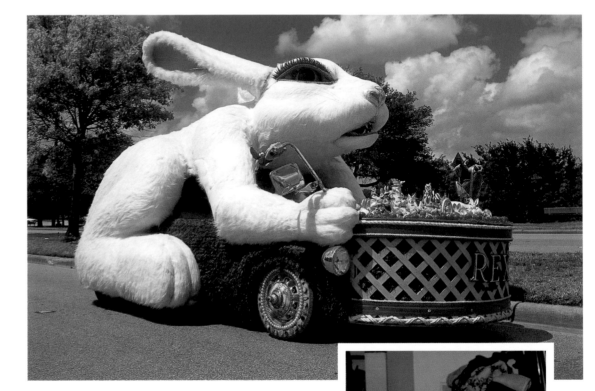

Skewing reality with its extreme manipulation of scale, *Rex Rabbit* toys with fellow drivers. Larry explains, "The most important aspect of the car is its unexpected scale. When people drive down the street, they don't expect to see a gigantic rabbit bigger than their own car. It's like in *Alice In Wonderland*, when she takes a pill and she gets small, then she takes a pill and gets big. The change in scale is what makes it all work." Never having worked with foam, Larry spent months

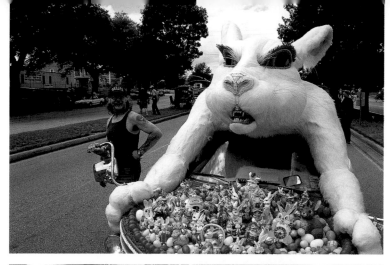

carving the foam to shape the body just as he wanted. The meticulous execution of the piece is what brings the illusion to life. Larry's consistent drive for perfection is a big part of his aesthetic, which he takes very seriously:

"The difference between custom cars and art cars is that the customs are about quality, about 100 times higher than that of art cars. The attention to detail, the craftsmanship, the craft itself in customs is highly evolved. Custom cars strive to be cool, and they are cool! My ideal is to raise the quality of my art cars to custom standards. That's one reason why my stuff is pretty good. I grew up on custom car shows. A lot of art car people are not even into cars. I love cars. I truly love cars! Custom cars are done by gearheads, whereas art cars are done by people who want to express themselves. Some art car artists are not necessarily 'artists,' they just want to

make an artistic statement. Some of them just feel lonely and want to meet chicks. The way I distinguish myself from the other art car people is that I was first. I'm perfectly willing to listen to anybody else's stories of how they were before me, but as far as I can tell, I was first."

The idea of who started the contemporary art car movement is an interesting question and is addressed in chapter 8 (page 126). Personally, I have a great appreciation for Larry's aesthetic and have learned a lot from him. There's no question in my mind that Larry is one of our greatest contemporary artists.

Ripper the Friendly Shark by Tom Kennedy

Portland, Oregon

Tom had it all. He was young, good-looking, and married, and he owned a house and pulled in a hefty annual salary from the *Houston Chronicle*. He even drove a company car. But as he edged up on 30, he began to realize that he was not living the kind of life he wanted. Although he was successful and secure, something was missing. By the time he emerged from a three-year period of soul-searching, Tom had parted from his wife, given up the company car, quit his job, and set out in pursuit of his dream of living the life of an art car artist.

His transformation began in 1988 as he watched the Houston Art Car Parade. Studying the faces in the crowd, he was struck by their smiles and wonderment. Even more stirring was the wonderment he felt inside himself. The longer he watched the zany art car drivers, the more he

realized that this was something he wanted to be a part of. Soon after, he plunged into transforming his 1982 Nissan Sentra into a primitive version of a shark car.

Built initially with a steel frame, sheet metal, spray foam insulation, and silver spray paint, *Ripper the Friendly Shark* was gradually upgraded and took on many manifestations. A streamlined coating of polyurethane resin and chrome gills have given the car a sleek, new look. Today *Ripper* is one of our most-recognized and inspiring art car icons, in part because Tom has taken the car everywhere—from Houston, where the shark has landmark status, to nearly every art car event in the country, including five Burning Man Festivals.

Like *Ripper*, much of Tom's work takes the concept of the automobile fin to new levels. There are *Max the Daredevil Finmobile*, *Dusty Dave the Dolphin* (page 8), *One Eyed Wonder* (page 131), and several fish bikes such as *Smoker Bike* (page 115). Unlike most art car artists, Tom aspires to make a career of creating art cars and concept vehicles for himself and for hire. He also wants to make a difference. He describes art car artists as "ambassadors of good will" and dreams of taking *Ripper* to hot spots like Bosnia, Israel,

and Russia. His aim? To cultivate joy and common ground with his fierce and friendly "smile machine" and to be a catalyst for interaction, perhaps even inspiring small steps towards peace:

"I know I can't change the world or single-handedly inspire people to decorate their cars. But I think that as a group, art car artists exert quite an influence and challenge people to consider new possibilities. Many people have inspired me, so it's always a gift when I hear that I have done that for someone else. One day I overheard a parent asking her three-year-old what kind of car he'd like to have someday. The child replied, 'A shark car, Mom!' That's a really cool acknowledgment that I've done my job."

Bottom: Tom Kennedy, Shelley Buschur (page 106), *Ripper*, and *Max the Daredevil Finmobile* at Burning Man Festival, 1995

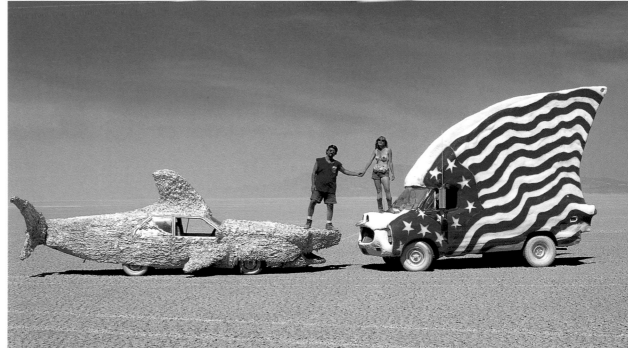

Skull Truck by Julian Stock

New Orleans, Louisiana

An experienced Mardi Gras float builder, Julian breezed through making his first art car in two and a half weeks. With the help of his friend Billy Rainbow (shown on right in photo on page 101), Julian built the *Skull Car* out of papier maché. Originally a 1980 BMW 2002, the car was hard to drive because the driver had to peer through the nasal cavity, severely limiting peripheral vision. Unfortunately, before Julian could apply fiberglass to the car, it was destroyed by a heavy rainstorm, which turned the paper to pulp.

Julian didn't make that mistake on his second art car, the *Skull Truck*, which he fiberglassed immediately upon its completion in 1995. It took him six months to complete this daily driver. The skull's design is a hybrid of different skulls, is uniquely removable, and rides atop a 1980 Dodge Ram truck. However, the skull is so important to Julian, it's unlikely he will ever remove it. Julian's passion for skulls is wonderfully evident in his art cars, with further proof in the form of a huge cow skull tattooed across his back.

"I think that the skull is one of the most sculptural forms in nature," says Julian. "Ever since I was a little kid, I've been collecting bones and skulls. When I was a boy, I went fishing near the gumbo capital of the world, Bridge City, Louisiana, and I came across a whole slaughter-yard filled with sheep, goats and cows. It was a traumatic experience to see the remains of these dead animals in piles after their meat had been harvested. As I walked farther along, I saw more corpses and piles of skulls, ripe for the picking. I picked up 30 of them, which I later sold or gave away. Skulls and bones are not a morbid thing. They're the backbone of life. They also show our vulnerability. Even though there's no life left, there's a symbol of that life that stays there forever. My art truck is part of my personality now, though it didn't start out that way. When the art car is running, it makes me feel like a rock star. When it breaks down, I'm just a mere shell of a man. In a way, I myself get reduced to a skull. The skull gives me life, and with the art truck, I give life to the skull."

Carthedral
by Rebecca Caldwell
West Oakland, California

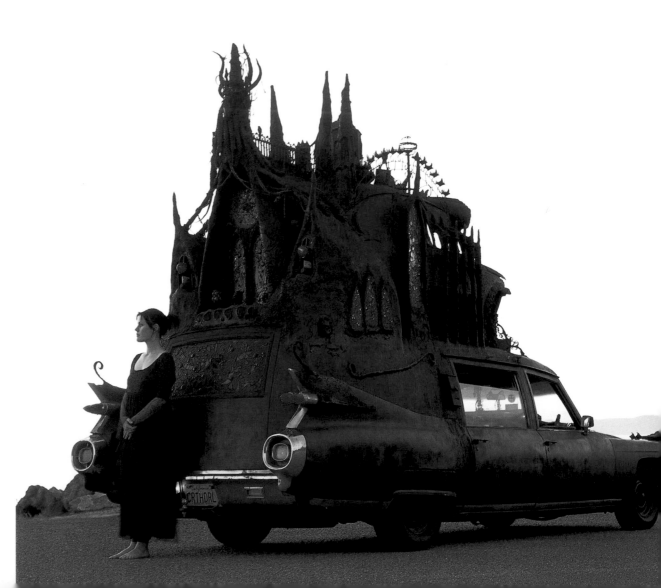

Years before she created the *Carthedral*, Rebecca thought her life lay like a red carpet before her. At 21, she believed that her purpose in life was to have children. She fell in love and began planning for a family, but her life turned completely upside down when doctors discovered that she was infertile. Devastated and disillusioned about her life's path, she divorced her husband and fell into several years of melancholy. She had her body decorated over a period of time with an elegant black tattoo. Starting just below her navel, the ivy-like design climbed up, wrapped around her body, then wound down her arm to the fingers of her left hand. She realized

later that the tattoo was a symbol of her quest for a new destiny. Rebecca discovered that her mothering instinct was a creative urge that could be channeled through art. Already a self-taught painter, she decided to go back to college and study art. She created a large body of work, mostly paintings, which were often labeled Gothic. In response to a label she considered vague and inappropriate, she decided to create something truly Gothic in every respect. While she was researching cathedrals, she came across the work of Antoni Gaudi of Barcelona, Spain, and her inspiration was born. "I fell in love with the Sagrada Familia Church in particular," she recalls. "I was totally amazed by this thing. It felt alive, unlike any building I have ever seen. I knew right away that I wanted the *Carthedral* to have that same feeling of life."

Using her 1971 Cadillac hearse as the base, Rebecca welded a VW Beetle on the top, along with various other car parts, including classic 1959 Cadillac rear fins. She used fiberglass and other materials to add many details found in traditional Gothic cathedrals, such as flying buttresses, pointed windows, gargoyles, a rose window, and a bell tower. Within the nooks and crannies, niches, and wheel wells, one can discover toy skeletons, ravens, animal skulls, cande-

labras, and a catacomb made from dozens of dental molds. Anyone familiar with Gaudi's architecture will recognize Rebecca's use of his signature elements in the items hidden around the car. Light shining through the red and blue glass mosaic of the rear window gives the inside the look and feel of a cathedral interior. Equipped with external speakers and a stereo system, the *Carthedral* plays an assortment of appropriate music such as Mozart's Requiem. With her ambitious vision expressed and fulfilled, Rebecca finally finds solace through her creativity:

"I deal with my melancholy through art. This car was something that gave me passion and a reason to get up in the morning, a reason to be excited about life. It's an obsession, and as long as I have an obsession, something that I am passionate about, I'm happy."

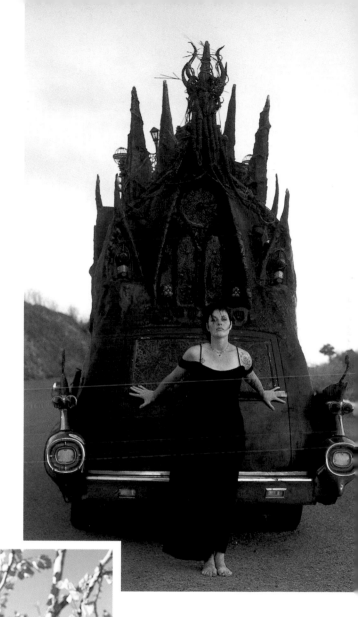

The Host by Michael Gump

Newhall, California

Michael Gump's idea for *The Host* came from his experiences as a street busker in Europe. "It was cool. I got to interact with people, and they gave me donations," he recalls. "I thought, 'Hey, this is kinda fun, but too bad this wouldn't work in the U.S. of A.' In the U.S. you need something bigger or more for sale. People aren't really prepared to pay for entertainment in the streets. Anyway, when I finally got back to the States, I devised this idea of a traveling show that sold stuff, like the old snake-oil peddler shows. What I decided to sell were 'frozen bugs,' something that hit all the senses. You can touch it, it feels different, it looks crazy, it sounds weird, it changes before your very eyes. It's a performative sculpture. I wanted to make something that was an exciting art piece, unlike any other known art, and something that anyone could afford, like for a few dollars. Then I realized I needed a vehicle from which to sell these bugs, and that was when *The Host* came along."

In 1994, Michael began putting the shell of a VW bug on top of his 1980 Chevy van. He added portholes from which he could operate hand-puppet shows, an exterior PA system, translucent Plexiglas windows for doing shadow puppetry, and of course, an interior freezer. Once the car was completed, he hit the streets looking for places packed with people. Typically, after the car attracted a crowd of people, he performed a circus show to entertain them. After his act, he sold the frozen bugs, which people bought for their novelty.

Michael also works as a toy designer and is studying to become a filmmaker. His latest art car is a black Toyota pickup truck to which he glued a single coffee cup. He claims it is his most successful, attention-getting art car yet. He calls it *Toyoduh!* As Michael explains, "Driving an art car takes you swimming in an ocean of emotions. An art car stimulates something in the people who see it. It stirs emotions, good or bad. It stirs them up like no regular car could ever hope to. Their spontaneous reactions and emotional responses are the cream in my coffee cup."

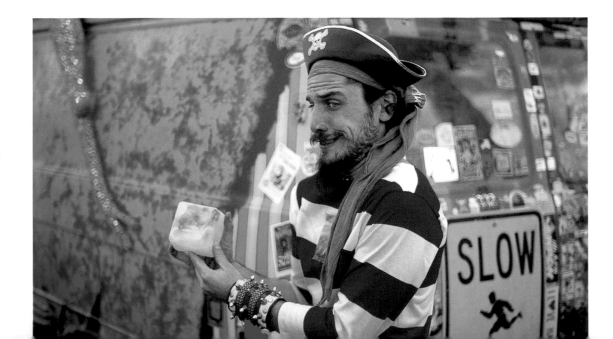

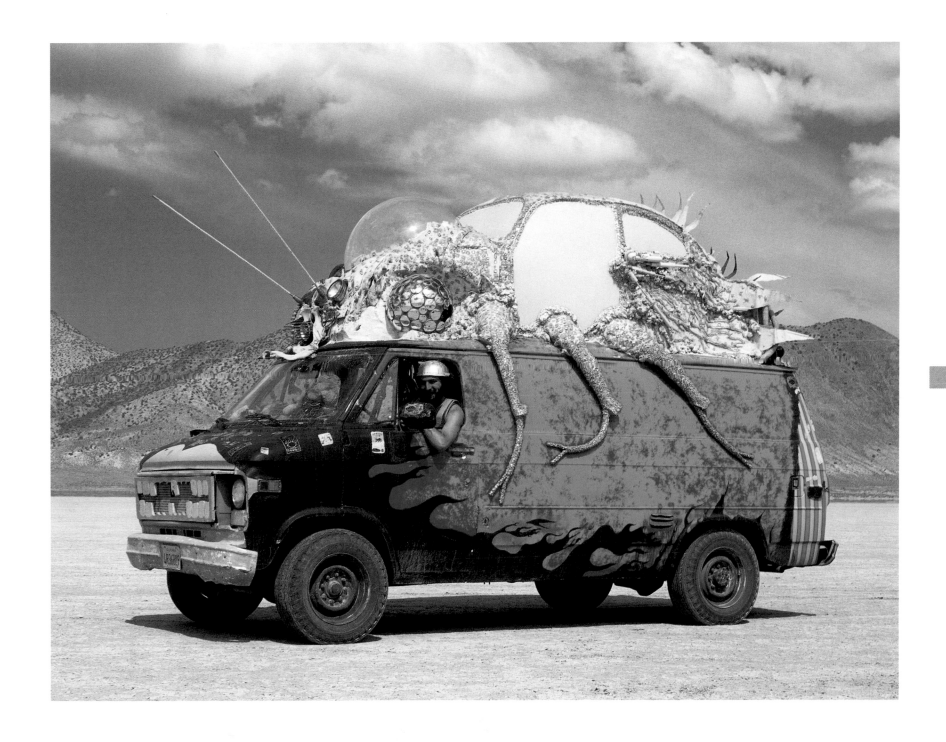

Eelvisa by Shelley Buschur

Houston, Texas

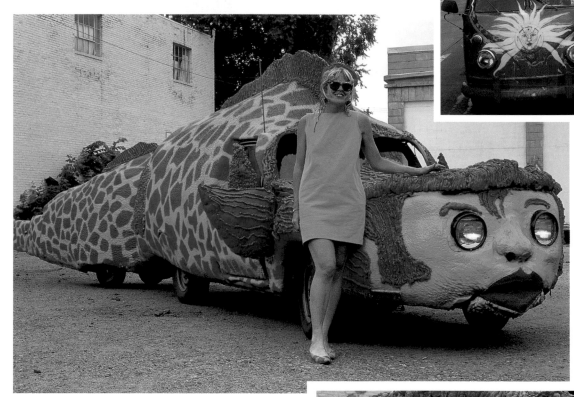

An artist who also works full-time as a midwife, Shelley expresses her creativity in ways that revolve around the feminine. This is refreshing in the art car world, which until recently has been dominated by men in their thirties and forties. Designed to break down gender and racial barriers and stereotypes, her first art car, *Planet Karmann* (page 13, top left), features nude women, painted in fluorescent colors and floating amidst stars and planets. In her second art car, *Eelvisa*, she portrays an eel with human characteristics. This car started out as a male "Eelvis," but became a punkish female Presley fan. Her latest art car, the *Temple of the Landscape Goddess*, is a painted 1967 V W Microbus featuring an interior of wind chimes and bells with which Shelley creates musical accompaniment to the passing landscape as she drives.

In addition to her art cars, Shelley creates cast silver jewelry with feminine themes, including images of birth and the female body. Recently, she even put a giant breast, surrounded by babies, on top of *Planet Karmann*. She drives her art cars on a regular basis and participates in many parades and special events. Shelley shares her ideology of the art car:

"The art car is a precious medium because of its potential for empowerment. The creation of one's own images and the alteration of one's own environment are acts of self-empowerment. Anyone with a car can have a go at making an art car. There is no particular aesthetic to be adhered to, though if the finished project incorporates some measure of absurdity, so much the better!"

The Toyboata by Matt Slimmer. In one week, using 1-inch (2.5 cm) tubing and galvanized bolts, Matt Slimmer attached a 1975 15-foot (4.5 m) Sportman boat on top of a 1983 Toyota Tercel chassis, to make this skiff fly down the highway. Inspected, tagged, and street-legal, the boat has 45,000 miles (72,000 km) on it after its first three years. "The boat car is better than a puppy dog at the beach for meeting people," say Matt. "I met my last two girlfriends with it! Art cars are about the road gallery, not the art gallery!"

Bedrock to Bartertown by Derek Arnold. This car was built in 1995 with the help of a $500 grant from the Artscape Festival in Baltimore. Derek's car is natural and organic, a mix of the past and the future. "Bedrock" refers to the prehistoric hometown of the cartoon family the Flintstones, and "Bartertown" comes from the futuristic Mad Max movies.

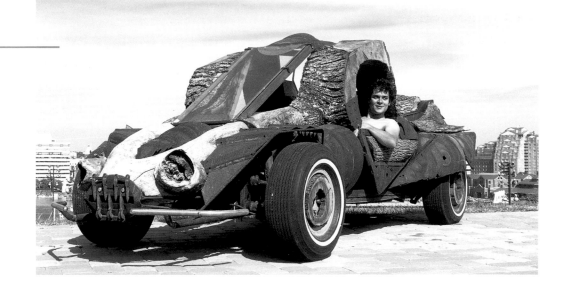

The Red Car by Wayne Koscinski. Stripped of its body and rebuilt with tree branches and bailing wire, this stick-figure of a car features a spinning wheel of mirrors that rotates while the car is driven. Wayne, an artist in Baltimore, likes to hold onto the wheel while the car is parked. It spins him around, providing a surreal, carnivalesque atmosphere. Unfortunately this 1981 GLF Subaru was taken to the junkyard just as this book was being written.

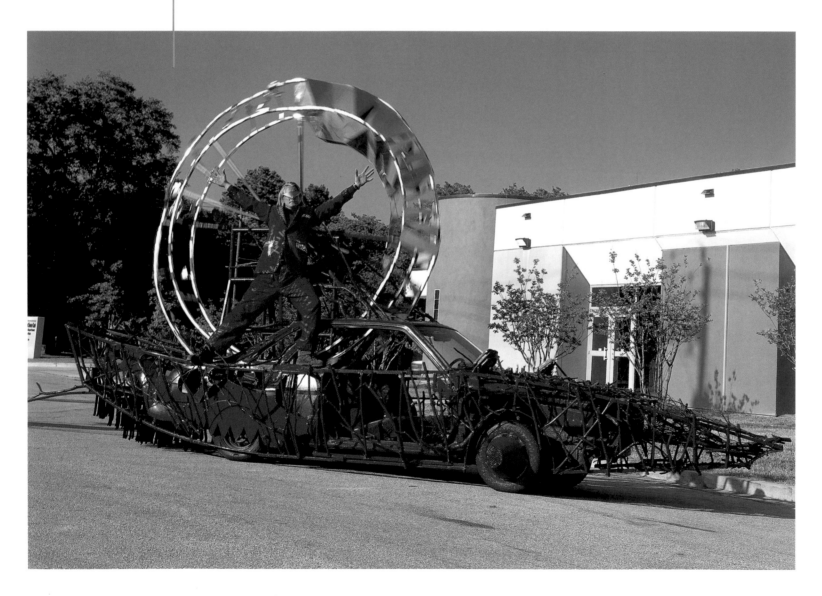

Casa Linda Lace by Rafael Esparza-Prieto and Jose Barajas

Montecito, California

Rather than adding things to his vehicle, Rafael Esparza took a lot off! *Casa Linda Lace* is considered the finest of about 20 similar wrought-iron VWs created by Rafael (shown on left in the photos). He crafted it with particular care for his friend Jose Barajas, who commissioned it. Rafael hails from Aguascalientes, Mexico, and made his first wrought-iron VW for his boss at a Volkswagen plant in Zacatecas. The satisfying process encouraged him to make the others.

Rafael constructed the car in 1985 over a period of four months in Jose's garage. Using only a heavy hammer, anvil, and ½-inch (1.3 cm) iron rods, Rafael pounded and shaped more than 2,600 floral and curlicue designs. He hammered each of the small curls at least 50 times and spot-welded the pieces together. The car was unveiled in front of Jose's Mexican restaurant, *Casa Linda* (thus the car's name) and remained parked there for most of the next eight years, making the restaurant in Montecito a local landmark.

What's especially interesting is that as this car was being built, Joe Gomez was making his beautifully gilded *Wrought Iron VW* in San Antonio, Texas. Both men claim that theirs is the best and the first. That two people could have such a far-out idea and execute it totally independently of one another indicates that art cars are not a fluke, but rather a dynamic part of our culture and history.

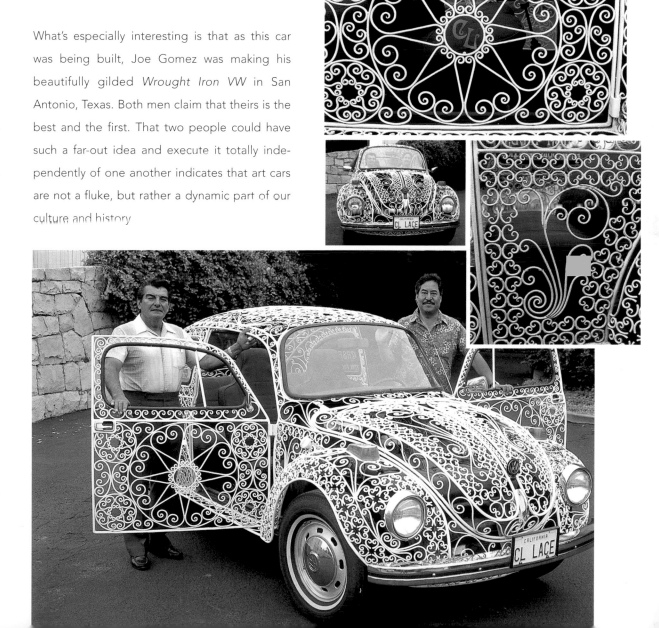

Radio Fiyer Wagon by Bob Castaneda

Oakland, California

A hot rod enthusiast, Bob considers his work a combination of hot rod and art car. In 1996 Bob and his cousin Art Baker custom-built this wagon with a tubular frame, a Chevy engine, and Chevy running gear. It was designed so that the wagon could be easily lifted off the chassis and other bodies put on it, such as a coffin Bob made. One of the faster art cars, it can travel at 80-plus mph (128 km) before it starts getting the shakes. Though the car isn't street-legal because it lacks a windshield, Bob likes to drive it for the thrill whenever he can. He explains:

"More than building the car, I like showing it off because it always makes people smile. When I drive it down the street, people look at it. At first they're shocked, and then they smile. Always. I get a lot of stories from people who had wagons when they were kids. Lots of people! A lot of people pull their kids around in wagons instead of strollers. One woman in her mid-70s told me that when she was born, her father bought a wagon and pulled her around in it. She still has it and says that it's her most-prized possession. She fell in love with the car instantly. Some kids go nuts, and they really want to ride in it; others are afraid of it. I have this car because I like to have fun. I'm adventurous. Like other artists I do this partly for the attention. It's amazing to ride in!"

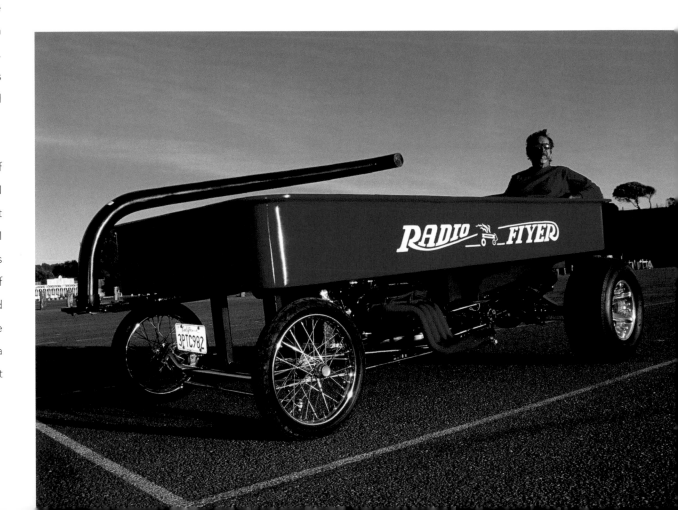

Table Car by Reuben Margolin

Berkeley, California

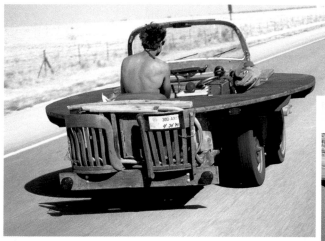

Top right: Reuben and friend Eric Freitag (right) working on *Table Car*

After graduating from Harvard with a degree in English literature, Reuben wanted to try his hand at writing. He came up with the idea of making an art car shaped like a round table. He would drive the table all over the world and encourage conversations with people, giving him something to write about.

Reuben designed the windshield to fold down and become part of the tabletop, and the back of the car carried four wooden folding chairs. He crafted the chassis from a VW Beetle with a section cut out. In April of 1995, with a manual type-writer on board, he set off from Berkeley to his first destination, the Houston Art Car Parade. Due to the shortened wheel base, the table was

slightly unstable. When the car traveled over 50 mph (80 km), the front end actually began lifting off the highway. Exciting to watch, but it was truly frightening to ride in!

After the parade, Reuben continued his own journey, during which he learned that art cars invite the same questions repeatedly, and it drove him nuts. The inspiring conversations he was hoping to have around the car turned out to be about the car itself. "So why are you driving a table?" "What is this for?" "Why'd you do this?" After about a month, he became disillusioned with the project and abandoned the car in a cemetery outside Austin, Texas.

Reuben hasn't made any other art cars since, but he's tried other experiential projects such as hitchhiking cross-country with a 200-pound (90.8 kg) anchor chain. He also recently designed and built an incredible battery-operated, six-foot-long (1.8 m) wooden caterpillar that moves just like a real one. Of course, it elicits its own gamut of questions!

Telephone Car by Howard Davis

Avon, Massachusetts

Ever since he was a boy, Howard has been curious about telephones. At age eight, he was taking them apart and putting them back together. By age 12, he was removing all the elements of a phone and mounting them onto pieces of fabric-covered plywood to expose the way the phone functioned. In high school, he began making "art phones" by turning generic objects into phones. He made a parking meter phone, for example, in which money would have to be deposited to make a call. Around the same time, he began searching flea markets and yard sales for other unusual phones.

Enthralled with the magic of phone technology, Howard was determined to become a telephone repairman. Despite his parents' disapproval, he didn't go on to college but started working for a telephone installation and repair company instead. After a few years, Howard decided to start his own communications company, despite the fact that everyone thought he was crazy because AT&T controlled the entire marketplace. Over the years, his company, Datel Communications, grew into one of the largest Toshiba telephone distributors in the Northeast.

Howard's excitement for phones remains strong. "When I come across an old telephone that I don't have, I can feel this adrenaline pumping, and I know that I have to find a way to get it," he says. "I have a large collection of telephones, over 3,000, in fact. I have telephone-related items, too, like phone booths, military remote phones, and one-of-a-kind prototypes; anything imaginable with phones, I've got it. I have telephone cuff links that I wear to work and over 20 different neckties with phones on them. The phone system I have set up in our house is bigger than most businesses have. I have about 35 phones, so when we get a call, all these distinct rings go off. It makes getting a phone call kind of fun. Before my wife and I got married, she enjoyed the phones but I don't think that she really knew what she was in for. After we got married, well, she just sort of tolerated them. She still enjoys surprising me with a phone that I don't already have. My kids enjoy my obsession, too. They all have several phones in their rooms, which a lot of other kids don't have."

With such a passion for phones, it's no wonder that Howard would one day dream of driving one. Once the idea came to him in 1983, he had to do it, and it took two years. He and a long-time employee, Stephen King, started by stripping a VW bug down to its chassis. Using the

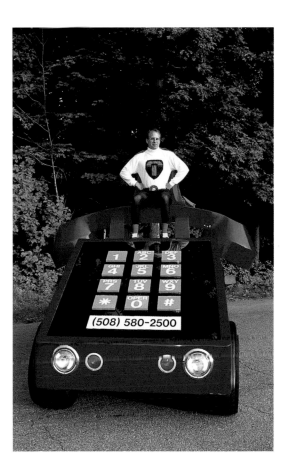

dimensions of a standard desk phone, they constructed a blown-up replica out of welded aluminum. After the replica was bolted to the chassis, the aluminum body was sanded, prepped, and painted professionally. The car features a windshield made of smoke grey safety glass, a microphone, and an external speaker system. The car can travel at about 50 mph (80 km), making it the world's fastest phone. Predictably, when the horn is pushed, it rings!

trikes and bikes

Since 1989, when I first began documenting art cars and their makers, I've often come across other interesting characters along the way, such as visionary artists, obsessive collectors, and people who made art trikes and art bikes. Since my focus was always on art cars, I didn't begin seeking out and documenting these other characters until about five years later. I became an obsessive collector myself, gathering imagery of these like-minded folks, getting to know them, and forming a patchwork of eccentric friends all across the country.

Though the focus of this book is art cars, art trikes and motorcycles are included because they share the same highways. I personally have never driven a motorcycle or even been to a motorcycle show, so my exposure to them has been limited. I have learned that one key issue with art trikes and motorcycles is that they need engines with good ventilation. This requirement can actually limit the design and performance of a vehicle. I did have the opportunity to ride on the back of Crazey Blazey's chariot-like *Tricula* (page 115, bottom). What's interesting about rid-

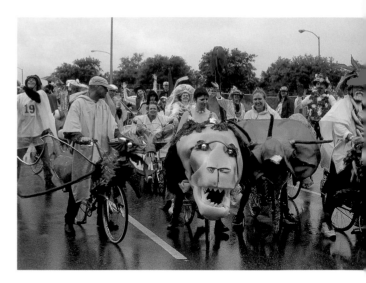

ing on an art motorcycle or trike is that the driver is more exposed and thus more of a part of the piece and performance. Blaze often dresses the part by wearing a silver body suit, a big black cowboy hat, and glittery glasses, as if he's a futuristic chariot driver.

The affordability and accessibility of the bicycle makes it an ideal canvas. With its ease of mobility and great public exposure, an art bicycle can have the same impact as an art car. Additionally, one can reap many of the same rewards without polluting the environment and stay in shape at the same time. And, most important, with bicycles, people of all ages can enjoy the art vehicle experience.

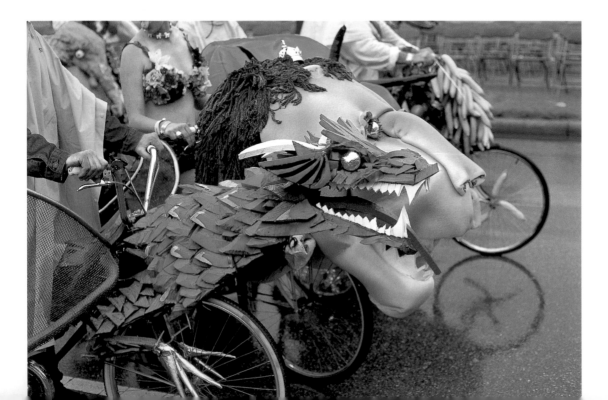

An inspirational group of St. Louis artists/bicycle enthusiasts formed the nonprofit Banana Bicycle Brigade (page 114), which encourages children and adults to make art bikes and conducts educational workshops. Composed of more than 30 members with their own art bikes, the Brigade participates in parades and festivals all across the country. Its mission statement reads, "To be a children's charity that brings out the creative child in everyone!"

Most art bikes are not ridden every day but are used for special occasions, parades, and festivals. However, there are exceptions like James Bright and Chris Wilson, who ride their art bikes, JB Mobile 2000 and Mean Green Machine (pages 116 and 117) on a daily basis. For them, the bikes are extensions of themselves and their ideology. They are their bikes. On the other end of the spectrum, fantasy bikes that conjure up illusions of other things, such as Tom Kennedy's shark-like *Smoker Bike* (top right), tend to be more difficult to ride but are extremely entertaining to an audience. As with art cars, art trikes and bikes add vibrance and creativity to the otherwise banal streets of normalcy. Ride on!

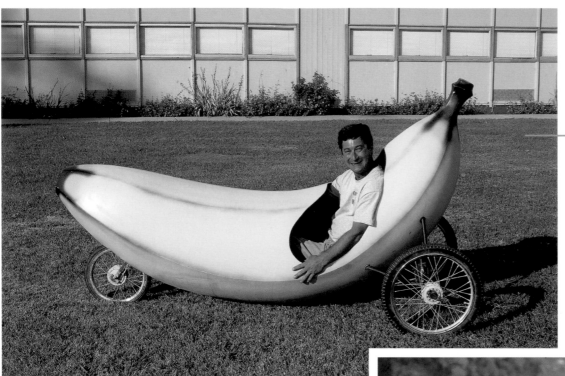

Banana Bike by Terry Axelson. Terry used bicycle and moped parts and fiberglass to construct this banana, which was originally an assignment for his beginning sculpture class. It can be pedaled, powered by a moped engine, or both. It was entered in the first-ever Artist's Soapbox Derby put on by the San Francisco Museum of Modern Art in 1975.

JB Mobile 2000 by James Bright. Started in 1980, this bike features more than 100 lights, a stereo system with loudspeakers, a car alarm, and hand-painted pictures of Malcom X, Martin Luther King Jr., Mother Teresa, Princess Di, the Statue of Liberty, a Native American, Laurel and Hardy, and others. James says, "My bike is my hobby. It is something that I and other people enjoy looking at. Whatever you can do to a car or a motorcycle, you can do to a bicycle!"

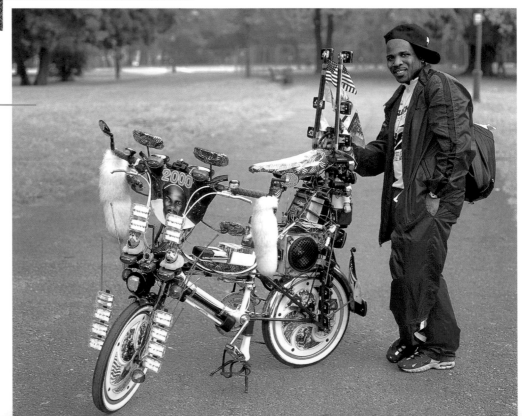

Mean Green Machine by Chris Wilson. Gold glitter designs and emblems of Heineken beer and the New York Yankees set this bike apart from all others in Brooklyn and beyond. Entirely hand-built by Chris since 1981, this bike has many accessories, such as a stereo and car alarm cleverly camouflaged in watertight compartments. "My bike is my transportation," says Chris. "I don't have a car. It's a form of expression for me, made for me only, not for anybody else. It's adapted to me, and I've adapted to it. It's like a part of me."

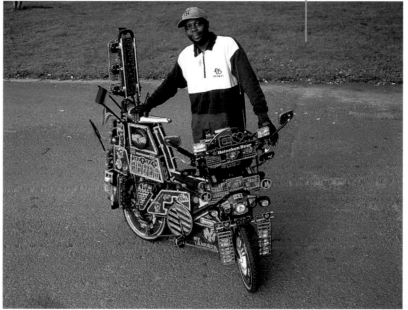

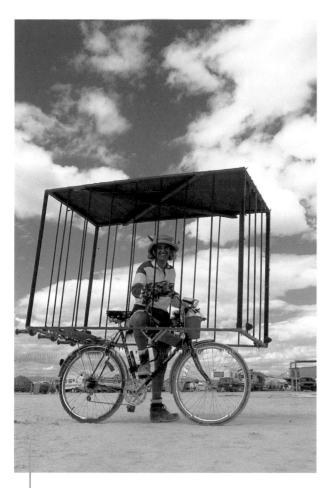

The Cage-Bicycle by Natali Leduc. This self-powered mobile prison questions one's freedom in society. Who is behind the bars? The one who rolls inside a cage or the one who stands outside? Who is more free? After all, one is not very different from the other, except that you can feed the artist in the cage!

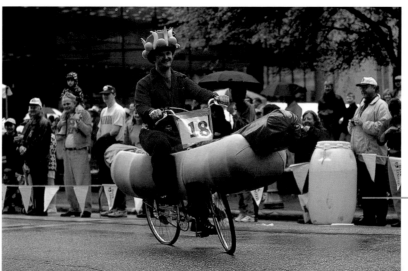

Hot Dog Bike by Chris Koehler. A member of the Banana Bicycle Brigade, Chris has befriended many unusual characters with similar interests, including Frank Webster, hot dog collector and curator/owner of the Hot Dog Hall of Fame, and Harry Sperl, creator of the *Hamburger Harley* and founder of the Hamburger Museum (page 122). Chris's very popular bike is shown here in the 1997 Houston Art Car Parade.

Giraffe Bike by Jon Jung Echols. After a friend welded a female bike onto a male bike by joining them at the seats, Jon tried to ride it, but it would flip over backwards. To balance it, he decided to make it into a giraffe so the front end would be heavier. A member of the Banana Bicycle Brigade, Jon watched giraffes at the zoo for hours to get the proportions right!

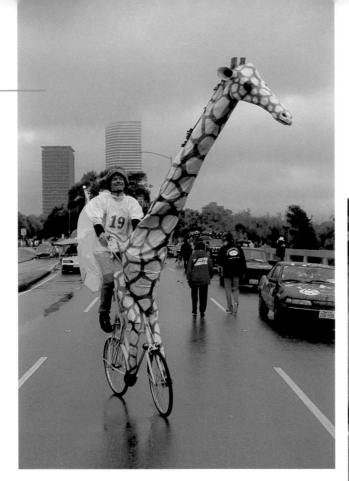

Trysanasaurus Rex Bike by Karen Redel. A member of the Banana Bicycle Brigade, Karen designed this bike to amuse children with its mixture of dinosaur parts. It is made of foam rubber and PVC tubing. Only the head is pictured here. Including the body, the overall assembly is 25 feet (7.5 m) long.

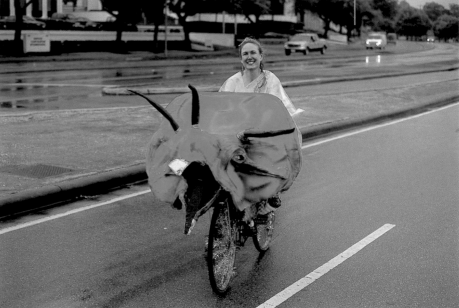

'57 Bike-Air by Frederick Stafford. Inspired by his wife Pamela's love of the 1957 Chevrolet Bel Air, Frederick created this bike for her. She has appeared with it in the 2000 Houston Art Car Parade and uses it whenever they ride bikes. They have thus deemed it a "regular rider"!

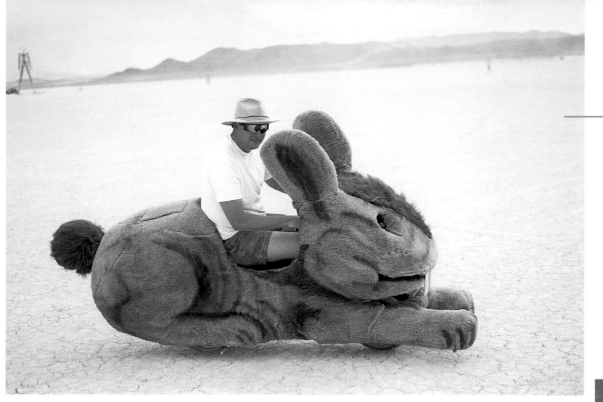

Rabbit Scooter by Keith Dunlop. Inspired by the art cars he saw at the Burning Man 1994 festival, Keith, who works in construction, framed this rabbit on a scooter and debuted it at the following year's festival. Due to its popularity, he was encouraged to make yet another art scooter the next year.

Aardvark Scooter by Keith Dunlop. Built as a two-seater to allow Keith's wife Laura to copilot, this termite eater will do 60 mph (96 km) and has a luggage trunk, stereo, and more than 3,500 highway miles (5600 km) on it. Keith claims that he rides it so often it's become part of his persona. He's now referred to by people in his community as "the aardvark guy."

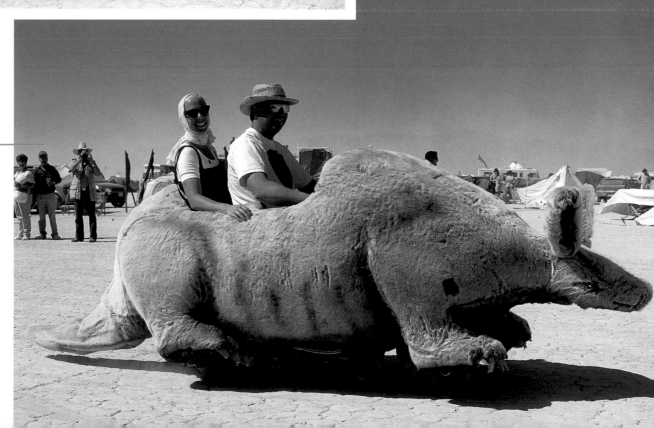

Guitcycle by Ray Nelson

San Jose, California

Built from a 1980 Yamaha 650cc and featuring a sound system that broadcasts guitar music, the *Guitcycle* combines Ray Nelson's passions for motorcycles and music. "I was playing music full-time when I got the initial idea in 1971," Ray recalls. "I had a drawing done of a guitar over a motorcycle and used that on an album cover of motorcycle songs that I recorded. At that time, I was known as the number one singer of motorcycle songs."

Ten years later, Ray decided to build the *Guitcycle* to draw attention to his band. He constructed the bike by first measuring the dimensions of the motorcycle to determine what size to make the mold of the guitar. Working with two 4 x 8-foot (120 x 240 cm) sheets of plywood and 100 pounds (45.4 kg) of plaster, he cut and formed the two sides of the mold on the floor of his garage. Next, he covered the pieces with candle wax, over which he placed layers of fiberglass cloth and resin until it was about 1/4 inch (6 mm) thick. He then bolted the two pieces together over the motorcycle frame and sanded the shell. In the last step, a friend gave it a professional spray of several coats of lacquer.

After Ray's band broke up, Ray started using the bike to promote Guitars Not Guns, a nonprofit charity he founded to put guitars in the hands of needy children and to provide guitar lessons. Ray hopes to encourage famous guitarists and manufacturers to support the program.

At this point, Ray has put more than 60,000 miles (96,000 km) on the *Guitcycle*, having ridden it from coast to coast in 1982 to promote his band. He appeared in the syndicated cartoon *Ripley's Believe It Or Not!* for this feat, and is currently planning another trek for 2002 to muster support for Guitars Not Guns.

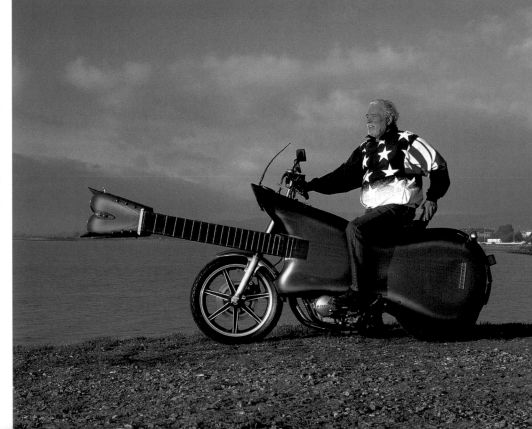

Rocket Cycle by Scott McNamara

Petaluma, California

At age 12, Scott was very moved by reading *Mad Magazine* features about delivery trucks designed to resemble the products they delivered. Fifteen years later, stuck in stop-and-go traffic on the Golden Gate Bridge, he began to fantasize about how cool it would be if he could be on top of a rocket and blow past everyone. Part of his desire was to shake people up and wake them from their trances as they drove to work.

A successful model maker at a special effects studio, Industrial Light and Magic, Scott had the skills and experience to build his vision. When someone gave him a motorcycle, it was the project's catalyst. When he began planning the details, the biggest question was how he would sit on the cycle. He decided on a saddle and found a used one that worked perfectly. The rest of the bike came together fairly easily, although it did take more than a year of working on weekends to complete. But Scott discovered the bike had unanticipated effects:

"Making the *Rocket Cycle* fulfilled my dream of wanting to build something like this. But the reality of having it now is that I'm really not that comfortable with the amount of attention it gets. That's why I keep it in the garage. I'm really a shy person. Part of me wants to kind of shake people up and be outrageous, but a bigger part of me doesn't want to be the center of attention. This bike makes almost everyone look at *me*. I like people to look at the bike, but not at me on it so much. It's definitely not part of my identity, nor does it match my personality that well. I'm glad I did it, though!"

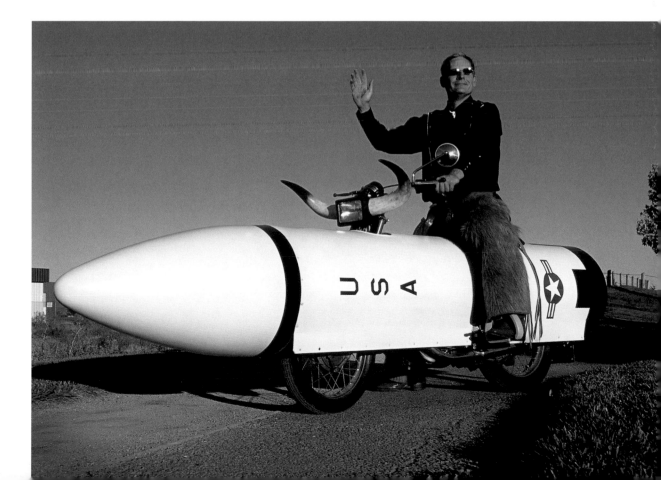

Hamburger Harley by Harry Sperl

Daytona Beach, Florida

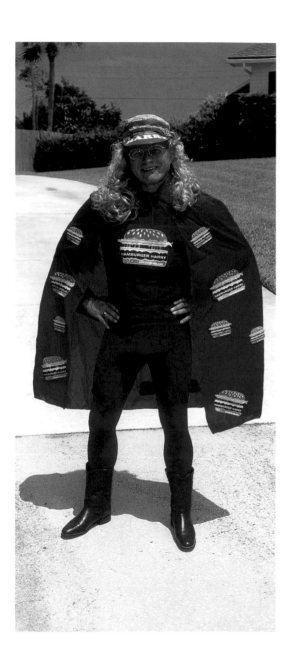

Born and raised in Germany, Harry was fascinated by American TV shows and dreamed of one day going to the United States. When he was 25, he hitchhiked all over the States, finding its geography, people, and culture so fascinating that he knew he would immigrate there one day. He loved Florida's beaches, warm climate, and its proximity to Germany, ultimately moving there in 1987.

Harry began a successful business, Cruising International, that sold memorabilia and novelty items such as license plates, belt buckles, and key chains. On the side, he developed a unique hobby that reflected his passion and love for the hamburger. For Harry, the hamburger is an American invention and definitive icon that represents his own American dream. Harry has assembled a tremendous collection of thousands of hamburgers and hamburger-related items, including a giant hamburger waterbed, a hamburger phone, and the ultimate hamburger creation of all, his $100,000 *Hamburger Harley*.

To build his dream based on a Harley Davidson trike, Harry consulted many designers and friends. The trike features a bun that uses hydraulics to open and close. Inside the top bun is a door that slides back and forth, allowing the rider to get in and sit comfortably. The trike also has a built-in smoke machine that expels hamburger or bacon smell, and will soon feature the sound of frying hamburgers. It comes complete with a tray that holds speedometer and odometer "milkshakes" and a basket of burger and fries to go. Harry really enjoys driving his ultimate hamburger fantasy:

"I like it when everyone asks me, 'Why?' They have to know why. I don't know why. Why do I collect hamburgers? Because I like hamburgers," says Harry. "I want to surround myself with items I like. I like to wake up and look around me and see my collection of hamburgers. I surround myself with pleasure, and I am feeding myself mentally. When I look at my collection, I'm just like a stamp collector who gets out his stamp album and looks at his collection over and over again. I am also an inventor and an artist, and I create things that weren't here before. Creating something from scratch and watching it develop makes me happy but not totally satisfied. When I

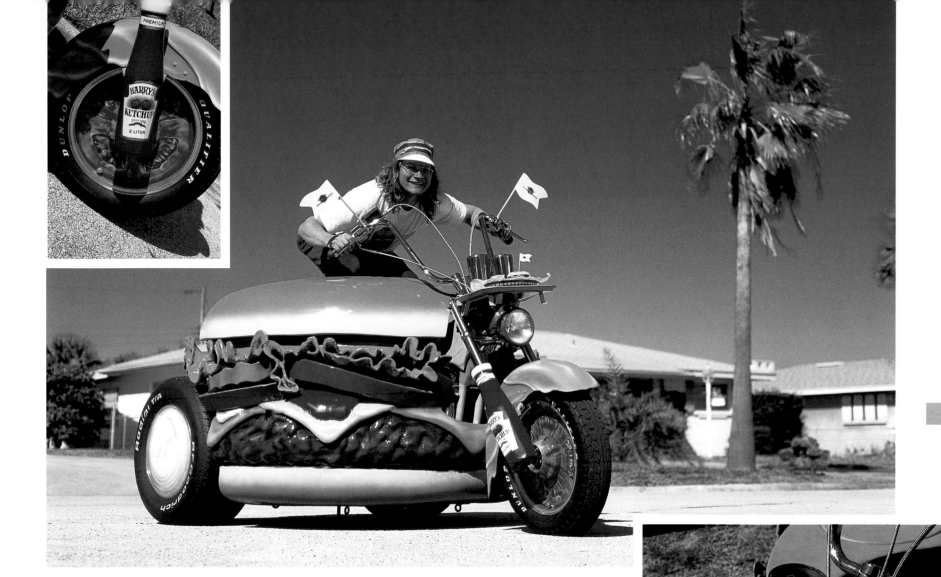

complete it, then I become completely satisfied. My dream now is to make the Hamburger Museum shaped like a hamburger, and it will contain my entire collection of hamburgers and even more. The museum will need to have a roof that opens so that I can fly my Hamburger Helicopter in and out. I will also have a Hamburger Parachute in case I need to jump and a Hamburger Hot Air Balloon. Almost everything in my collection and in my business and my dream relates to America and my love for it."

Red Stiletto by David Crow

Seattle, Washington

David Crow's *Red Stiletto* was born out of a domestic argument. "One day, my ex-girlfriend, Cyd, came home with three pairs of shoes from Nordstrom," recalls David, also known as Crow. "Without thinking, I made a sarcastic remark like, 'Jeez, who do you think you are, Imelda Marcos?' but she saw no humor in that. She was offended because she felt that she deserved the shoes due to a promotion at work. A heated argument ensued, and it left me wondering just what clothing means to women. I had seen a lot of closets belonging to women, and I knew there were a lot of shoe fetishists out there. Then I thought about my own passions and fetishes. I was a hot rodder and I loved cars. I mean, some of my motorhead friends were so hot with machine lust that they would look through an automotive catalog like it was *Playboy* or *Penthouse*! The more I thought about it, I realized that my fetish for cars was very like her fetish for shoes. Then the idea just hit me: Wouldn't it be cool to combine the two images and make a motorized red stiletto!"

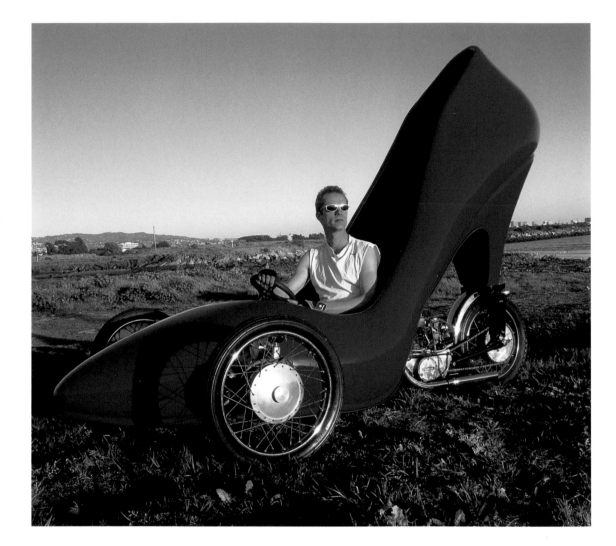

In 1994, Crow began fabricating this high-heeled shoe trike from the ground up. He used a 1972 Honda CB 350 motor and running gear and created an alloy tubing dragster-style frame, integrating the fiberglass shell of the shoe. He has made every attempt to bring his creation to custom-car levels of paint, chrome, and finish, and he claims that he still has more to do. He considers the trike a combination of art car and custom car, and it excels in both categories. Crow debuted the trike at the 1997 ArtCar Fest in San Francisco, and in 1998 he won the prize for Best Art Car in the Houston Art Car Parade. Pleased with his accomplishment, Crow reflects on the image:

"All cars express a level of social or sexual prowess to varying degrees. People tend to wear their cars as a sort of third skin. Cars have names and attitudes cultivated through advertising to try to emphasize this fact. My car is more of an overt statement about that fact. When you look at representational visual art, you usually see this blending or combining of metaphors. Maybe that's how we try to make sense of things or to find a new meaning. I was not anticipating such public response to the image, but some people feel I have achieved my goal to make the sexiest car ever!"

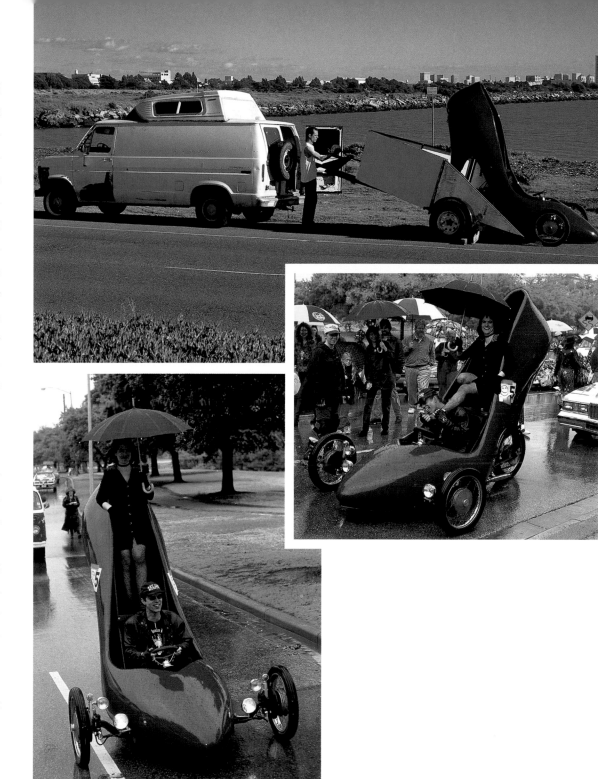

inspiration and influences

Throughout the history of transportation, there have been decorated, customized, one-of-a-kind vehicles. From early decorated Gypsy wagons, to slogan-covered cars, to the painted buses of the 1960s, to lowriders, hot rods, and custom cars, to concept vehicles by George Barris and Big Daddy Roth, monster trucks, and even race cars, all represent the prevalent forms of automotive expression. Decorated vehicles have also been an integral part of various cultures around the world, such as taxis in Haiti and the Philippines, buses in Mexico, and trucks in India, Pakistan, and Afghanistan. All of these forms of automotive design and alteration could be said to have influenced the contemporary art car movement. However, there are a few, more direct influences that deserve acknowledgement.

The first contemporary art cars appeared in the 1970s and '80s. Most of their makers did not know of any others working in the medium and just started creating on their own as if in a vacuum. Most did it out of a need for personal expression, and their cars became their canvases. Many people started making art cars around the same time all across the country. Why? Possibly some were rebelling against the omnipresent Big Three automakers. Some were moving out of the hippie "we generation" and into the contemporary "me generation." Maybe other people were simply improving their aging vehicles' appearances. Whatever the reason, early art car artists played an inspirational role, setting the example that decorating one's car was a possibility.

A few scattered exhibitions featuring a small number of art cars were held in the late 1970s to mid-1980s, and they are considered to have been instrumental in the genesis of the art car movement. One of the earliest organized art car events was actually a miniature-vehicle contest, the 1975 *Artist's Soapbox Derby* put on by the San Francisco Museum of Modern Art. Out of that event came a group of inspired artists, including Larry Fuente, Dickens Bascomb, Mickey McGowan, and David Best. Some of these men collaborated on several glue cars until each broke off on his own. Dickens Bascomb became a recluse in the Philippines, and Mickey McGowan created the *Unknown Museum*, a collection of 100,000 pop-culture artifacts in his home in San Rafael, California. Larry Fuente and David Best went on to become art car stars.

It was, however, during the mid-'80s that art cars really began to break out. Art cars were incorporated into the 1982 Krewe of Clones Mardi Gras Parade in New Orleans. The 1983 *Collision* exhibit, curated by Ann Harithas (who later founded the Art Car Museum with her husband, Jim), took place at the University of Houston and inspired the Houston Art Car Parade. In 1984, several art cars were exhibited at the Temporary Contemporary Art Museum in Los Angeles.

The next big development in the popularization of art cars came in 1988, with the emergence of the Houston Art Car Parade. Consisting of 10 to 15 art cars, this first Houston parade was produced and organized by Susanne Theis and the Orange Show Foundation, which protects, teaches, and encourages folk and visionary art. The parade continued over the years, energized by

Clockwise from top left: *Mobile Phone* by Mark Bradford, Houston Art Car Parade, 1999; *Duck and Cover* by Guy Seven, Houston Art Car Parade, 1993; ArtCar Fest, San Francisco, 1998; Houston Art Car Ball, 1999

the passion of foundation director Susanne Theis. I met Susanne following this first parade. We became good friends, and by sharing information, essentially doubled our respective knowledge of art cars, which helped in the real-

ization of *Wild Wheels* and the growth of the parade. The parade expanded exponentially each year, featuring nearly 250 art cars and 125,000 spectators in 2001. This event has inspired hundreds of people to make art cars and attracts an annual pilgrimage of artists, such as those who formed the art car caravan from the West Coast.

In the early 1990s, I organized several art car caravans to Houston, and later, Philo Northrup

(page 86) took over the helm for a few years. In contrast to events that draw spectators, an art car caravan brings a mobile exhibit to the public. It's surprising to see a single art car in the context of everyday life, but seeing a group of 30 to 50 art cars come down your street can be mind-blowing and liberating. Like a circus that's just dropped out of the sky or a Fellini film on wheels, the caravan, with all its explosive vibrance, unique range of noisemakers, and contagious zaniness, parades through small towns across America, evoking from viewers one question: "What the *hell* was that?!" Leaving excitement and bewilderment in its wake, the art car caravan inspires a public that otherwise might never have been exposed to art cars. Of all art car experiences, the caravan is my personal favorite and an unforgettable adventure!

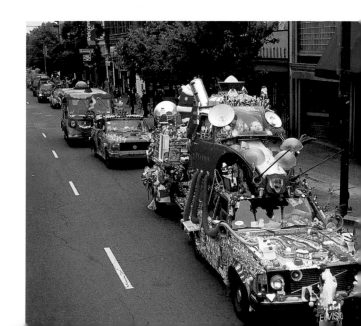

In 1995, Philo Northrup and I teamed up to produce and coordinate that year's caravan to Houston. We worked well together and realized that we shared the philosophy that art cars should not be like parade floats, but were most powerful when driven on a daily basis. We decided to form our own West Coast event, featuring daily-driver art cars. In 1997, we co-produced the first ArtCar Fest, which has since become an annual event. It features a parade, a local caravan around the San Francisco Bay Area, an exhibit of art by the art car artists, an art car film festival, and an alternative fashion show. The event attracts 80 to 100 art cars and 50,000 spectators.

Many other art car events were formed in the mid-1990s. By providing legitimate venues for showcasing art cars, they celebrated the medium as a whole and encouraged the creation of more art cars. In Houston and San Francisco, for example, art cars have come to flourish. Other cities with established annual art car events include Minneapolis, Baltimore, and Seattle. Many cities have significant numbers of art cars but haven't yet sustained an annual event, including: Portland, Oregon; St. Louis, Missouri; New Orleans, Louisiana; Los Angeles and Santa Cruz, California; Chicago, Illinois; Dallas and Austin, Texas; Key West, Florida; and Bisbee, Arizona.

Also instrumental in the proliferation of art cars in the 1990s was the annual Burning Man Festival. This alternative arts festival, held in Nevada's Black Rock Desert, attracts a variety of artists whose work is rarely exhibited because it includes unconventional elements such as fire, nudity, or large scale. The event encourages eccentricity, individuality, and cutting-edge artistic expression. After attending for the first time in 1993 and finding it an ideal venue for art cars, I returned each year thereafter and organized an annual art car theme camp.

Art car education and exhibitions also took root in the early to mid-1990s. Rebecca Bass, a high school art teacher in Houston, was the first to organize the creation of an art car as a class project. Inspired by the local parade, Rebecca's students have made a different, fantastic, wheeled wonder each year since 1991. Testaments to Rebecca's teaching, cars made by her students frequently win the grand prize award in the parade.

Permanent exhibitions of art cars, open to the public, have been established at the Art Car Museum and the Art Car Park in Houston, and most recently at Art Car World in

Clockwise from top left: Stan Lemkuil, *The World's Loudest Man*, performs at ArtCar Fest, San Francisco, 2000; Charles Hunt and *The Grape* at Burning Man Festival, 1996; Burning Man, 1995

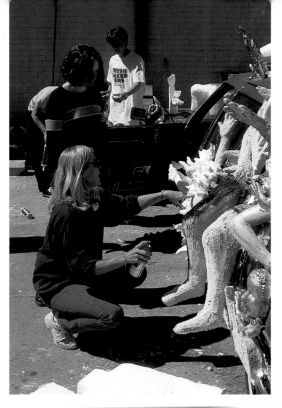

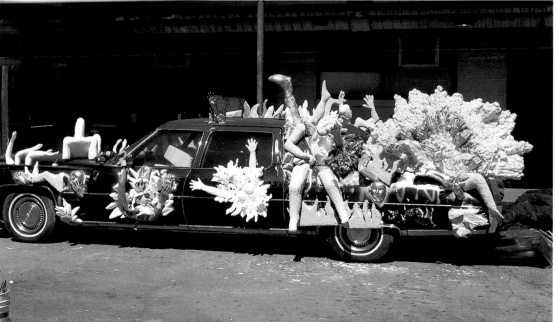

Clockwise from top left: Instructor Rebecca Bass and her Bellaire High School students at work in Houston; Rebecca; the students' *Hot Time Summer in the City* in progress, 1998

Walnut Grove, California. You can also find virtual exhibitions on the Internet. See page 142 for a listing of some Web sites; doing your own search will produce even more.

Since the 1990s, art cars have appeared in a multitude of TV shows, films, books, newspapers and magazines, both domestically and internationally. Some 55 million people worldwide have seen my first art car film, *Wild Wheels*, since it was first broadcast in 1993, and the book by the same name, published by Blank Books, is currently in its third printing. Other significant publications include *Art Cars. Revolutionary Movement*, published in 1997 by the Ineri Foundation, which is directed by Ann and Jim Harithas. The 1999 book *Women at the Wheel: 12 Stories of Freedom, Fanbelts and the Lure of the Open Road*, by Marilyn Root, features a large number of art car portraits.

It is evident even from this limited history that over the last 10 to 15 years, not only have art cars emerged as a viable artistic medium, but they are also becoming integrated into popular culture at an increasingly rapid pace. One of the hottest art forms of the millennium, art cars juxtapose contemporary self-expression with an unexpected canvas, the almighty icon of the automobile. If you have an art car or are going to make one, fasten your seat belt. We're going for a ride!

9 the car is a canvas

how to make an art car

Before making an art car, there are many things to ponder, but first and foremost the car should be considered as a canvas. The more you look at your car this way, the more freedom you'll feel in its design, construction, and application. If you're wrapped up in the monetary value of a car, its resale value, or maintaining its brand, your creativity will surely be inhibited and the possibilities limited. It can be very difficult to free our perceptions of what a car should be. For example, auto companies convince us that a car will some-

how make us more sexy, rugged, sporty, or sophisticated. But why buy into a car manufacturer's brand appeal when you can create your own? After all, when stripped of its advertising hype, a car is simply a blank canvas.

When you make an art car, you give your car your own personal brand. This said, it's equally important before you get started that you are really committed to the idea. Once you start painting, gluing, or sculpting, it will be too late to go back.

So before starting, here are some issues to consider, followed by some technical and creative options for realizing your art car vision.

choice of canvas

If you are serious about making an art car and are prepared to put considerable time and money into it, then choose a canvas that's mechanically reliable. What a car looks like or what condition its body is in doesn't matter as much as how well it runs. Most people take an old clunker and begin making an art car regardless of its physical condition. This is fine and is often all that one can afford, but understand that eventually you may become a slave to your car. After putting so much effort into creating an art car, when it breaks down, you're likely to do whatever it takes to keep it running, whether or not it's rational or affordable to do so.

It's also a good idea to choose a canvas that's appropriate in shape and size, one that can carry the weight of the type of art car you want to create. For example, using a 1-ton (.9 t) van as a

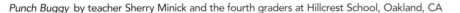

Punch Buggy by teacher Sherry Minick and the fourth graders at Hillcrest School, Oakland, CA

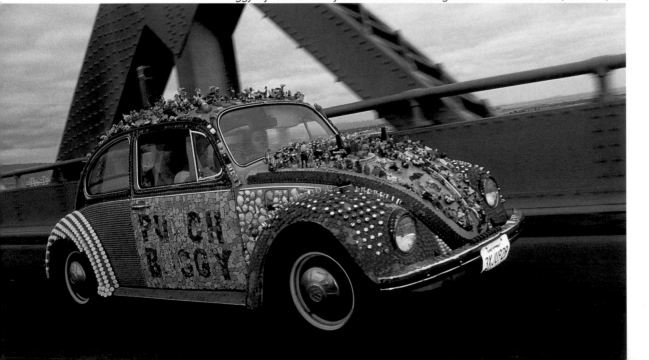

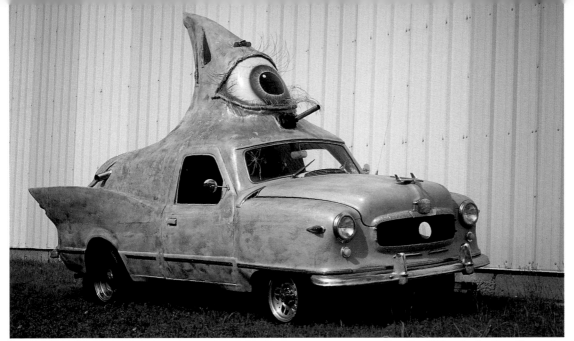

One Eyed Wonder by Tom Kennedy

canvas for a potentially heavy, sculptural pig car is a better idea than using a sports car. Another fact to keep in mind is that a car's gas efficiency will be diminished with extra weight. If you have the means to choose, you might pick a car with decent gas mileage to begin with. Alternative cars, such as hybrids and electric cars, can make cool canvases, and looking ahead, seem wise choices as more laws are passed to keep old polluters off the road.

legality

When making an art car, you should consult the vehicle codes and requirements in your own state to be sure the car will pass legal inspection. In most cases, an art car will be legal and road-worthy if (a) there are no structural alterations made to the original chassis or body of the car, (b) it meets all height, width, length, and weight requirements; (c) it has working signals, hazard lights, headlights, and taillights; and (d) it has an unobstructed view through the windshield and to all necessary mirrors.

It may seem obvious, but art car artists really have a responsibility to make sure that their creations are structurally safe and not harmful or dangerous to others. For example, if you attach television sets to your car, extra care must be taken to be sure that they won't come off on the highway. If you're unsure whether something is safe and roadworthy, consult someone who knows. If worse comes to worst, go to the Department of Motor Vehicles and get an inspection before proceeding any further.

insurance

Insurance is a gray area. Currently it's very difficult, if not impossible, to get collision insurance for an art car, as there is no valuation system developed for art cars. This may change as art cars become more popular, but the cost of the insurance may be prohibitive. Getting collision insurance for the blue book value of the car itself is possible, but not for the artistic embellishments. Obtaining liability insurance can even be difficult, as some insurance agencies are reluctant to insure art cars at all. Some hold the sentiment that art cars are "attractive nuisances" and may get into or be the cause of more accidents. However, many artists have found they can get liability insurance for their cars before making them into art cars.

time and money

Think about whether you have the time and money to make an art car. Of course, it depends upon the type, but art cars frequently take much longer and cost more than estimated. When I created the *Camera Van*, for example, I thought it would take six months and cost no more than $5,000. It ended up taking two years, with the

help of five assistants, and it cost about $30,000. Once it was halfway done, I just couldn't quit, so it really set me back financially for several years. The whole point is to explore your passion and vision and decide if it's the right time to commit to such an undertaking.

attention

If you intend to create an art car for special events and parades, then this issue isn't important. If, however, you're planning to make a daily driver, think seriously about how much attention you can handle. I've tried to convey just how much attention art cars get, but there really is nothing like the experience itself. If you're on the fence about the attention issue, I recommend that you make your first art car out of an additional car, not your primary car. Another option is to find someone with an art car and inquire about riding along with them for a day to see how you like it. Or, if there are no art cars in your area, visit one of the art car events (page 142) and get a closer look at the art car dynamic. Odds are, though, if you're this far into thinking about making an art car, you are going to do it anyway!

vandalism and the police

Regrettably, you must be prepared for some vandalism to your art car. This is especially true for glue cars and cars that address social or political issues. This is not to say that it happens all the time, but it does happen. I recommend that you buy extra paint and even extras of your favorite objects so that if vandalism happens, you can make a quick fix. Use extra care when attaching your favorite objects, too. For instance, placing special objects in the middle of the car where they are out of easy reach helps keep them unharmed.

With regard to the police, it's a good idea to pay particular attention to safety and legality, especially when just starting out in your hometown or going on road trips. Art cars attract everyone's attention including the police, who will pull over an art car just to have a look at it, sometimes even to take a picture. Then, of course, they check your license, your seat belts, registration and insurance. Once they've checked you out, often they will leave you alone. That is, if you obey the laws! So be prepared and know that you are eventually going to get pulled over. It's

part of the art car territory. As art cars are increasingly perceived as something positive, I have found that police are less threatened by them and actually seem to enjoy them. Generally, people who work in or with traffic tend to like the spice that art cars bring to their daily routines.

the elements and maintenance

Many people take it for granted, but in the design stages of an art car, especially a daily driver, attention should be paid to the elements. A driving, 60-mile-per-hour (96 km) wind will cause not only wind drag and low gas mileage for sculptural vehicles, but will also loosen tenuously-attached objects. Rain will leak through any and all holes put into the vehicle, short out wiring, and turn unprotected paper products into pulp. The sun, perhaps the greatest enemy because of its imperceptibly slow effect, will fade all plastics and most paints. Over time, it makes plastic items brittle and gradually disintegrates them.

Once you make an art car, the investment doesn't stop there. Having an art car is like having a pet or a child; it needs your attention. Not

only will it require mechanical upkeep, but it will need artistic maintenance as well. Objects must be replaced or secured, and the car is likely to grow over time. Fortunately, there are some materials that can be applied over a car's surface to protect it; they are discussed later in this chapter. But if you want your art car to last longer, it is worth considering a way to park it indoors or under a tarp when it's not being driven. Keeping it off the street sort of defeats the purpose of an art car, but if the car won't be driven for a period of time, it's a good idea to properly park and store it.

evolution

Creating an car is an organic process, and your first one may take quite a bit of manipulating until you get it just right. Relax and allow your creation to evolve based on what you learn along the way. Some ideas will not come to you until you've realized others. You'll be in a better position to assess the car's functions once you see how everything has come together. Ideas for safety devices and animated moving parts often happen after your initial car is created.

Don't forget to wave!

Community art car made in Philadelphia to promote *Wild Wheels*, 1992

Emily Duffy paints the *Mondrian Mobile*

painting

preparation. Whether you will be painting or gluing and bonding things to a car, it's important to prepare the surface properly. The adage that a good paint job is all in the prep work really is true. The better you prepare the surface, the finer the paint job will be. First assess the condition of the car's original paint job. See if there are any rust spots, exposed bare metal, or peeling paint. If there are, you should fix them, or they will reappear to haunt the paint job you are about to do. Use a power drill with a wire brush adapter bit to gently grind off any rust or loose paint, down to the metal (good idea to use safety goggles here). Wipe off the dust, and use rust preventative primer spray paint to spray all bare metal. (Do this outdoors if you can and/or use a particle mask.) Let the paint dry for 30 minutes.If the rust has eaten away parts of your car and there are holes in the metal, you can opt to fix them with body filler. (If you're keen on making your paint job super clean and nice, consult a technical manual on automotive bodywork and painting.)

The next step is to sand the car. Generally, a light sanding with 100-grit sandpaper is sufficient. A particle mask and eye protection are recommended. The purpose of the sanding is to remove the sheen from the original paint job, as well as any grease, oil, or other slick substances. If you will be spraying your paint job and you want it to have a smooth surface, then it's a good idea to sand the car with a finer sandpaper, 220-grit or even finer. If you're going to use a brush to apply the paint, then 100- or 120-grit paper should be sufficient. If you want to paint on chrome (a hubcap, for example), you'll need to sand it and paint it with a primer because many paints don't stick to chrome. If you want to paint the tires, clean them really well with a degreasing solvent and let them dry thoroughly. (Painted tires are cool, but they only last a few months before needing repainting, and paint is not very good for the rubber.) After you finish sanding, be sure to dust the car off well.

The last of the preparation is to mask all the parts of the car that you don't want to paint, such as the chrome, headlights, taillights, windows, mirrors, and rubber window seals, unless, of course, you don't care what the paint gets onto. A razor blade or even better, a flat razor knife can be used to remove paint from windows. (It's not a good idea to paint the rubber seals as the paint actually disintegrates the rubber over time.) It's worth going to the paint or hardware store to ask

for a masking tape that doesn't leave residue or pull up existing layers of paint. Some masking tape, if left on the car overnight, will leave a residue that can be removed with a special solvent. Once you have the tape, grab a pile of newspapers and start masking. Put a tarp or ground cloth down around the car. If you will be spraying indoors, be sure to cover everything to protect it from overspray. Once all these steps have been completed, you can begin painting with confidence.

paint selection.
There are many types of paints that can be used and each has its advantages and disadvantages. I am dividing the more commonly used paints into two groups: toxic and nontoxic. I haven't personally used all of these paints, so please do additional research and ask a lot of questions at the paint store.

toxic paints.
By far the most popular paint for art cars has become the lead-based sign painter's enamel called One-Shot. It has a fantastic color chart, including fluorescents, and comes in several sizes, including half-pints. The paint is durable, adheres well, and retains its color longer than most others. Its main drawback

is that it is very toxic, so you should wear a respirator when you apply it. It is also very expensive.

Enamel spray paint is another option if you want to do a fast paint job. It goes on faster than brushing and dries faster. Enamel paint can also be acquired in cans and brushed on, though it applies less evenly and dries more slowly than spray paint. Enamels have a great color chart and are relatively inexpensive, but the colors begin to fade after about a year. Spray paint is also prone to dripping and is bad for the environment.

Automotive paints can also be used. Some contain metal flakes, and there's a new paint that changes colors when viewed at different angles. These paints are extremely expensive, but might be fun to play with.

nontoxic paints.
Nontoxic paints, such as acrylic, latex, and tempera, are safe when children are present, clean up easily, and are relatively inexpensive. For a more permanent paint job, acrylic is recommended but should be protected with a clear top coat. Acrylic also seems to be the most popular choice when children are involved in the project. Latex exterior house paint seems to work too, but fades very quickly

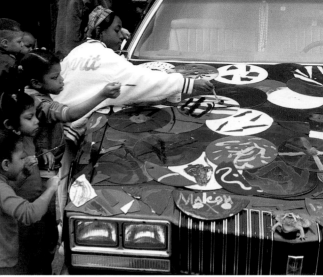

WWOZ Radio community art car (detail), New Orleans, 1993

and isn't very vibrant. However, it's readily available and you can pick up a lot of paint cheap. Deka sign paints have vivid colors and come in a good selection, but they are very expensive. If you want to do a temporary art car, then tempera paint is your only choice. Some people want to enjoy the prolonged thrill of painting a car, but do not want the prolonged thrill of driving it around!

painting techniques.
Once you choose the type of paint, selecting compatible brushes is important. If you use the wrong kind of brush, it may lose its bristles in the paint or leave unattractive streak marks. When buying the paint, ask what kind of brushes to get. There are many painting techniques and styles, and your choice of paint will likely dictate the possibilities. Before embarking upon a huge paint job, it may be worth-

while to experiment first with different types of applications and styles, and to get a feel for the paint to see if you like working with it. As I've said, One-Shot paint is preferable, but other paints can be used and will hold up if protected.

No matter which paint you use, your paint job can be protected from fading and scratching by applying one or more final coats of clear coat. There are many forms and brands of clear coat available, so again, it's a good idea to do a test and some research beforehand. There are varnishes, polyurethanes, polyacrylics, and lead-based enamels such as One Shot. Some artists are also having success with new products from a company called Triangle Coatings. All of these products are available with a UV protectant, which I highly recommend. One of the drawbacks of clear products is that some turn yellow or cloudy, and others peel and flake over time. Also, some types of clear are not compatible with certain types of paint, so be careful to use compatible products. One other option is to have your car sprayed professionally with a UV protectant coat, though this can be costly.

gluing

preparation.
The preparation for gluing objects or materials to a car can be fairly easy unless the original paint job is peeling, flaking, greasy, oily, or rusty. If the original paint is in bad shape, refer to the section on preparation for painting (page 134). If the paint is in good shape, you should be ready to begin gluing. However, if you want to be absolutely certain of getting a good bond, wash the car by hand with a degreasing and cleaning agent, or better yet, lightly sand it before gluing. Many glues will not hold very well to greasy materials such as Armor All, oil, and wax. Once the surface is clean and dry, most glues will work just fine. The question then becomes which glue to use.

silicone caulk.
For most art car applications, 100% silicone caulk is the best, as it adheres to just about anything and is nontoxic. What's most impressive is that silicone maintains a rubbery consistency and does not get hard or brittle over time, as do most other adhesives. It's available in a few different colors, but most people prefer the clear. Silicone caulk comes in a tube and is applied with a caulking gun, which may sound more complicated than it is. There are several types of caulking guns, but they're relatively inexpensive and are really easy and safe to use. Many adhesives come in similar tubes, so be sure to choose the right one. Silicone

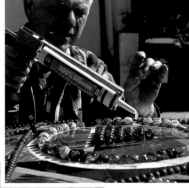

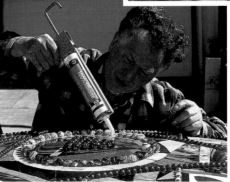

Left to right: Gluing glass onto community art car in Gainesville, Florida, 1993; Ron Dolce silicones marbles to his *Glass Quilt*

begins to set up in an hour or so, depending on the humidity and temperature, and dries overnight. It's translucent, not clear, when it dries, so keep in mind as you glue that excess blobs of silicone will be visible and may not be very attractive. Silicone is paintable but only temporarily, because over time the paint will crack and peel off. It is possible to use a razor blade to cut off excess silicone once it has dried, but it's a better idea to remove the excess with a rag or paper towel as you glue. Using a screw driver to pull up excess silicone that spills out around an object is a good way to go too.

liquid nails, dap 2000, and e-6000.
These adhesives also come in caulk form and work with a wide range of materials. They are, however, toxic, and smell bad. Many art cars have been made with these adhesives, but over time, objects may come loose because these adhesives harden and can become brittle with age. Long-term maintenance is difficult too, because if an item comes off the car, a crusty residue of old glue remains on the car and is hard to remove. Old silicone can be removed more easily.

goop.
Household, Marine, and Plumber's Goop all make great bonds and are stronger than silicone, but are very toxic and get hard. If you screw up with Goop and later want to replace an object glued with it, good luck. A bond made with Goop is often stronger than the glued object itself. Goop can be used like a regular glue, but it can also be used as a heavy-duty contact cement. This is achieved by applying glue to both the object and the car, letting it set up for 5 to 10 minutes, and then pressing the object firmly into the tacky glue on the car. After the glue sets overnight, it will be very difficult to pull the object off the car without breaking it first. For interiors, especially on ceilings, objects glued with silicone have a tendency to fall off before the silicone dries unless they are temporarily taped down. Using Goop as a contact cement will yield better results.

epoxy.
Epoxy is a two-part adhesive. It's prepared by mixing a catalyst and a hardener and is applied right away. It creates a very good bond, but is also toxic. It's good to use when there's an item that you want to be sure will stay on the car for a long time. JB Weld, called a cold weld, is an epoxy-like material with metallic particles in it. It's fantastic for adhering metal objects to the metal of a car. As with all gluing, the larger the surface area of the base of the object to be glued, the better the bond. The bond with cold weld is so strong that the two parts will be practically inseparable. Remember that epoxy dries very quickly. It's great if you want to glue a few objects, but it's impractical for gluing a whole car because you'd be mixing epoxy every ten minutes.

glues not recommended.
I don't recommend using white craft glue or hot glue on art cars. Craft glue is weakened by moisture and rain. Hot glue softens in warm temperatures, and both the inside and outside of a car get hot enough to weaken its bonding ability.

gluing techniques and tips.
Gluing objects to the side of a car can get tricky, as gravity wants to make them slide down. One way to prevent slippage is to start gluing from the bottom and work your way up. Another option is to use masking tape to hold items temporarily in place until the glue cures. If an object is too big or heavy to be held onto the car with glue, then it should be reinforced with screws or

hex-head sheet-metal screws.

A favorite fastener of many art car artists is the hex-head, self-drilling, sheet-metal screw. Insert it with a hex-head driver bit in a power drill (be sure the hex-head and drill bit are the same size). Since the screw is self-drilling (also called self-tapping), you normally don't have to pre-drill a hole. The hex-head screw will go through the object to be attached, a clamp or brace, and right into the metal of the car. If you are screwing

Clockwise, from top left: Student at Sierra School, El Cerrito, California working on the *Toy Car*, spring 1997; Philo Northrup uses hex-head screws to maintain his *Truck in Flux*

a brace of some kind. It may take some experimentation to determine which objects can be glued successfully. Mixing or layering different types of glues is not a good idea and probably won't work. For example, Household Goop will not stick to silicone, and vice versa. So if you're reattaching an object, ideally the old glue should be taken off first. Some types of materials may not adhere well with particular glues so be sure to read the directions and if in doubt, do a test.

additional fasteners

When gluing is not sufficient for attaching an object, you may consider using screws, rivets, nuts and bolts, angle braces, plumber's tape, hose clamps, bungee cords, or a combination of some or all of these. Use your imagination!

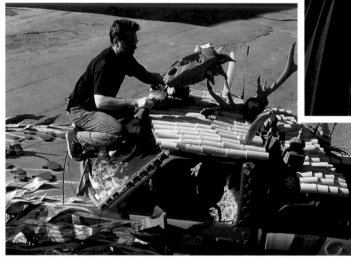

into the ceiling of the car and are concerned about leakage, put some silicone around the screw before drilling it in. These screws come in many lengths, so choose the length you need and not much longer. Generally, if you use short screws you should be fine. The length of the

screw should depend on the thickness of the object you are putting onto the car. It's a drag to have a bunch of screws sticking into the inside of the car. If you use a screw that's too long and it sticks through your headliner, break it off by tapping it sideways with a hammer. Be careful not to drill into window mechanisms, gas lines, hoses, tires, batteries, etc. After some practice, you'll get the hang of it. Many people are reluctant to drill into a car, but it's kind of fun.

pop rivets. Another option is using pop rivets. Rivets are a great way to attach metal objects, such as coins, brass items, or crushed aluminum cans. You'll have to buy a pop-rivet tool (which is not that expensive) and pop rivets. The rivets come in various lengths, sizes, and materials. Aluminum rivets are a good choice because they don't rust, but it's a good idea to inquire at the hardware store about your particular needs. Like choosing screws, getting the right-sized rivets should depend on the thickness of the objects that you want to attach. The process is fairly simple and makes a secure bond. Using a 9/64-inch (3.6 mm) drill bit, drill a hole into the object you want to attach and one into the car where you want to attach it. Then put the pop rivet into the end of the tool and push it through the hole in the object and all the way into the hole on the car. Squeeze the handles of the rivet tool together until the stem pops off, leaving the rivet holding the object on the car.

miscellaneous fasteners. If you want to attach larger and heavier objects such as TV sets or appliances, it's time to break out the good old nuts and bolts, brackets, and wrench or socket set. You may want to start out by adding racks, a platform, or another secure base on which to attach bigger items. Use a power drill with a bit the same diameter as the bolt, and pre-drill holes through the object. Then, use the bolts and lock nuts to attach L-shaped or other brackets to the object. (Lock nuts work better than regular nuts, which come loose with the car's vibrations.) Next, bolt the other side of the bracket to the car itself or to the roof rack. Metal plumber's tape (also called strapping tape, generally used to secure water heaters) is also handy. Use shears to cut it to the length needed, then either bolt or screw it to the object and the car. Hose clamps and even a good old bungee cord will also sometimes work.

As mentioned before, it's very important to make sure all objects are well secured. If you have any doubts, get a second opinion and professional confirmation that you did a good job.

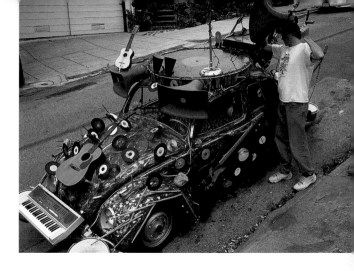

sculpting

If you're going to make a sculpted vehicle, adding to the existing shell of the car is probably easier and more likely to meet legal requirements. If you modify the chassis or build a body from scratch, you'll need substantial welding and mechanical knowledge and skills. I have never made a sculptural car, so I am providing this information courtesy of Tom Kennedy, creator of *Ripper the Friendly Shark* (page 98).

Top to bottom: Harrod attaches military speaker to *Pico de Gallo*; Tom Kennedy's sketch of his *Ripper the Friendly Shark*

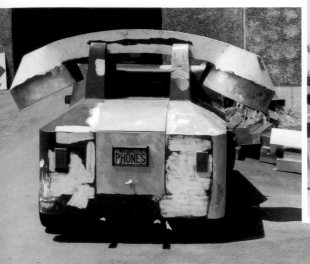

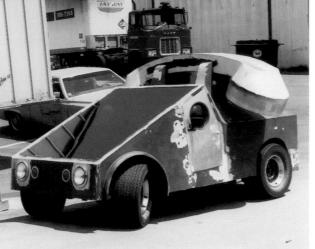

Telephone Car, by Howard Davis, under construction

the points where the frame attaches to the car are strong. If the frame is made of steel, remember to paint it with primer before you apply the skin of the sculptural shape. It's worth the extra time to work out the kinks in your design at this stage rather than after you've put the skin over the frame.

applying the skin.
You will need to cover the frame with a material such as chicken wire, metal screen, or wire mesh to add further support for the skin. Next, apply a skin of cloth, papier-maché, foam, sheet metal, fiberglass, or similar material over the wire shape. The material you use should be consistent with how long you want your creation to last. If you plan to have people climb onto the car, make sure your frame and skin are strong enough to support the weight. Spray insulation foam can be used to create a bumpy texture, or applied and then carved and sanded to create the shape you desire. You can also have your car professionally foamed if you have the

It is not absolutely necessary but certainly helpful to start out with a sketch of your idea. Consider taking photographs of your original car from many different angles and using tracing paper to trace over the photographs. Add the lines of the sculptural shape that you want to create. This will help you figure out the basic lines for your frame.

making a frame.
Frames can be constructed from either wood or steel. If you choose steel and you don't know how to weld, it's a good idea to get some help with your first car. As you create the frame, take time to step back from the car and look at it from many angles. Then attach the frame to the car with self-drilling machine screws, bolts, and/or rivets. In the process, make sure to preserve the functional aspects of the

vehicle. For example, the doors should still work and access to the engine and gas tank should be preserved. Make sure you can still change a tire if you get a flat, and have enough visibility to drive safely. In addition to checking visibility, it's a good idea to drive the car around for a couple of days to test your welds and make sure that

Construction of *Dusty Dave the Dolphin* by Tom Kennedy, Harry Leverette, and Penny Smith

budget to do so. Carved foam and papier-maché skins should be sealed with a waterproof substance such as a paint or resin to weatherproof both the outside and the underside of your creation.

finishing the surface. Finally, add
finishing touches to your surface with foam, fiberglass, body filler, and/or paint, depending on the look and texture that you are going for.

Above: Shelley Buschur and friend paint the "skin" of *Eelvisa*; right: Lucy Harvey at the wheel of *Lulu*

electrifying

Regardless of the type of art car you end up making, you may want to flesh it out with accessories, such as additional lights, an external sound system, and other mechanical and electrical parts. You can add a lot to an art car once some basic electrical information is obtained. Since I do my own electrical work in a nonprofessional way, I can mention some basic options, but know that there are more sophisticated alternatives. If you're not electrically proficient, consult with a professional mechanic or electrician, because incorrect wiring can cause a fire.

One option is to work from your existing fuse block and add the accessory to it. Whatever you add, make sure there is a fuse and an on/off switch between your accessory and the power source. You may want to consult your mechanic on how to add an accessory. Another option is to install your own fuse block with separate wiring from the battery. All of your accessories should go to on/off switches, then to the fuse block, and then to the battery. A third choice is to install an additional alternator in your car (if there's room) and an additional battery. Designate this second alternator and battery to run the accessories. Of course, unless you are mechanically inclined, you will probably need to consult your mechanic or have him or her do it. This is not so easy and may cost a few hundred dollars. You can also add household appliances, computers, fans, television sets, etc. by installing a power inverter that converts 12 volts into 110. Inverters range in price and load capacity. For example, you can get a small power inverter that will run Christmas lights for under $100.

Art Car Web Sites

general art car sites

Art Cars for hire, image licensing, etc. ·· **www.artcaragency.com**
Art Cars in Cyberspace ·· **www.artcars.com**
Art Car Links (Cosmic Ray) ································· **www.geocities.com/SunsetStrip/1485/artcar.html**
Banana Bicycle Brigade ·································· **http://www.bananabikebrigade.com/**
BMW Art Cars ·· **www.bmw.com/bmwe/pulse/events/art_cars/**

annual parade and festival sites

ArtCar Fest ·· **www.artcarfest.com**
Burning Man Festival ·· **www.burningman.com**
Houston Art Car Parade ··· **www.orangeshow.org**
Seattle Art Car Blow Out ···························· **www.speakeasy.org/~docschlk/blowout00.htm**
Wheels As Art Parade & Festival ···················· **www.intermediaarts.org/eventwheels.html**

art car exhibition sites

American Visionary Art Museum ························· **www.avam.org/artcar/index.html**
Art Car Park ······································ **www.artcars/ArtCarPark/ACPINDEX.HTM**
Art Car Museum ·· **www.artcarmuseum.com**
Art Car World ·· **www.artcarworld.com**

personal art car sites

Bedrock to Bartertown by Derek Arnold ·································· **www.ghostmine.com**
Big Horn by Hyler Bracey ·· **www.Big-Horn.com**
Calliope by Gustine Castle ·································· **www.gustinecastleandyou.com**
Camera Van by Harrod Blank ·· **www.cameravan.com**
Cast Me! by Dennis Woodruff ·· **www.radproductions.com**
Frivolous Niece by Ken Gerberick ·························· **www.geocities.com/ken_gerberick/**
Guitcycle by Ray Nelson ··· **www.ray-guitar.com**
Hamburger Harley by Harry Sperl ·· **www.burgerweb.com**
Leopard Bernstein by Kelly Lyles ··· **www.kellyspot.com/**
Lu-Lu by Lucy Harvey ··· **www.mosaicranch.com/**
Pez Car by Cliff Lee ································· **http://users.ev1.net/~criff/pezcar.html**
Mirabilis Statuarius Vehiculum by Scot Campbell ···················· **www.teleport.com/~extremo/**
Sticker Car by Conrad Bladey ·································· **www.toad.net/~sticker/sticker.html**
Ripper The Friendly Shark by Tom Kennedy ··························· **www.artcaralley.com**
Telephone Car by Howard Davis ·· **www.datel-com/profile.htm**
The Duke by Rick McKinney ··· **www.jigglebox.com**
The Peace Car by Uri Geller ··· **www.urigeller.com**
The Stink-Bug by Carolyn Stapleton ····································· **www.thestinkbug.com/**
Truck in Flux by Philo Northrup ··· **www.philo.com**
Tulip by Nina Paley ·· **www.ninapaley.com**
Universe Hearse by Todd & Kiaralinda ·································· **www.kiaralinda.com/**
Whimsy by Bill Stevenson ·· **http://drive.to/enjoy**

Acknowledgments

This book is dedicated to my zany mother, Gail Blank, for her encouragement, spirit, silliness, and love. I am also grateful to my eccentric father, Les Blank, for his support, his zest for life and adventure, and for teaching me how to see. I would like to thank all of the artists in this book for sharing their creativity and individual spirit, may their flags fly forever.

I also would like to express my gratitude to all of the producers and organizers of art car events, including Susanne Theis and Jennifer McKay from the Houston Art Car Parade, and Philo Northrup, my ArtCar Fest cohort, for their years of dedication to the art car movement.

Special thanks to the many who helped, housed, and supported me along the way, especially Kevin Ratliff, David Silberberg, Alexis and Toni Spottswood, Ron Dolce, and my stepfather, Burt Keenan.

Thanks also to Raya Miller and Hunter Mann for preparing this book for print, and to Lark Books and its staff for its bold publication. Enjoy the ride, and I'll see you all on the road!

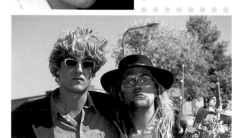
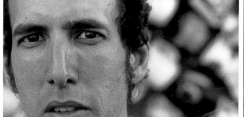

Clockwise, from left to right: Gail Blank; ArtCar Fest 2000; Les Blank; Ernie Steingold; Philo Northrup; Alexis Spottswood; Harrod Blank and Susanne Theis; David Silberberg; Harrod and Leonard Knight; Harrod and Rick McKinney; Jennifer McKay; Kevin Ratliff; Harrod and Ron Dolce

Index

Photo Credits